RENOIR

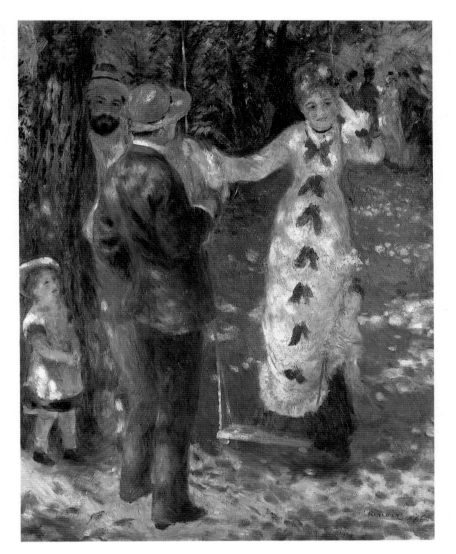

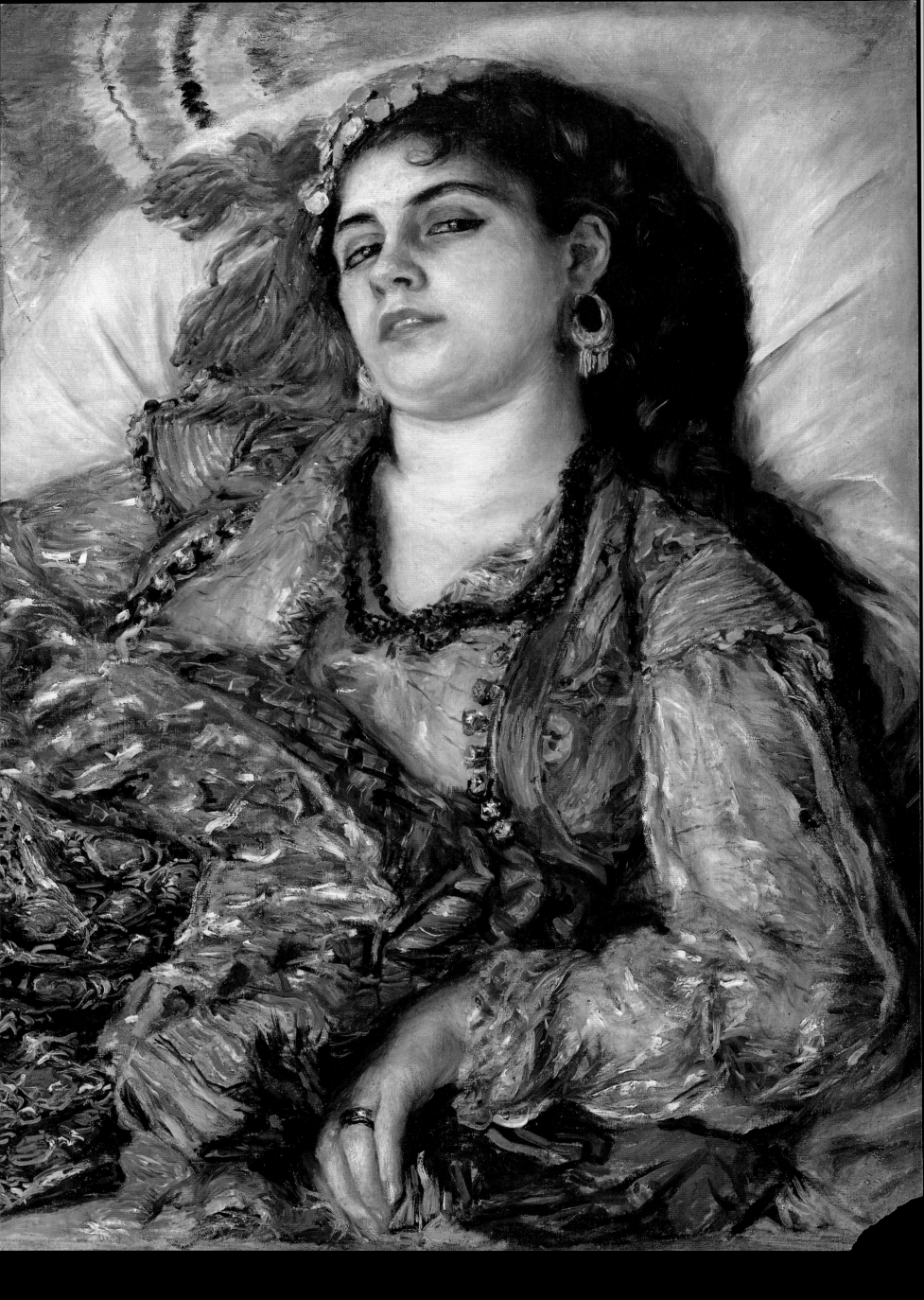

RENOIR

LESLEY STEVENSON

SMITHMARK

This edition published in 1993
by SMITHMARK Publishers Inc.
16 East 32nd Street
New York, New York 10016.

SMITHMARK books are available for
bulk purchase for sales promotion and
premium use. For details write or
telephone the Manager of Special
Sales, SMITHMARK Publishers Inc.,
16 East 32nd Street, New York, NY
10016, (212) 532 6600

Produced by Brompton Books Corp.,
15 Sherwood Place,
Greenwich, CT 06830

ISBN 0-8317-7383-9

Printed in Hong Kong

10 9 8 7 6 5 4 3 2 1

FOR JOHN AND MARGARET
WITH LOVE

Page 1: *The Swing,* 1876

Page 2: *Odalisque; Woman of
Algiers*(detail), 1870

Contents and List of Plates

Introduction

Renoir's paintings are some of the most popular, well-known, and frequently reproduced images in the history of art. They seem to present the modern spectator with an uncomplicated vision of a forgotten world. And yet this contemporary sense of nostalgia for something lost forever was in fact a symptom of Renoir's own attitude to life and art which reveals a much more complicated and frequently paradoxical situation than a reading of his paintings as representations of a simple, harmonious existence would at first suggest to the casual observer.

Renoir is probably best known as a leading member of the Impressionist group which between 1874 and 1886 held eight group exhibitions organized as an alternative to the state-controlled and conservative Salon. However, he exhibited with this independent group on only four occasions while he submitted paintings to six Salons during the same period. In this respect, he aligned himself more with the official forum for the arts, than with the alternative venue of the Impressionist group shows.

This view of Renoir as a prominent member of an avant-garde group of

painters presents him as adventurous and innovative in his practice. Certainly some of his paintings, particularly those of the late 1860s and 1870s, are among the most striking and formally daring of the nineteenth century. It is worth remembering, however, that throughout his life Renoir had no desire to capitalize on his position as a 'revolutionary.' As well as continuing to exhibit at the staid Salon he considered himself not as some Romantic, iconoclastic genius, but as a painstaking artisan in the tradition of his artistic heroes, the eighteenth-century masters, whom he admired throughout his life and praised for their superb craftsmanship.

Renoir's allegiance to the artisanal class partly developed out of his roots in the Parisian working class and he was the only member of the Impressionist group who had to earn his living by manual labor before devoting himself to painting. Even at the end of his life, when he was living in a luxury far removed from the Parisian slums in which he had been raised, he maintained a healthy respect for this craftsmanship. However, by then he had long since left his working-class origins behind and even by the 1870s and 1880s he mixed with some of the most fashionable and wealthy members of the Parisian bourgeoisie. By the 1880s and 1890s his work reveals a desire to belong to that leisured class.

At the same time as he encouraged an image of himself as an artisan, Renoir attempted to distance himself from anything which might be construed as intellectual activity. His letters, and reported conversations, reveal a mistrust of highbrow theorizing. Such a view is seldom disputed by those who attempt to reconcile Renoir the man with the notion of the Romantic genius, for it plays upon long-cherished notions about artistic creativity residing in spontaneity and originality. However, of the original Impressionist group, it was Renoir who perhaps came closest to a manifesto (albeit one which disputed the aims and methods of orthodox impressionism) and who could argue articulately and compellingly in print when he wished.

Some criticism in recent years has been directed against Renoir and his art because of his perceived misogyny. Many of his

Below left: Berthe Morisot and her daughter Julie Manet, who became Renoir's ward after her mother's death in 1895.

Below: Renoir painted this self-portrait when he was 35.

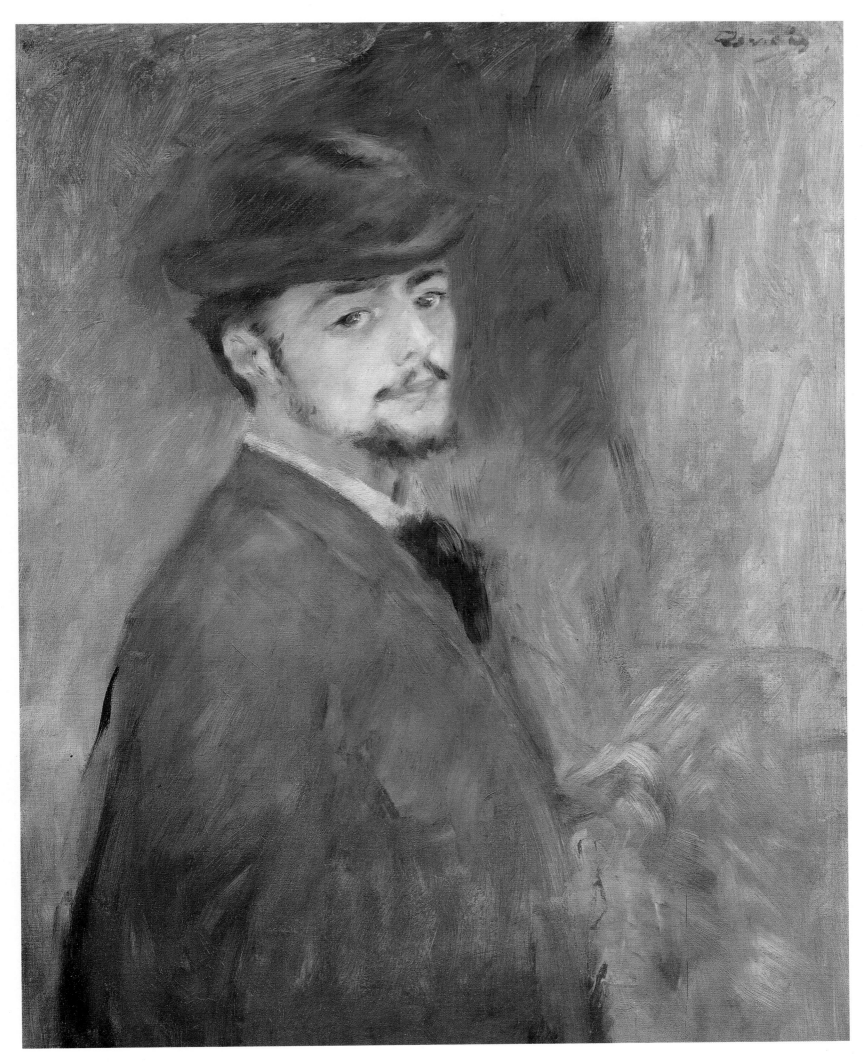

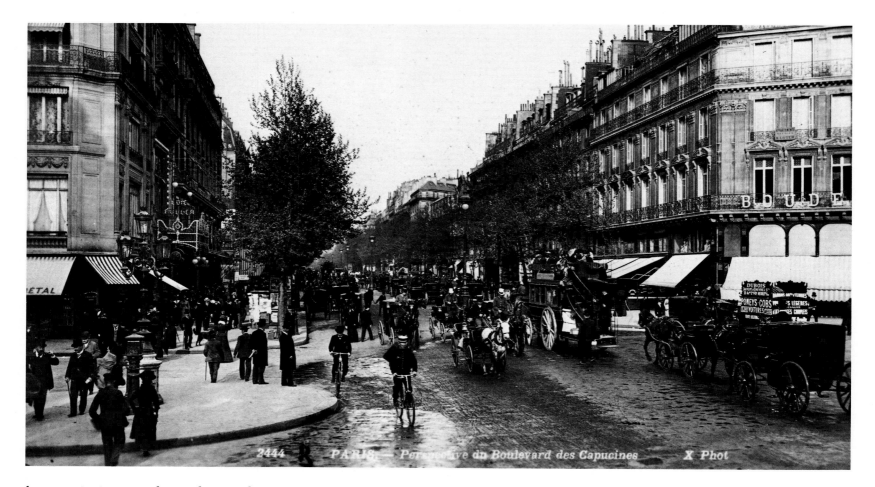

later paintings took as their subject women, often nude women, in a domestic role and confined setting and for this Renoir has been criticized. Such criticism is perhaps over-simplistic. Certainly there were demands for female emancipation throughout the late nineteenth and early twentieth centuries, and women were beginning to emerge from the home to pursue careers, but in the main, Renoir's thinking was certainly no different from that of his contemporaries. The crime of misogyny, levelled against the artist who revelled in the depiction of women, was compounded by early commentators who encouraged a narrow reading of his works. It is important, therefore, to reassess those critics' writings alongside the original production and presentation of the works themselves. It comes as a revelation to discover that one of the artists whom Renoir most admired among his Impressionist peers was Berthe Morisot. She was one of the most sensitive and intelligent members of the Impressionist circle and he held her in high regard while retaining something of a servile attitude to her patronage. Morisot seems genuinely to have liked Renoir and entrusted him with the guardianship of her only daughter, Julie Manet, after her death.

Similarly, the anti-Jewish sentiments of which Renoir may quite justifiably be accused, were commonplace in France at the turn of the century and indeed were ignited by contemporary writings. His anti-Dreyfus, conservative standpoint was hardly unusual and those members of the Impressionist circle who did support Dreyfus in the 1890s (notably Pissarro, the writer Emile Zola, and Monet) were in the minority. What is revealing is that at the same time as holding these reactionary views Renoir continued to mix with and cultivate Jewish patrons.

One of the most frequent terms of praise used of Renoir's painting, particularly that of his impressionist period, was of its fidelity to nature, its apparent 'realism,' and an examination of contemporary criticism reveals that it was within that frame of reference that Renoir's work tended to be seen in the nineteenth century. At the same time however, other writers recognized its underlying unreality, the selective and idealizing process to which it had been subjected. Once again, the modern viewer is left wrestling with an apparent contradiction.

These complications in any reading of Renoir's art are to a large extent due to his early biographers who have left us with an image of Renoir which has until recently been accepted unquestioningly. These early biographers, Ambroise Vollard the picture dealer, the writer Georges Rivière and particularly his son the film director Jean Renoir, were themselves colorful figures who were not above enhancing facts if it made for a more lively text. Each of them knew Renoir well at a different stage in his life and many of the anecdotes they relate have been freely swapped and embroidered. By repetition these whimsical recollections have acquired the weight and status of facts and in the end the reader or spectator only gets close to the artist through a series of fictions.

Jean Renoir's biography *Renoir my Father*, one of the chief sources, was written long after his father's death and drew on a series of conversations held while he was recuperating from injuries inflicted during World War I. Up until then, he appears not to have known his father very well, sheltered as he had been throughout his childhood by an army of women who saw to the running of domestic affairs in the Renoir household. Clearly keen to present his father in a good light he is aware that his own role is not that of a mere biographer but something more creative and he makes a half-hearted attempt at an apology to that effect in his preface.

Similarly Ambroise Vollard, the picture dealer who met Renoir in the mid-1890s and who amassed one of the largest collections of his works, had a vested interest in presenting a fairly specific image of the artist to his public. He was eager to establish that he knew the painter and his working procedures well and thereby lend authenticity to those works he owned. However, he knew very little about Renoir's early life and had to rely on anecdotes plundered from other writers. Early biographers such as Vollard and Jean Renoir were responsible for shaping the confines within which much later twentieth-century criticism operated.

Perhaps the most embarrassing complication in any assessment of Renoir and his art arises from what are, by any standards, some very poor works. His early paintings were consistently accomplished in their execution but many of his late works fall short of that early promise. This is partly because by the end of his life, Renoir's art was popular and fetched high prices so that even rough sketches from his studio were saved and acquired the status of finished works. Moreover, as letters written at the beginning of the century to his dealer

Durand-Ruel demonstrate, Renoir was increasingly called upon to authenticate works which were clearly not his and at one point he considered taking legal action to establish which paintings were his and which were forgeries. Some works now attributed to Renoir are, in fact, of dubious authenticity. Any consideration of his work as a whole must take account of these facts.

Early Life in Paris

Pierre-Auguste Renoir was born on 25 February 1841 in Limoges, the sixth child of Léonard Renoir (1799-1874) and Marguerite Merlet (1807-96). In 1844 the family moved to Paris where Léonard Renoir earned his living as a tailor.

The process of industrialization had begun in France in the the 1820s, and under the rule of Napoleon III who had become Emperor of France in 1852 it was accelerated and an ambitious and pragmatic rebuilding of Paris began. Under the control of Baron Haussmann, the city was transformed from one of cramped, insanitary streets with few green spaces into an elegant and spacious capital to equal London, the capital city of France's rival in international trade at that time. It was furnished with broad boulevards, running water, and street lighting; trees were planted and public spaces created, and policemen patrolled the streets. Communications were improved; the railroad and canal networks were enlarged and commuters traveled into the city each day from outlying suburbs. Such progress was achieved only by displacing large sections of the population, and the working classes were moved from their homes near employment in the city center to specially created areas on the outskirts of the metropolis. The desire to prevent similar insurrections to those which had punctuated the earlier part of the century was clearly one of Haussmann's main concerns in his urban planning. The new broad boulevards would be much more easily defended from rebels than the old narrow streets which had frequently been barricaded.

Napoleon III's foreign policy was less successful. Algeria had been a colony since 1830 and a number of artists had gone there to capture the flavor of the 'Orient,' but ill-judged wars and a political scandal in Mexico in 1867 contributed to his lack of political success abroad. His reign finally came to an end in January 1871 after the disastrous Franco-Prussian war.

Only after 1871 did France enjoy a relative political stability and the new Third

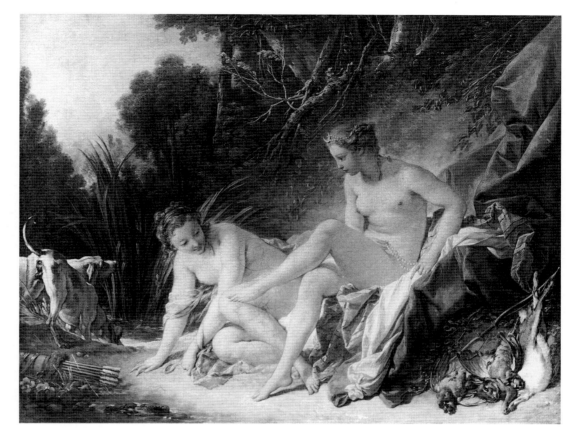

Republic lasted until 1940. During this period the reforms of the previous régime were consolidated and compulsory primary education was introduced in France in the 1880s, the same decade which saw the legalization of trades unions. Yet Renoir's nostalgia for a golden era looked beyond the economic and social changes of his youth back to a harmonious mythical past.

In 1854 Renoir left school and began his apprenticeship as a porcelain painter at the firm of Lévy frères. His precocious talent for painting china is documented by all his biographers and his regard for craftsmanship and a sense of pride in manual labor dates from this period in his life. His career as a porcelain painter would have been assured had the firm not gone bankrupt in 1858 as a direct result of new industrial processes which reproduced designs on china much more rapidly and more consistently than a painter could ever hope to do. A hostility to mechanization which Renoir later expressed may date from this time. Without a steady trade, Renoir dabbled in a number of different jobs, painting blinds and fans but it seems that he may have decided to become a full-time painter around this date.

On 24 January 1860 Renoir was granted permission to copy in the Louvre, a practice which he maintained for the next four years. Ambroise Vollard later chronicled a conversation with Renoir in which he recalled this early taste for eighteenth-century masters, including Fragonard, Lancret, Watteau and above all Boucher:

I would say . . . that Boucher's *Bath of Diana* [page 9] was the first picture that really grabbed me, and I continued to love it all my life, just as one adores one's first love.

Renoir's taste for these decorative Rococo works was typical of the 1860s when they enjoyed a rehabilitation in public taste after decades of neglect because of their associations with *ancien régime* decadence. One or two of his early paintings use the theme of the bather (eg pages 38 and 58) but it was not a subject which occupied him until the mid 1880s. During the 1860s it was presumably Boucher's painterly handling, his high tonal key, and his attention to detail that Renoir admired.

By the following year, 1861, Renoir had begun attending the studio of Marc-Gabriel-Charles Gleyre (1806-74), a Swiss teacher who offered practical instruction to a number of artists who went on to specialize in landscape painting and work in the impressionist idiom. Gleyre had come to Paris as a young man and studied at the Académie Suisse, probably the best-known free, or independent, studio in the capital. While he was there, Gleyre met the English painter Richard Parkes Bonington (1802-28) who specialized in landscape painting and who may have been influential in encouraging him to practice this genre. After a painting trip to the Middle East, Gleyre returned to Paris and had his only real success at the Salon; a large history painting entitled *Evening (Lost Illusions)* (page 10) which earned him an instant reputation. The work was based on a system of curves and painted in a smooth, finished style. Although this polished execution would have found favor with the Salon jury its Romantic mood would have gained Gleyre no influential supporters within academic circles and his career as a Salon painter never really progressed beyond this point. However, that same year he took over the running of one of the

Below: *Evening, Lost Illusions* of 1843 by Renoir's teacher Gleyre. This painting was a success at the Salon.

Far below: Cabanel's *Birth of Venus*, a typical Salon nude which earned Napoleon III's approval when it was exhibited in 1863.

1862 until a couple of years later. Admission to the Ecole was necessary for any young artist intending making a career in painting, since any sales or commissions at that time were generated through the official Salon (from 1863 an annual exhibition of paintings chosen by a jury, which was composed mainly of members and professors of the Ecole des Beaux-Arts). Picture dealing or running a private gallery were often just sidelines for paint merchants or picture restorers. Therefore any artist who wished to have a successful career had to operate in the official channels, exhibiting at the Salon and enrolling at the Ecole, which complemented the instruction he received at the private *ateliers*.

Renoir may have submitted a work to the 1863 Salon entitled *Nymph with a Faun* and which according to his biographer Duret represented a naked woman, lying on a bed, with a dwarf playing a guitar beside her. If he did submit such a work, Renoir had it refused by the jury along with an unprecedented number of works by other artists that same year. The great success at the Salon was Cabanel's *Birth of Venus* (page 10), a mildly erotic subject masquerading under the guise of a classical theme. However, many artists, most of them more established than Renoir, saw themselves being robbed of their livelihood for some time by not having their

most prestigious teaching studios in the capital, which had originally belonged to Jacques-Louis David (1748-1825) and Gleyre instructed some of the most gifted pupils in Paris.

Renoir may have been drawn to Gleyre's studio because it was relatively inexpensive. Like other students he paid 10 francs a month to cover the cost of rent and to pay the models' fees: Gleyre did not accept payment for any instruction. Two of the lessons he learned there were to remain with him for the rest of his life: an emphasis on the importance of drawing as the basis for painting, and on the need to work on landscapes in the open air. Along with his fellow pupils Renoir seems to have liked and admired his teacher and was saddened by the closure of the studio early in 1864 because of the master's ill health and lack of funds: as late as 1890 he continued to refer to himself as a 'pupil of Gleyre.'

At the same time as he received his practical instruction at Gleyre's, Renoir enrolled at the Ecole des Beaux-Arts and records show that he was there from 1 April

Right: A cartoon from the *Journal Amusant* of 1869 which mocks the amateur painters who sketched in the open air in the Forest of Fontainebleau.

Below right: *A Studio in the Batignolles Quarter* by Fantin-Latour. Renoir, wearing a hat, looks at Manet's canvas with Bazille, Monet, and Zola.

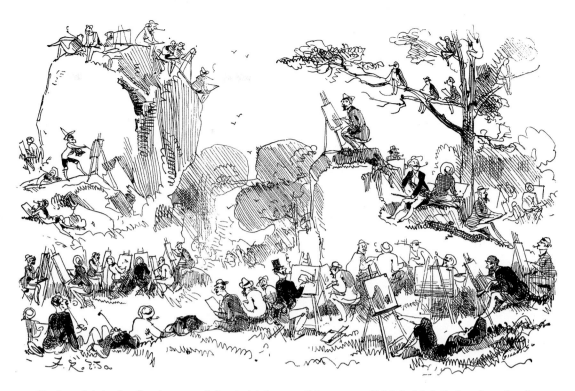

work endorsed by the Salon jury and there was a tremendous public uproar. Napoleon III in a gesture of magnanimity, exercized his imperial prerogative and decreed that there should be a Salon des Refusés. While this meant, in theory, that all works submitted to the Salon that year could now be seen, many artists withdrew from this counter-exhibition because of the fear of stigma attached to their having been refused. The *Salon des Refusés* was important because it was one of the first large-scale exhibitions by a number of artists which formed an alternative to the Salon and thereby provided a model of sorts for the first Impressionist exhibition eleven years later; the outcry surrounding it forced the art establishment to examine and liberalize its administration to some extent; and it provided a convenient figurehead in the person of Edouard Manet (1832-83) for what was gradually perceived as being a loosely based group of artists who disagreed with the practice and theory of the academic system.

At the Salon the following year Renoir had his first success – an ambitious literary work illustrating a scene from Victor Hugo's *Notre Dame de Paris*. The painting was entitled *Esmerelda Dancing with her Goat around a Fire Illuminating the Entire Crowd of Vagabonds*. Unfortunately Renoir appears to have been dissatisfied with the work and destroyed it after the exhibition. His earliest surviving Salon painting, a portrait of *William Sisley* (page 30), is from 1865. In this work Renoir has departed from his earlier practice of sending *grandes machines* that is, large, ambitious history paintings with spurious literary associations, to the Salon and has painted a fairly informal record of a friend's father.

At the same time as he produced these pieces, Renoir also painted much more intimate pictures, often simple studies rather than highly finished works suitable for exhibition. Gleyre encouraged his pupils to go and sketch in the countryside around Paris, often in the forest of Fontainebleau to the south of the city. The landscape studies the artists worked on there were not paintings suitable for sale or exhibition, but quick sketches, with the emphasis on spontaneity, and with the intention of capturing the effects of atmosphere. Sometimes these rapid sketches would be worked up in the studio and figures and details would be added to bring the whole thing into focus, but more often they merely served as a visual reminder when an artist worked on a large finished and highly artificial landscape painted in the

studio in which the freshness of the initial response was lost forever. Gleyre's insistence on this kind of training and his emphasis on the importance of landscape as a genre was not new; the Barbizon painters of the previous generation had worked *en plein air*.

Renoir may have worked outside with fellow students in the summer of 1862, and the following year he spent the Easter vacation in Chailly in Fontainebleau with other young artists from Gleyre's studio with whom he had become friendly the previous winter. These were the future Impressionist painters Claude Monet (1840-1926), Alfred Sisley (1839-99) and Frédéric Bazille (1841-70). Other artists whom he met around this time were Henri Fantin-Latour (1836-1904) who attended Gleyre's and the Ecole and who already had had several Salon successes, and Camille Pissarro (1830-1903) and Paul

Cézanne (1839-1906) both of whom worked at the Académie Suisse. By 1863 the nucleus of the future Impressionist group was formed.

Renoir later acknowledged his debt at that time to the invention of the collapsible metal paint-tube, which was freely available by the 1860s and which made sketching and working in the open much simpler. Jean Renoir reported a conversation with his father

Paints in tubes, being easy to carry, allowed us to work from nature ... Without paint in tubes, there would have been no Cézanne, no Monet, no Sisley or Pissarro, nothing of what the journalists were to call impressionism.

Fantin-Latour later immortalized some of these friends in *Studio in the Batignolles* of 1870 (page 11, below). The work was a homage to Edouard Manet, the recognized leader of this rather disparate band of

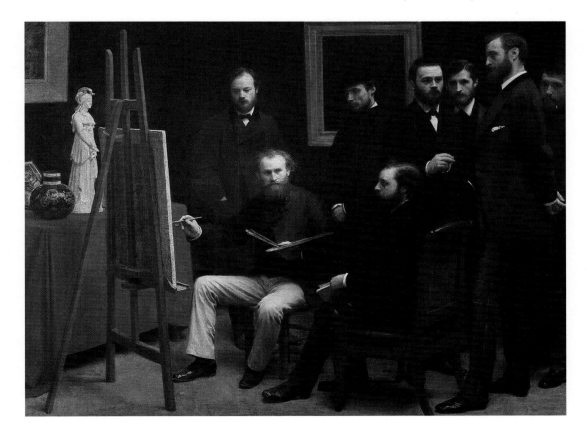

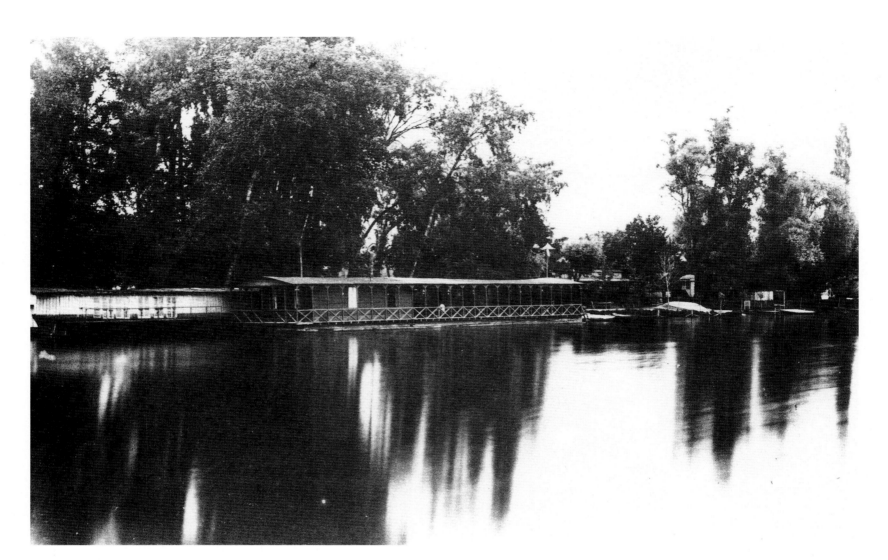

painters, who is depicted working at his easel. Renoir, wearing a hat, looks down at Manet's canvas, the tall figure of Bazille stands to the right-hand side and Monet looks out of the picture at the viewer. The writer Emile Zola, an early champion of Manet, Monet and Renoir is included.

Once the practice of painting *en plein air* was established, and even after Gleyre's studio closed in 1864, his four students would regularly spend the summer months working in the countryside, usually in the Fontainebleau region. However, it was not until much later that Renoir completed landscapes in the open. Typical works from this period include *Mother Anthony's Inn at Marlotte* (page 34) which although painted in the forest of Fontainebleau is a genre scene painted indoors, and *Jules le Coeur in the Forest of Fontainebleau* (page 36), a work which was clearly painted in the studio, perhaps based on sketches done in the open.

Jules le Coeur (1832-82), a painter who had trained as an architect, owned a house in Marlotte at which Renoir was frequently a guest at this time. At the end of 1865 Le Coeur introduced him to the seventeen-year-old Lise Tréhot who became his lover and model until her marriage in 1872. She

posed for a number of works and modelled for the paintings Renoir submitted to the Salon, such as *Diana* (page 39) and *Lise with a Parasol* (page 41), both painted in 1867, *Summer* (page 44) of 1868, *Bather with a Griffon* (page 58) and *Woman of Algiers* (pages 60-61) of 1870.

Because these works were destined for the Salon they tended to be rather conventional in their composition and very smoothly executed but at the same time Renoir was painting much more informal works in which the traditional distinction between sketch and finished painting was gradually being eroded. In the summer of 1869 he and Monet worked together and produced what are usually regarded as the first landscape paintings in which the impressionist style of painting is properly evident. They abandoned Fontainebleau that year and worked at La Grenouillère on the Seine near Bougival (page 52). This was a newly fashionable place where people would spend their leisure time walking, boating, and bathing in the river, just a short journey from the center of Paris. Between them, Monet and Renoir executed a number of works there and seven are known today. Renoir's depictions of the area (pages 52 and 54) show its charac-

teristic artificial island (called the 'camembert') which one reached from the banks along a narrow footbridge.

The status of these canvases by Monet and Renoir is unclear. Monet wrote to Bazille that summer:

I have a dream, a picture of the bathing place at La Grenouillère, for which I have made a few poor sketches, but it is only a dream. Renoir, who has spent two months here, also wants to paint the same picture.

This letter implies that the works he and Renoir produced at La Grenouillère were regarded as preparatory sketches, from which a 'picture' would later be made. Yet the works are clearly more finished than rough sketches and the works are signed, indicating the artists' satisfaction with them.

The works are painted on fairly small, easily transportable canvases and their lack of finish betrays a rapid execution typical of works done out of doors, capturing the essentials before the light changes dramatically. The choppy brushwork used in the works imitates the effect of flickering light rippling across the surface of the river and falling through the trees and contributes to a sense of immediacy. This type of hand-

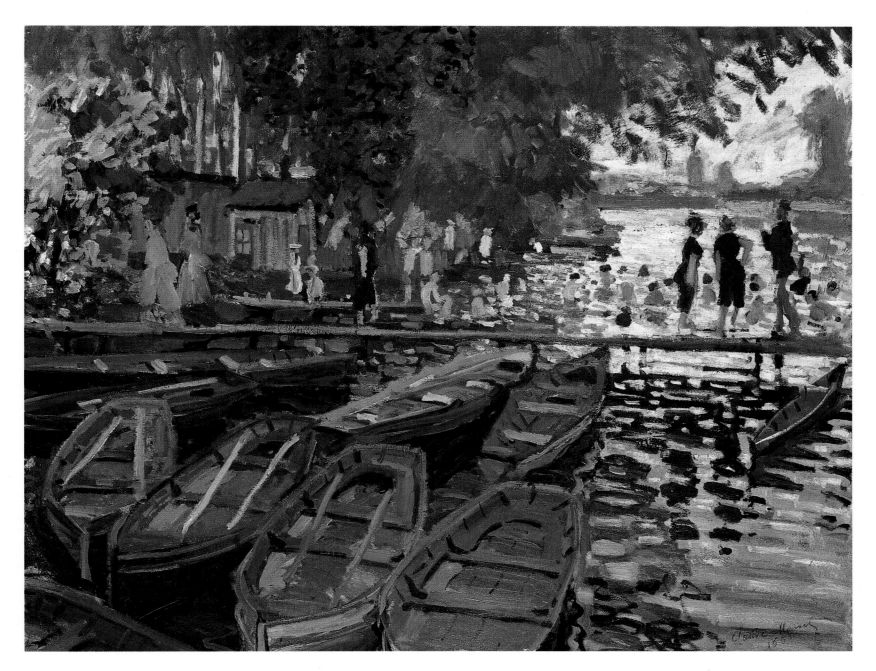

ling was not new, both artists would have acquired a degree of fluency with a brush while working at Gleyre's particularly on sketches done in the open, but its use in a painting which we now regard as finished was novel.

Compared with another early landscape painting done by Renoir, *Jules le Coeur in the Forest of Fontainebleau* (page 36), which was painted in the studio, one of the most dramatic changes in the works done at La Grenouillère was in the artists' use of color. The earlier work was still tied to the use of earth tones, but in the more recent canvases the artists have adopted more colorful palettes. In each of his works Renoir has mixed his colors with white and the effect is of an increased luminosity and a much lighter tonality. Both Renoir and Monet have increased the general brightness of the work by the use of color complementaries, particularly the juxtaposition of red and green in the boats. One of the principal tenets of the impressionist method, that the local colors of objects are affected by their neighbors, is observed here. Finally both artists increase the sense of 'immediacy' in their works by stopping the picture at apparently arbitrary places. Both achieve this effect by chopping off the

rowing boats at abrupt angles. Of course, in each, the composition is a very conscious construction, held together by the lines of the horizon and the jetty.

The Salon and the first Impressionist Exhibitions

The following year Renoir had two figure paintings accepted at the Salon – *Bather with a Griffon* (page 58) and *Woman of Algiers* (page 60), for both of which Lise had posed. Despite the fact that Renoir did not go to Algeria for another ten years he has successfully managed to imbue *Woman of Algiers* with a North African exoticism which would have appealed to the public. Certain conventions in the depictions of North African themes had been established by Delacroix (1789-1863) among others, after French colonization in the 1830s and these would have helped to lend to the work's appeal and accessibility. While the Western conventions governing the *Bather with a Griffon* make her appear aloof as she draws attention to her nudity rather than concealing it by the carefully contrived position of her hand, her Oriental sister is provocative and passionate. The availability and sensuality of Algierian women was seen as indisputable.

On 19 July 1870 France declared war on Prussia and the following month Renoir was mobilized. He was drafted into the Cuirassiers – armored soldiers on horseback – and posted to Tarbes in the Pyrenees. Whether because of family commitments, or out of an unwillingness to support Napoleon III's political régime, most of his artist friends avoided being drafted. Cézanne hid out at L'Estaque in the south of France; and Monet, Pissarro, and perhaps Sisley went to London, while Bazille was conscripted and killed on 28 November 1870 at Beaune-la-Rolande. The French were defeated and surrendered on 28 January 1871.

While in London Monet met a Parisian picture dealer, Paul Durand-Ruel (1831-1922), whom he introduced to Renoir in the summer of 1872. That year Durand-Ruel bought a flower still life for 300 francs and the *Pont des Arts* (page 42) for 200 francs from Renoir. Shortly thereafter, Renoir moved into a studio at 74 rue Saint-Georges, one of the streets running off the new great boulevards planned by Haussmann, where he painted some of his most memorable scenes of Parisian life and which was to be the center of his life for the next decade.

Renoir's submissions to the 1873 Salon, a portrait and *Riding in the Bois de Boulogne* (page 71) were both turned down by the jury, and as in 1863, a counter-exhibition of refused works was held. This *Salon des Refusés* may have been instrumental in Renoir's decision not to submit to the official Salon the following year but to stage an independent exhibtion with his friends.

In the summer of 1873, Renoir went to stay with Monet and his wife and child at Argenteuil, nine kilometres north west of Paris on the Seine. Once again their close artistic collaboration was to prove fruitful, and each produced a number of works in which their practice is similar. In *Monet Painting in his Garden at Argenteuil* (page 72) Renoir demonstrates how far these private works have departed from the more ponderous style he adopted for Salon paintings such as *Riding in the Bois de Boulogne*. The influence of his friend is clear in the bright, glowing colors and the smaller flickering brushstrokes, particularly evident in the dense foliage which screens Monet from the town of Argenteuil in the background of the scene. Along with Manet's *Monet Working in his Floating Studio at Argenteuil* (page 15), painted the following summer when Monet, Manet and Renoir all worked there together, this work is a testament to the impressionist credo. In each painting Monet is shown working on a small, easily transportable canvas which has been primed with white paint which increased the luminosity of colors applied to it. The canvas sits on a light sketching-easel, a necessary piece of equipment for the landscape artist as was the white parasol which lies under the easel alongside the box of paints in Renoir's work. In Manet's painting Monet and his work are sheltered from the glare of the sun by the awning which projects from the cabin in which Camille his wife is sitting. Manet's depiction of the *botin* reveals the extent to which even an apparently spontaneous artist such as Monet skillfully selected and edited his motif. The floating studio gave him the freedom to turn towards a more picturesque scene, if he wished, than the industrial chimneys in the background of the river picture. Similarly, Renoir painted Monet looking away from the expanding town of Argenteuil in the background of his painting, and into a carefully controlled environment in his own garden.

After the failure of the 1873 Salon, Gleyre's former students and artists like Pissarro and Cézanne began seriously to consider holding an exhibition of their work which would be free of the constraints of the Salon system. The idea of a group show had been suggested as early as 1867 but because of the disruption caused by the Franco-Prussian war, and then a measure of financial support from Durand-Ruel, the plan had been shelved. In fact the financial independence which these pur-

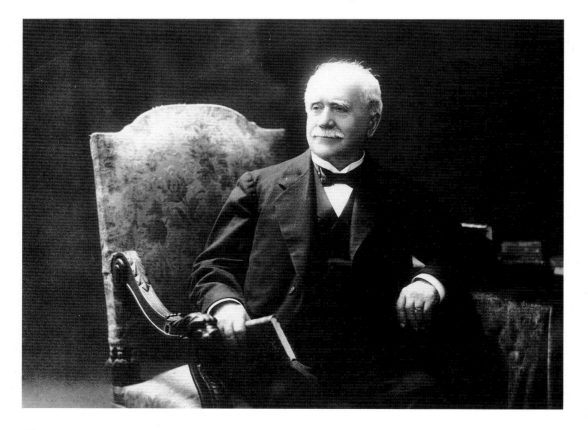

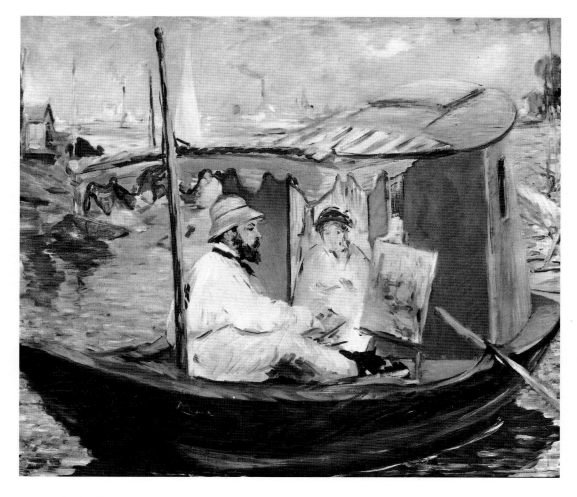

exhibited seven works, including *Dancer* (page 77), *La Loge* (page 79) and the *Parisienne* (page 75). The main aim of the exhibition was the freedom to exhibit work without the constraints of a jury system and any practical decisions which had to be made in the hanging of the works were taken democratically. The works were hung alphabetically, after lots were drawn to determine which initial came first. Generally works were hung on one level, rather than according to the more hierarchical system adopted at the Salon whereby those paintings which were 'skied' had little chance of being seen. At the same time as wishing to assert a degree of artistic integrity, each of the artists exhibiting was keen to sell his or her paintings, particularly now that Durand-Ruel had stopped buying their works. The marketing of the exhibition was skillfully managed to take

chases had offered the group, meant that it was only Renoir who had continued to send to the Salon in 1872 and 1873. His continued allegience to the Salon demonstrates that he considered it much more than simply a means of generating sales but as an important testing ground for his pictures. However, Durand-Ruel's early optimism in their work meant that by 1874 the dealer was suffering a severe financial crisis, and his backing dwindled.

By the end of December 1873 Renoir, Pissarro, Monet, Cézanne, Berthe Morisot (1841-95), Sisley, Degas (1834-1917) and other artists, some of whom had already had a measure of success at the Salon, had registered themselves as a joint stock company. Manet did not join them, preferring to pursue his career at the Salon where he was beginning to have some success. Originally the politically radical Pissarro had drawn up an exhaustive list of rules and regulations governing membership which he had modelled on the charter of a bakers' union, which established the group as a cooperative. Renoir objected to what he saw an overly bureaucratic system and eventually most of the conditions were simplified or removed. This early instance of his mistrust of political systems, particularly when they were proposed by Pissarro, was to become more marked and eventually led to hostility between the two artists.

The exhibition opened on 15 April 1874 at a prestigious venue, the recently vacated premises of the photographer Nadar at 35 boulevard des Capucines, one of the great boulevards, and only a short walk from Renoir's studio on the rue Saint-Georges. The catalogue listed thirty names. Renoir

account of this. Long opening hours were introduced, with the intention of reaching as wide a public as possible and the exhibtion was open daily from ten in the morning until six, and then a second session from eight until ten o'clock in the evening. The entrance fee was one franc and catalogues cost fifty centimes. A reduction of ten per cent was offered to anyone making a purchase during the period of the exhibition.

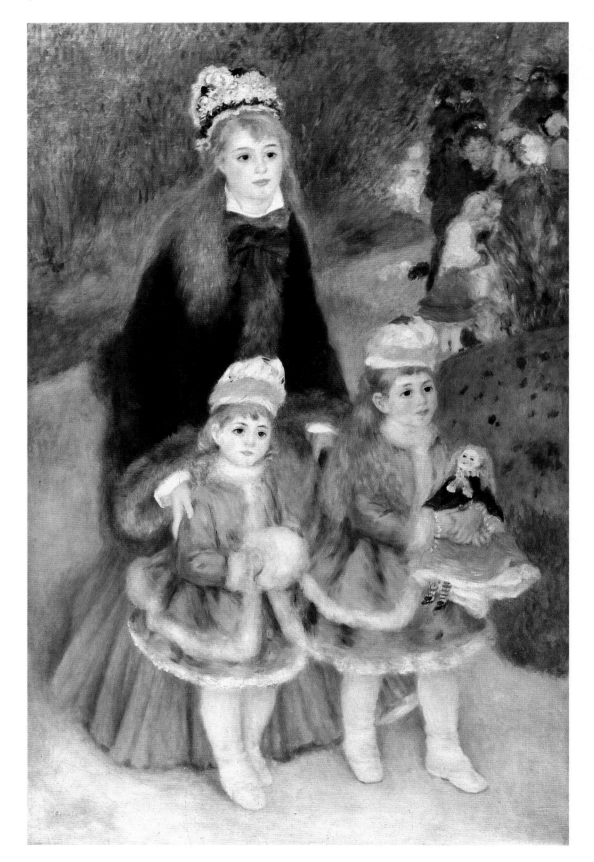

The hanging of the works was regarded as being crucial to their reception. The walls on which the works were displayed were hung with dark flock wallpaper, as was the norm, and lighting was a combination of both gas and natural daylight from windows overlooking the streets outside. The writer Philippe Burty (1830-90) described the hanging in an article entitled 'The exhibition of the limited company of artists'

The paintings are presented most advantageously, lit more or less as they would be in an average apartment, set in isolation, not too numerous, not detracting from one another by being too stridently or too dully juxtaposed.

Burty's was just one of over fifty articles or notices in the press about the exhibition. Although some of these were critical, most found something worthwhile to say, if not about works themselves, then about the artists' challenge to the stranglehold of official art exhibitions. A number of writers used the word 'impressionist' in their articles to designate the group which as yet lacked any kind of identity other than simply that of 'limited company,' but Louis Leroy's formulation is credited with being the first. In an article in *Le Charivari* on 25 April he mocked Monet's *Impression, Sunrise*, a sketchy seascape:

Impression – I was certain of it. I was just telling myself that, since I was impressed, there had to be some impression in it . . . and what freedom, what ease of workmanship! Wallpaper in its embryonic state is more finished than that seascape.

However, despite scathing comments like these, the exhibition was judged to be a success in terms of visitors. In the month it was open, from 15 April to 15 May, 3500 people visited the show. Moreover, a number of articles were sympathetic to the artists' aims and some writers had kind words for some of the exhibits. The show was a financial failure, however, and Renoir was put in charge of the liquidation committee. They had no choice but to dissolve the company, and after their expenses were settled each artist was left owing 185 francs 50 centimes.

Because of the need to clear their debts and in order to gain some publicity, Morisot, Monet, Renoir, and Sisley decided to hold a public auction of their work in the Hôtel Drouot, the Parisian auction house, on 23 and 24 March 1875. Renoir sold 20 paintings for a total of 2251 francs, some of them for as little as 50 francs, less than their reserve price. Shortly after the auction he received a commission from Victor Chocquet (page 88), a customs official who was a great Delacroix enthusiast. Chocquet (1821-91) was one of the most important early collectors of works by Impressionist painters, particularly Cézanne, Monet, and Renoir, from whom he purchased at least 14 paintings. His first commission was a portrait of his wife Caroline (1837-99) (page 89). That same year Renoir was commissioned by the indus-

Right: The dancehall at the Moulin de la Galette in Montmartre towards the end of the nineteenth century.

Below: The Moulin de la Galette in 1875 which shows the still largely rural nature of Montmartre.

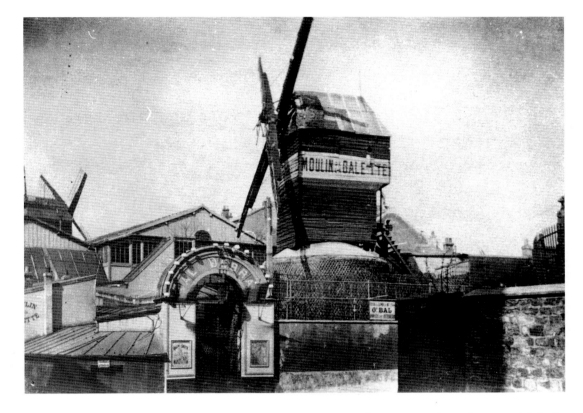

trialist Jean Dollfuss (1823-1911), a native of Alsace, to copy Delacroix's Jewish Wedding (page 85) in the Louvre for 500 francs. The copy is faithful, quite different from his own style at that time, and demonstrates the extent to which he was prepared to compromise for a commission.

In April 1876 the second Impressionist exhibition was held at 11 rue Le Peletier. Renoir exhibited 19 works, six of which were loaned by Chocquet and two by Dollfuss. Manet was listed as the owner of *Frédéric Bazille, painter Killed at Beaune-la-Rolande* (page 37).

That summer he began work on a major painting, sketching at the Moulin de la Galette in Montmartre and in the garden of a new studio he had rented in the nearby rue Cortot, at the top of the hill near the picturesque windmills while continuing to live in the rue Saint-Georges at the foot of the hill. A that time Montmartre with its market gardens still retained some of the charm of its original village atmosphere, although the areas around were increasingly industrialized. It seems that from the outset, Renoir regarded this work as a major artistic statement, akin to a Salon painting in conception if not in finish. He tackled it with the same degree of single-mindedness, working it up from rough sketch through a much larger oil sketch to the finished picture.

In his biography *Renoir et ses Amis*, Renoir's friend Georges Rivière (1855-

1943) gave an account of the place:

The Moulin de la Galette had no claims to luxury; it had retained its original rustic style, dating from the eighteenth century . . . The dance hall was made out of wooden boards painted a horrible green, which happily time had partly softened. At the end of the room a platform was reserved for the orchestra . . . [behind this] . . . there was a garden, or rather a courtyard, planted with stunted acacias and furnished with tables and benches. The ground was of rubble, hard and fairly even, so that in summer there could be dancing there at the same time as in the dance hall . . . [which on Sundays] . . . opened at 3 o'clock in the afternoon and closed at midnight, with an hour's interval to allow the musicians to eat . . .

According to Rivière he would help Renoir carry his canvas there every day from his studio where a number of friends posed for him. It seems likely that Renoir did not paint the large *Moulin* on the spot but worked it up in the studio from the study and the smaller oil sketch, which subsequently belonged to Victor Chocquet.

The *Moulin de la Galette* (page 92) was one of 21 works shown by Renoir at the third Impressionist exhibition in 1877. Along with controlling the administration of the show and generating sales, the group realized the third aim of an independent exhibition that year and pubished their own journal. *L'Impressionniste* was never properly a manifesto, and did not survive beyond the four issues produced for the 1877 exhibition, but it demonstrates the artists' commitment to exerting as much control as possible over the promotion and reception of their works. Renoir contributed to *L'Impressionniste* with a letter in the issue of 14 April and a fortnight later with an article on contemporary decorative art. However, most of the journal was written and edited by Rivière, much of it with Renoir's guidance and approval. Reviewing the *Moulin de la Galette* he wrote:

Certainly M Renoir has a right to be proud of his *Ball*. Never has he been better inspired. It is a page of history, a precious moment of Parisian life depicted with rigorous exactitude. Nobody before him had thought of capturing some aspect of daily life in a canvas of such large dimensions . . . He has attempted to produce a contemporary note and he has found it; the *Ball*, whose color has such charm and novelty, will certainly be the great success among the art exhibitions of this year.

In 1878 Renoir was accepted at the Salon, the first time for eight years, with *Le Café*, a genre painting of a fashionable

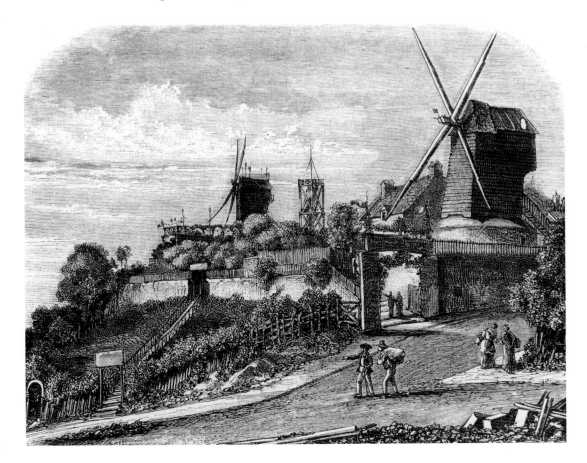

Right: Renoir in the early 1880s.

Below: This view of the rue de Rivoli shows the extensive damage caused by rioting after the commune of 1871.

young woman enjoying a cup of coffee. No group exhibition had been planned for that year and it was only a regulation preventing those at the Impressionist show from submitting to the official Salon that had prevented his showing there in 1877. The following year Renoir had to determine his allegiance and decided against participating in the fourth Impressionist exhibition. He showed four works at the Salon in 1879, including the large society portrait of *Mme Charpentier and her Children* (page 98). Marguerite Charpentier (1848-1904) was the wife of the publisher Georges Charpentier (1846-1905) and hostess of one of the most fashionable *salons* in Paris, at which Renoir was a regular guest. This portrait was hung in a prominent place at the Salon, mainly because of the intervention and influence of the sitter, and was critically well-received. Duly encouraged by this success, Renoir seems consciously to have decided from this date that henceforth the Salon was to be the natural forum for presenting himself to the public.

Although this could have been construed as a desertion of his former Impressionist allies, a letter written by

Camille Pissarro, ever loyal to the group exhibitions, reveals a degree of sympathy with Renoir's motives. Pissarro related that Renoir had had a 'great success at the Salon. . . . So much the better; poverty is so hard.' This pragmatic approach was most cogently put by Zola reviewing the following year's Salon for an article entitled 'Le Naturalisme au Salon.' Once again, Renoir had chosen to exhibit four works there:

M Renoir is the first to understand that commissions never arise [from independent exhibitions]; and because he needs to live, has begun to send to the official Salon again, . . . I'm all for independence in everything, and yet I confess that M Renoir's conduct seems to me perfectly reasonable. One must realize the admirable means for publicity that the official Salon offers young artists; because of our customs, it is only there that they can seriously triumph . . . A simple question of opportunism, as they say nowadays among our politicians.

That financial motives were uppermost in his mind was revealed in a letter Renoir wrote to Durand-Ruel in March 1881, by way of an apology for once again forsaking the group show:

I shall attempt to explain to you why I am sending to the Salon. There are scarcely 15 collectors in Paris capable of liking a painter without the Salon. There are 80,000 who won't buy as much as a nose, if the painter doesn't show at the Salon . . . My submission to the Salon is wholly commercial.

And the following year he once again pleaded his case to the dealer who was keen to present a homogeneous Impressionist group to the public and increase his own sales

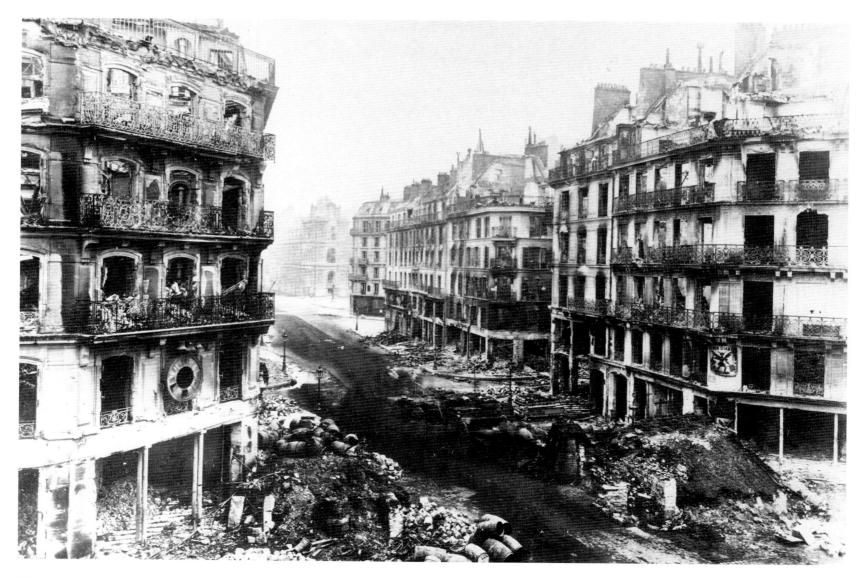

Unfortunately, I have one goal in my life, and that is to increase the value of my canvases. The way I go about it may not be good, but I like it. For me to exhibit with Pissarro, Gauguin and Guillaumin would be like exhibiting with any socialist . . .

This letter reveals that while money was a primary consideration for Renoir's abandoning the group show and, to an extent, the Impressionist cause, the underlying reasons were more complex and deserve investigation.

The end of Impressionism?

In January 1881 Durand-Ruel had begun purchasing far greater numbers of Renoir's paintings than previously and that year he spent 16,000 francs on them. This offered the artist an unprecedented degree of financial security and unlike the other members of the Impressionist circle he did not have a family to support which left him free to spend the money on foreign travel. The first two trips abroad Renoir made were to Italy and North Africa, destinations common for nineteenth-century artists and epitomizing two important strands in contemporary art. That Renoir was aware of these two opposing tendencies had been apparent in his Salon submissions of 1870, when his classical Westernized Venus was complemented by an Oriental odalisque (pages 59 and 60).

Renoir's first trip, following in the footsteps of Delacroix, was to Algeria with his friends Lhote, Lestringuez, and Cordey, for six weeks from 4 March to 17 April 1881. That fall he left Paris for Italy, which he toured from the end of October until the following January. For at least part of that time, he was travelling with Aline Carigot (1859-1915), although he did not mention her in any of the letters he sent to Paris. He had met Aline at the end of 1879 or the beginning of 1880. She had recently arrived in Paris, where she lodged with her mother, from the village of Essoyes in Champagne, one of a growing band of immigrants to come to the capital in search of work. It is not clear when she and Renoir became lovers, but the first painting for which she modeled was the ambitious *Luncheon of the Boating Party* (page 112), painted 1880-1. In Italy he visited Venice, Rome, Naples, Capri, and perhaps Florence and Padua.

If the trip to Algeria was in a sense a confirmation of his earlier work, then the Italian journey was to be influential for Renoir's art through the remainder of the 1880s, the most experimental and troublesome decade of his career. Renoir was reported as having said to his son Jean of this period in his life that 'perhaps I have painted the same three or four pictures all my life. But one thing is certain: ever since my trip to Italy I have been concentrating on the same problems.' If what he did and saw in Italy did not solve his artistic problems, it at least helped to define them.

Much of the work produced in the 1880s is groping and experimental in nature and bemused erstwhile supporters. Georges Rivière, one of Renoir's most passionate advocates in the 1870s, later said of the work of the 1880s, such as *The Children's Afternoon at Wargemont* (page 128).

. . . to anyone looking at the artist's oeuvre, these pictures indicate the extent of Renoir's internal disturbances at that time. He underwent both an intellectual and a moral crisis. The intellectual crisis was brought about by the lessons of the masters that the painter had

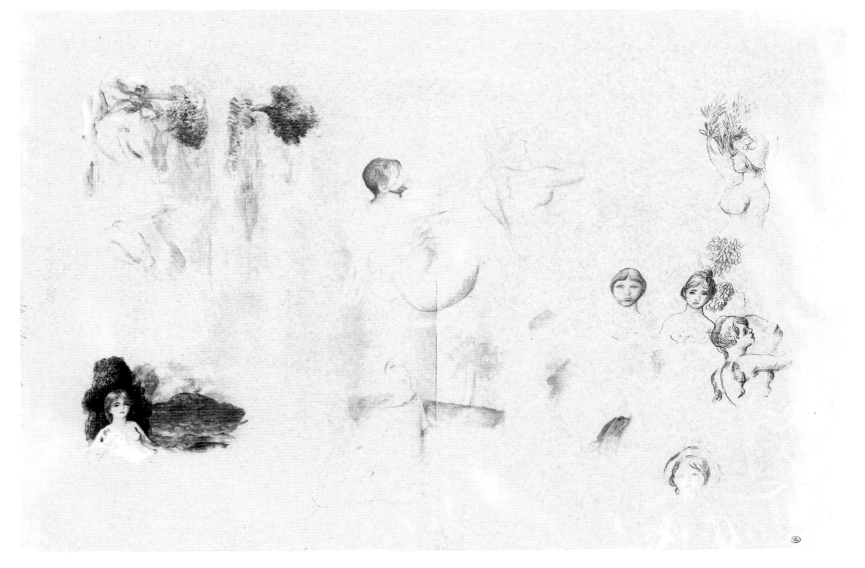

examined on his travels; the moral crisis was the result of a change in the artist's life: he had married and felt his new responsibilities.

Rivière can hardly have been unaware that Renoir did not marry Aline Charigot until 1890, when their eldest son was five years old, but he may have maintained the fiction that their marriage had occured much earlier out of a sense of discretion for his children who may not have been aware that their parents were not married until ten years after their first meeting. However, he was correct in maintaining that middle-age and domestic responsibilities had their effect on Renoir's art. He could not afford to take as many risks as he might have done previously when he was a single man with fewer financial worries, but these concerns did not come until the mid-1880s. Rivière pinpoints the other important reason for the change in Renoir's art at that time – the impact of the masters of the Renaissance whom he studied in Italy. Shortly after arriving in Naples, Renoir had written with palpable excitement to Durand-Ruel on 21 November 1881 'I've seen the Raphaels in Rome.' It was particularly Raphael's decorations of the Villa Farnesina that had impressed him, as he was to be struck by the Roman murals from Pompeii which he saw in Naples.

Renoir later said to Ambroise Vollard, 'Around 1883, a break occured in my work. I had reached the end of impressionism and came to the conclusion that I did not how to paint or draw. In a word, I had

reached an impasse.' We need not attach too great a significance to Vollard's rather arbitrary date of 1883; he was notoriously inaccurate in such details and the 'impasse' is evident before then. However, the quotation is important, for it encapsulates the main problem of what is sometimes referred to as the 'crisis' of impressionism. One of the main objectives of the impressionist style, an accurate analysis of the effects of light and color reflexions on objects in the open air, was riddled with paradoxes as Renoir and several observant critics had already recognized. Any attempt at a faithful rendering of the external world ultimately relied for its translation into paint on the intervention of the artist's subjectivity. This went beyond the conventions of selecting and editing in which any artist necessarily indulges, and resulted in more fundamental problems of communication. In translating the blue of the river in *The Skiff* (page 108) into paint, Renoir has built a picture with claims to objectivity, on his most personal, least communicable sensations of colors and tones. In *The Skiff*, a superb example of the impressionist idiom taken to its logical conclusion, Renoir's observations are turned into a painting in which the forms of the objects represented seem set to disintegrate. He explained this result to Vollard 'if the painter works directly from nature, he ultimately looks for nothing but momentary effects; he does not try to compose, and soon he becomes monotonous.' The problem therefore was how to save the picture surface from a total breakdown and

Renoir's reassessment of his work in the light of the works of the Italian Renaissance, particularly the decorative works of Raphael and those from Pompeii, confirmed that a much greater emphasis needed to be placed on the use of drawing to structure his compositions. This reinforced the lessons he had learnt at Gleyre's 20 years before.

In a painting such as the *The Umbrellas* (page 135) Renoir's change in practice is evident. The painting was begun around 1881 before the trip to Italy and the righthand side of the canvas betrays a fluffy handling which is characteristic of his work at this time, and much closer to *The Skiff*, for example. The work was only finished some four years later and the much tighter, structured, and linear approach differentiates the lefthand side of the painting. The new 'dry' style, of what is sometimes referred to as his 'sour period' reached its climax in *The Children's Afternoon at Wargemont* (page 128) and particularly the *Bathers* (page 136).

This last was worked up with the care and attention normally lavished on a traditional Salon painting, and may be read as the culmination of his researches until that time. The process was elaborate and time-consuming, with as many as 20 preparatory sketches still extant (page 19). The pose of the three central bathers derives from a bas-relief from Versailles by the French sculptor François Girardon (1628-1715) (page 20). When the work was displayed in Paris at Georges Petit's International Exhibition in May 1887, it was greeted with incomprehension by most of his former supporters and remained unsold for some time. In the catalogue title of the work *Baigneuses: essai de peinture décorative*, however, Renoir acknowledged not only the experimental nature of the work, but the all-important debt to the decorative paintings he had seen in Italy. The *Bathers* marked Renoir's return to the more traditional subject-matter of official Salon art, and after the mid-eighties the nude was to be of primary concern. The links with academic art, such as Cabanel's *Birth of Venus* (page 14, below), were clear, but Renoir was attempting in technique and subject to lend his art a classical and universalized flavor.

However, it was not only the work which he had seen in Italy which caused Renoir to begin a reappraisal of his subject and practice. On his return to France from Italy at the beginning of 1882, Renoir stopped off at Marseilles on the south coast where he met Cézanne. Renoir had known

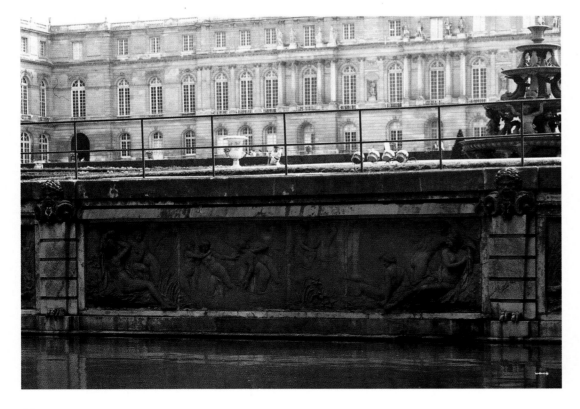

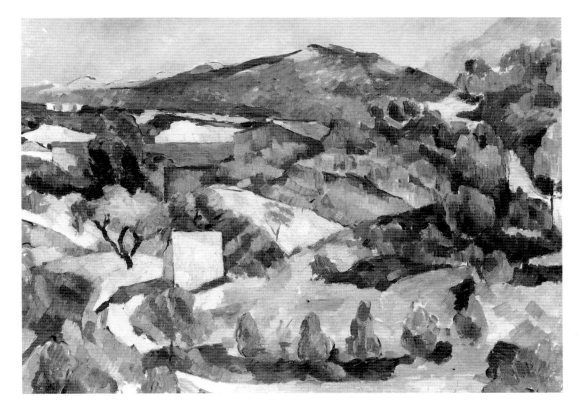

him for twenty years and he had been one of the original exhibitors at the first Impressionist show, but he had been working for some time in increasing isolation in the south of France, at his home in Aix-en-Provence. In a letter to Durand-Ruel on 23 January 1882, Renoir wrote that he and Cézanne were going to work together at L'Estaque on the coast (pages 21 and 120). Like Renoir, Cézanne had abandoned the independent group show as a suitable forum for his art, and despite continued rejection, had continued to submit works to the Salon. Although perhaps in a less conscious way than Renoir, Cézanne was equally aware not only of the limitations of the group show but also of the impressionist idiom. For several years he had been seeking to structure his compositions in a more systematic and controlled fashion, and his method is evident in work like the

Château de Médan (page 21, below), datable to the summer of 1880. In this work, the picture surface is tightly structured by a system of diagonal parallel hatchings.

This has the effect of merging near and far planes which would normally be differentiated by the use of aerial perspective, and the suggestion of the momentary, fleeting

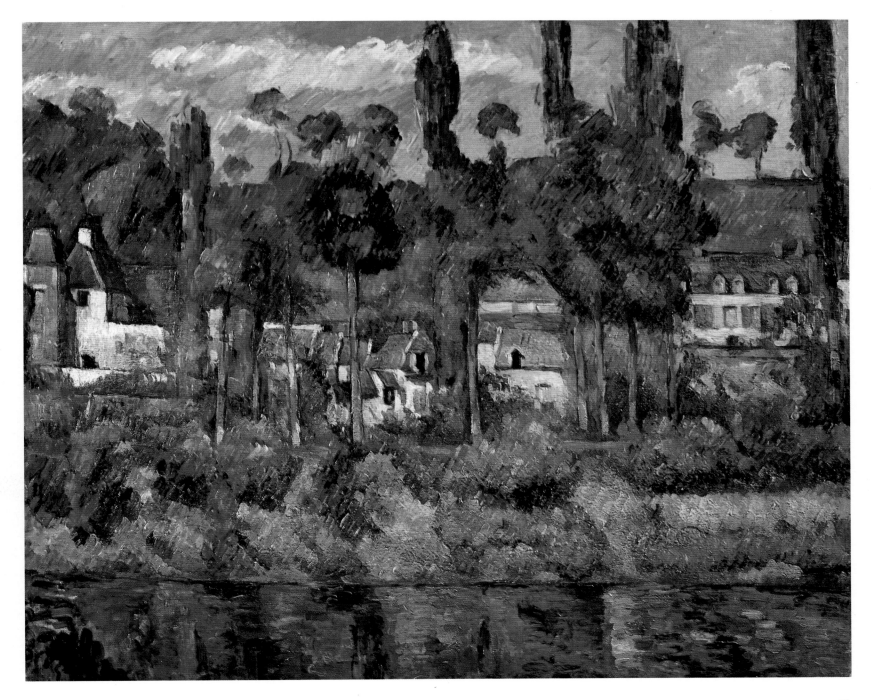

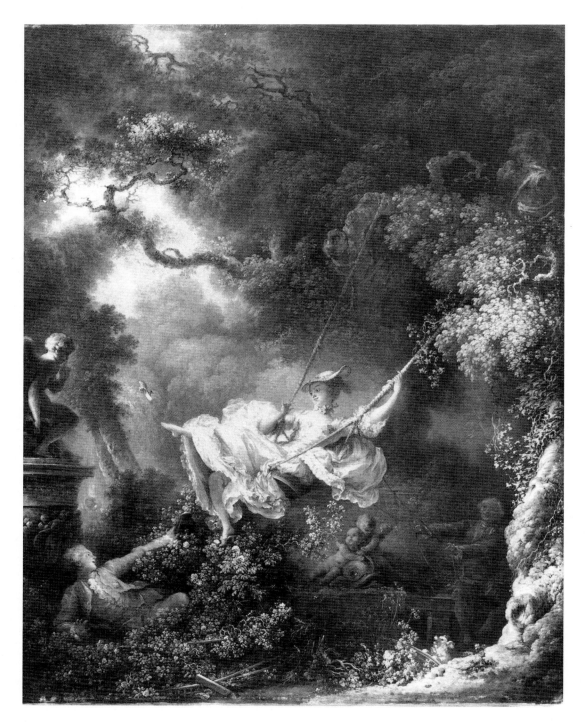

aspects of nature have been replaced by something more timeless, permanent and organized. On several other occasions in the 1880s, Renoir's collaboration with Cézanne proved as fruitful as that with Monet ten years previously (page 132).

It is perhaps not surprising, therefore, that in the light of changes in his artistic process Renoir opted for the Salon as the natural venue for his paintings, rather than the independent exhibition. It would have been only too easy to predict the kind of incomprehension that would greet his more labored attempts from erstwhile supporters there. In addition, the composition of the group shows had changed radically since 1874. Never a homogeneous group with a coherent or consistent manifesto, the rifts between the different ideologies which had been apparent from the outset

had widened dramatically, and Renoir was not the only original member to imagine the 'group' hijacked by younger artists whose work it was felt differed greatly from what an 'impressionist' style should be. Renoir's relationship with the Jewish, free-thinking Pissarro had never been easy, but it was his support and championing of Paul Gauguin (1848-1903) that Renoir found particularly infuriating. In 1882, when Durand-Ruel was desperate to present a seemingly united band of Impressionists at exhibition in what was to be the seventh group show, he wrote to Renoir who was still in the south with Cézanne, where he had been detained by a severe attack of pneumonia, pleading with him to join with his old allies. Renoir made it clear that he mistrusted the combination of Pissarro and Gauguin and that to be associated with

Gauguin at an exhibition would cause his canvases to fall by 50% in value. He wrote vitriolically to Durand-Ruel on 26 February about the projected exhibition:

Moreover, Pissarro would invite the Russian Lavrof or another revolutionary. The public doesn't like what smells of politics and I certainly don't wish to be a revolutionary at my age. To remain with the Israelite Pissarro, is revolution . . . get rid of people like that and give me artists like Monet, Sisley, Morisot etc, and I'm with you, because that is no longer politics, that's pure art.

The reference to the Russian socialist and anarchist Lavrovitj (1823-1900), who had recently come to Paris, implies that he feared the show was being abducted by political extremists, but to suggest that the other Impressionists whom he mentioned were producing an art free of any social or political context was odd given the problems with which he had been wrestling in Italy. He may have deliberately opted for an art which seemed to distance itself from the concerns of modern urban life, and in doing that the work of the eighties is quite different from the work of the seventies, but this desire for a timelessness, and for a return to some mythical past was in itself symptomatic of the self-deluding nature of reactionary politics in France at the time, as was his hatred of socialism and his anti-Semitism. Renoir's researches in Italy had demonstrated that art for him was a highly intellectualized pursuit which could not exist in a cultural vacuum, as his worries about the suitability of his work's reception all too clearly indicated. There was little he could do to prevent Durand-Ruel exhibiting 27 of his works from his own stock in March 1882 at the seventh Impressionist exhibition. However, Renoir's rupture with the group and with the style was complete – he did not exhibit at the eighth and final show in 1886.

Linked to Renoir's desire for a 'pure' art was the notion of a mythical past in which people lived in a 'natural' state, based on the model of a pre-industrial era and in which individuality was highly valued. For Renoir this involved an artisanal approach to art, and he found its archetype in the art of pre-revolutionary eighteenth-century France. Throughout his career, from his copying in the Louvre as a student, right until the end of his life, Renoir continued to praise the masters of the Rococo. In 1885 he wrote to Durand-Ruel, 'I have recovered, never to relinquish it, the old painting, sweet and light . . . it's nothing new but follows the eighteenth century.'

Below: *Shepherdess with Cow and Ewe* of 1886 is a typical example of Renoir's 'dry' style, with its emphasis on crisp, sharp outline, in part inspired by fresco painting which he had seen in Italy.

Indeed, Renoir had been compared with the masters of the Rococo by his contemporaries – in 1877 Rivière, presumably with the artist's implicit approval, had written of *The Swing* (page 91) 'it's the same French taste, whose tradition was just about lost in the midst of dramatic paintings inaugurated by Greuze and David . . . one must go back to Watteau to find a charm analogous to that which marks *The Swing*.' Fragonard's *The Swing* (page 22) encapsulates the qualities Rivière found in Renoir's painting, although there is nothing to suggest that he knew this work, as it had been in a private collection since 1865. Moreover, it was often in this light that early twentieth-century commentators saw Renoir. Julius Meier-Graefe, who published a monograph on Renoir in 1912, called him the

'living synthesis of our age and of the eighteenth century.' For these writers it was more than the similarity of subject-matter and mood which linked Renoir with Fragonard; it was the vision of a pre-industrial, craft-based society, in which people lived in harmony with one another. In the eighteenth century, such a society had necessarily been aristocratic; for Renoir it meant recognizing and accepting one's place in the hierarchy.

The Société des Irrégularistes

Renoir wrote to Durand-Ruel in May 1884 announcing that he was planning to go to Paris to hold a meeting of a new society which he was attempting to inaugurate. We know little about this projected organization, other than from notes he made, now in the Louvre archives.

His guiding principle for the new society was that of irregularity – and in his notes he explains that nature has a horror of regularity. Natural objects are infinitely varied in their formation, according to Renoir, the eyes in even the most beautiful face are not identical, nor are the leaves on a tree. When we examine the greatest works of art, whether paintings, sculpture or architecture, it becomes evident that their creators have sought to imitate nature in that respect and adhered to the fundamental law of irregularity. If French art were not to perish because of its adherence to regularity then he recommends certain steps to be taken, one of which would be the foundation of a so-called Société des Irrégularistes which would host exhibitions and whose members – painters, decorators, architects, goldsmiths, embroider-

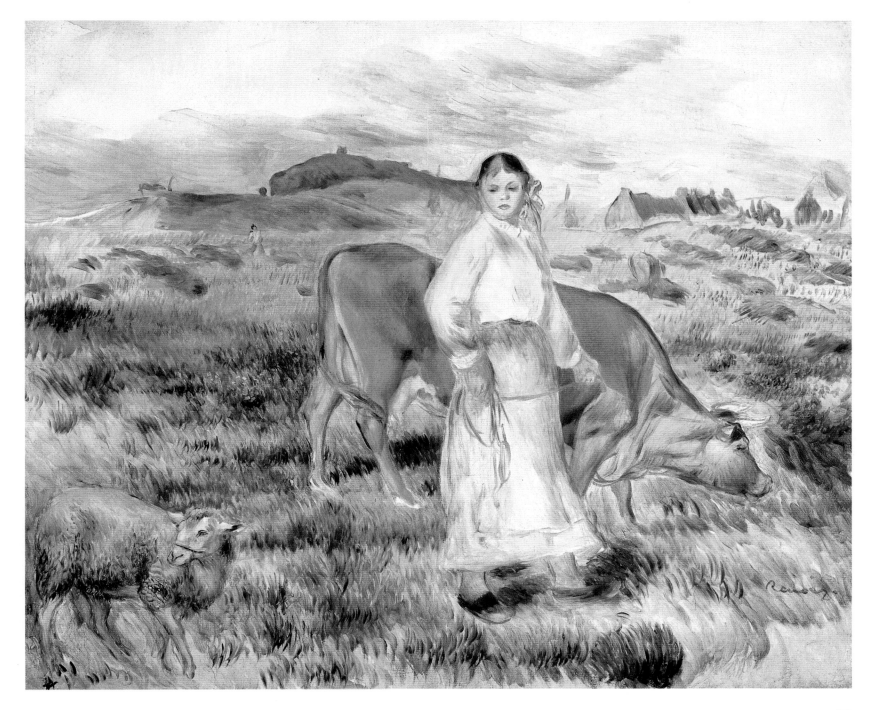

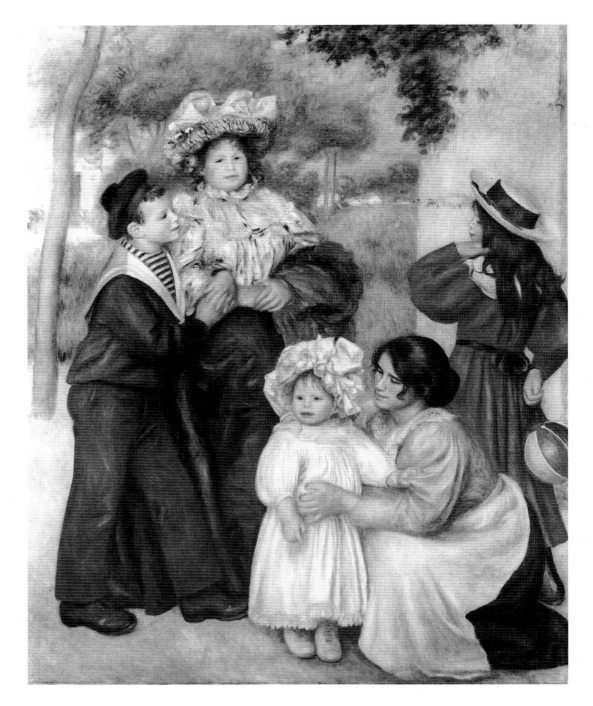

ers etc – would adhere to the principle of irregularity. In his notes, Renoir recommended that art should be a harmony of complementing contrast and diversity.

This notion of irregularity was clearly one of the guiding principles behind works such as the *Bathers* which combines impressionist elements – the landscape and the two women in the background, with a much more linear, tightly composed foreground. However, the notion of irregularity went much further than that and attempted to reassess the position of the artist in society. The vision of society that Renoir describes in his paintings by the 1880s is a pre-industrial one which is rigidly hierarchical. Beyond explaining individual works from the difficult 'sour' period, the notes for the society of irregularists help explain Renoir's entire artistic production from the early 1880s. The universalized society he depicted in his painting was in fact the blueprint for society as it ought to be ordered, in which harmony was achieved precisely because people were individual, dissimilar, and recognized their position within a rigid hierarchy. By suggesting that such a state of affairs was 'natural,' Renoir attempted to legitimize its inequalities. One of the effects of Renoir's reassessment of his work and ideology at this time was that women, particularly nude women, began to adopt a more prominent position in his art, but within narrowly defined roles.

Renoir's dislike of the 'progress' of the modern industrial world and its basis in scientific knowledge was a notion that was gaining currency at this time. In literature, there was a marked departure from the Naturalist school of Zola, and its attempts at providing a pseudo-scientific analysis of the world, most notably in the novel *A Rebours* by Huysmans, published in 1884. These ideas were not new. The philosopher and writer Hippolyte Taine (1828-93) had been appointed professor of aesthetics at the Ecole des Beaux-Arts in 1864, and delivered a series of lectures there that were subsequently published. It is quite possible that Renoir was acquainted with these ideas. In these lectures Taine stated that the purpose of the work of art was to

make known some leading and important character more effectively and clearly than objects themselves do. For that purpose, the artist forms for himself an idea of the character of that object. This object thus transformed is found to *conform to the idea* or, in other words, to the *ideal*. Things thus pass from the real to the ideal when the artist reproduces them by

modifying them according to his idea, and he modifies them according to his idea when, conceiving and eliminating from them some notable character, he systematically changes the natural relationship of their parts in order to render this character more apparent and powerful.

This formulation comes close to Renoir's own theories from this period. He is less concerned with discovering the universal principles which are manifest in all material reality; instead his ideals are more individual and linked to a recommended vision of ordering the world. Renoir is not 'classical' in the sense that he paints 'eternal truths'; instead his paintings and his writings, even in their unsophisticated form, are prescriptive in character.

Renoir's plans for the Société des Irrégularistes seem to have come to nothing, but the ideas he formulated at that time were to linger. The importance of individuality, artistic freedom and traditional, craft-based technique were issues that concerned him until the end of his life, and which his early biographers noted. The reasons for his attempts at initiating such

an odd association at that time derive in part from his foreign trips and from his estrangement from the Impressionist group, but his sense of isolation went further than that. By the 1880s most of the major Impressionists, except Berthe Morisot and Degas, had abandoned Paris for smaller, more rural environments in which to live and paint, and the sense of comradeship obviously disappeared to some extent. However, in 1883, the year before drawing up his plans for the Société des Irrégularistes, Renoir made his last submission to the Salon (except for a single painting in 1890). Clearly, he had conceived of the Société as an alternative, more sympathetic venue for his work. After this time, his work was displayed at a number of dealers' shows and at occasional independent exhibitions. The sense of isolation that Renoir experienced in the 1880s and indeed into the 1890s was social and cultural, but it was also to an extent political. His insistence on a traditional artisanal society was undermined by increasing industrialization, and by events such as the legalization of trade unions, with their emphasis on collective action, in 1884. In

had imagined to be like her husband's paintings.'

On 15 September 1894 their second son, Jean, was born and the previous month Gabrielle Renard (1879-1959), a distant cousin from Essoyes, had joined the household to help with the children. She subsequently became one of Renoir's favorite models (pages 146 and 147). The Renoirs' youngest son Claude, known as Coco, was born on 4 August 1901, by which time his mother was over 40 and his father was 60. A painting of 1896 (page 24) depicts Madame Renoir with her two elder sons and Gabrielle in their garden with the daughter of a neighbor.

the 1890s the Dreyfus affair in which a Jewish officer in the French army, Alfred Dreyfus (1859-1935), was wrongly accused of divulging secrets to the Germans, polarized the French nation between Dreyfusards and anti-Dreyfusards. This further alienated Renoir from more liberal, Republican friends such as Monet, Zola and, of course, Pissarro.

Around this time Renoir's domestic situation changed. His first son, Pierre, was born on 21 March 1885, and although the family still lived in Paris, they started visiting Aline Charigot's native village of Essoyes in southern Champagne that year and they became regular visitors. Their marriage did not take place until 14 April 1890, some ten years after their first meeting and it was only the following summer that Renoir introduced his wife and child to as close a friend as Berthe Morisot. That he should have kept his liaison secret for so long was characteristic. His relationship with Morisot, although based on mutual artistic admiration, was a delicate balance between intimacy and the kind of discretion that was observed between patron and protégé. Presumably Morisot would not have been shocked at his having a mistress and illegitimate son, since her letters to Monet reveal that she was aware of *his* infinitely more complex domestic situation. Renoir's reluctance to introduce his family to Morisot seems to have derived more from a sense that his domestic world, unlike his artistic world, had little in common with that of her wealthy and respectable bourgeois family. Various letters reveal the social chasm that existed between Renoir's wife and his friend. Shortly after their first meeting, Morisot wrote to the poet and art critic Stéphane Mallarmé (1844-98): 'I shall never succeed in describing to you my astonishment at the sight of this ungainly woman whom, I don't know why, I

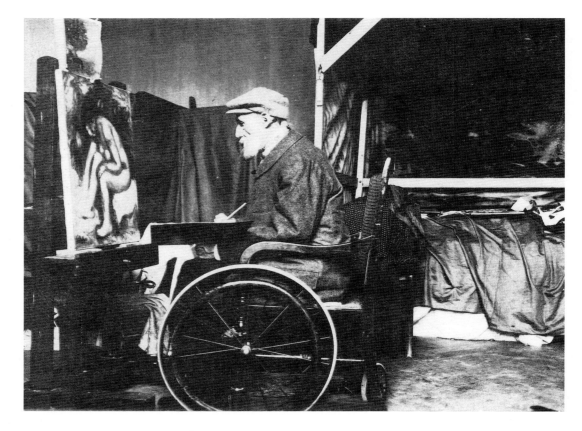

The Late Work

About 1884 Renoir left his studio on the rue Saint-Georges and increasingly his work revolved around Aline Charigot (page 131) and their children. As his domestic life became more settled, and his finances more secure, this pleasant bourgeois existence was reflected in his art. The security offered by his material comforts; the central place of women and children in his life; and a withdrawal from depictions of the hard facts of the external world represent a sense of personal achievement. With middle age, Renoir became more bourgeois and works such as the great triptych of *Dance* pictures (pages 122, 124, and 125) are celebrations of the valuable middle-class commodity of leisure.

Renoir's last submission to the Salon, in 1890, was a double portrait of the daughters of Catulle Mendès at the piano, and his first work bought by the French State (in 1892, on Mallarmé's recommendation), the *Young Girls at the Piano*, both deal with the theme of leisure. There are no less than five almost identical oil paintings exploring the subject of girls at the piano, including the version now in New York (page 142). In these works the models, and the artist himself, move at ease in a claustrophobic setting with all the trappings of middle-class urban life. The large group portrait of *The Artist's Family* (page 24) is an informal study in the garden of the Château des Brouillards in Montmartre, in which they lived from the fall of 1890. However, it is pervaded with the atmosphere of a group photograph in which each figure has been assigned a place and there

is a sense of slight unease suggested by their costumes. Madame Renoir, a vast matriarchal figure, presides over the group, resplendent in a magnificent bonnet in which, to judge from contemporary reports such as that by Berthe Morisot, she would normally have been ill-at-ease. Her eldest son, eleven-year-old Pierre, hangs on her arm, dressed in a fashionable sailor's suit. In the foreground, Gabrielle Renard, without a hat and wearing an apron, is very much in the role of family servant, attending to the toddler Jean Renoir, in a long gown and with a sumptuous bonnet like his mother's. The third child is the daughter of the writer Paul Alexis. The trees in the background, supposedly those from Renoir's own garden, have all the veracity of the photographer's backcloth. The work appears to affirm the Renoirs' arrival into the bourgeoisie.

On 21 February 1894 Gustave Caille-

botte (born 1848) died. He had been a naval architect by profession who painted in his spare time and had exhibited with the Impressionists at five of their shows. In the meantime he had built up an impressive collection of their works which on his death was bequeathed to the French State with the intention that it go on display in the Luxembourg, the Parisian museum devoted to the work of contemporary artists. His will had been drawn up in 1876, and had named Renoir as one of its executors, a measure of the regard in which he was held by his contemporaries for his administrative skills and his even-handedness. In order to see his friend's wishes upheld, Renoir also required a great deal of tenacity. The bequest comprised 67 pictures – including both drawings and paintings: eight works by Renoir, five by Cézanne, four by Manet, seven by Degas, eighteen by Pissarro, sixteen Monets, and nine Sisleys. However, it required three years of negotiation before the works finally went on display in the Luxembourg, and then only 38 works were accepted, with only those by Degas being represented in their entirety. Renoir's paintings included *The Swing* (page 91) and the *Moulin* (page 92).

During the 1890s Renoir began a series of foreign travels, often to see the great museums of the world. In 1892 he went to Madrid and admired the work of Velázquez in the Prado in particular. Later in the decade he visited Dresden, England and the Netherlands where he saw a large Rembrandt exhibition in Amsterdam. In France he continued to live in Paris, but the family bought a house in Essoyes in 1895. That same year, Berthe Morisot died and Renoir was appointed guardian to her daughter, Julie Manet, another instance of the respect in which he was held by his peers.

PANORAMA DE CAGNES

On 3 August 1914 Germany declared war on France and his two elder sons were wounded in action in October. The following year, Jean Renoir was badly wounded in the leg and hospitalized in Gérardmer in Eastern France. His mother went to visit him but the journey must have proven too much, as she died on her return to Nice on 27 June 1915.

Renoir had met the picture dealer Ambroise Vollard (1868-1939) in 1894 or 95 (page 156). He was to be one of the most important people in the last twenty-five years of Renoir's life, buying pictures, hosting exhibitions and influencing the artist's choice of subject-matter and medium. He also wrote one of the most

Renoir's maturity was marred by ill health. A fall from his bicycle in the summer of 1897 left him with a broken right arm, which exacerbated his arthritis. It was only from 1902 however, that it began seriously to affect him, and restrict his painting activities. Rheumatism caused him great pain and he had problems with a partial atrophy of the nerve in his left eye. He pursued as many cures and reliefs from pain as were available to him, taking the recently introduced painkiller antipyrine, indulging in thermal treatment and allowing his patrons the Bernheims to hire a costly Viennese doctor. However, by 1910 he was confined to a wheelchair and his grossly deformed hands had to be bound with bandages to relieve the chafing from attempting to hold a paintbrush. A letter written by the painter Mary Cassatt (1844-1926) gives an insight into the way in which the Renoir household revolved around the invalid. She wrote to a friend: 'I must take some of your nuts to Renoir, who suffers at times greatly, senile gangrene in the foot. His wife I dislike and now that she has got rid of his nurse and model she is always there.' A partial relief from the pain could be derived from living in a mild, dry climate and this may have helped Renoir to decide to buy a property in Cagnes in the south of France.

During 1907-08 he had a house and studio built on the site of an olive grove at Les Collettes and the family moved there in the fall of 1908. According to Jean Renoir, the family enjoyed every material comfort on offer at the beginning of the twentieth century: electricity, central heating, a telephone and Renoir had a motor car. After this date, he typically spent winters in Cagnes, and the summers in Essoyes with trips to Paris, to keep in touch with old friends, exhibitions and the museums.

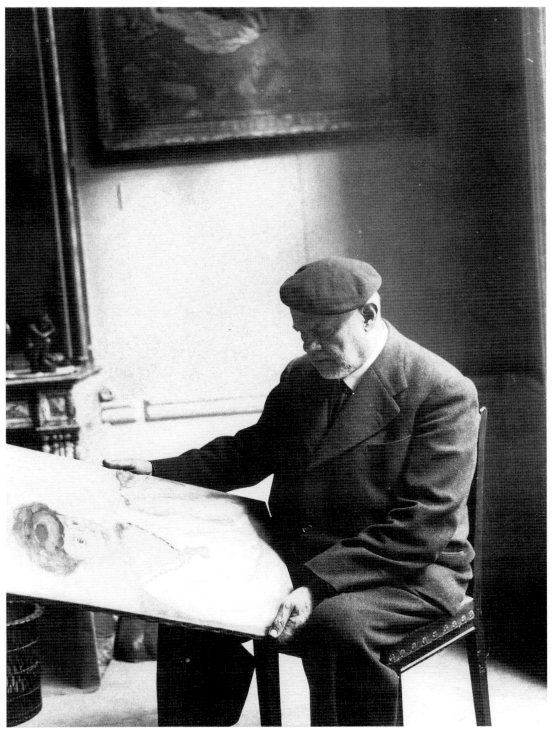

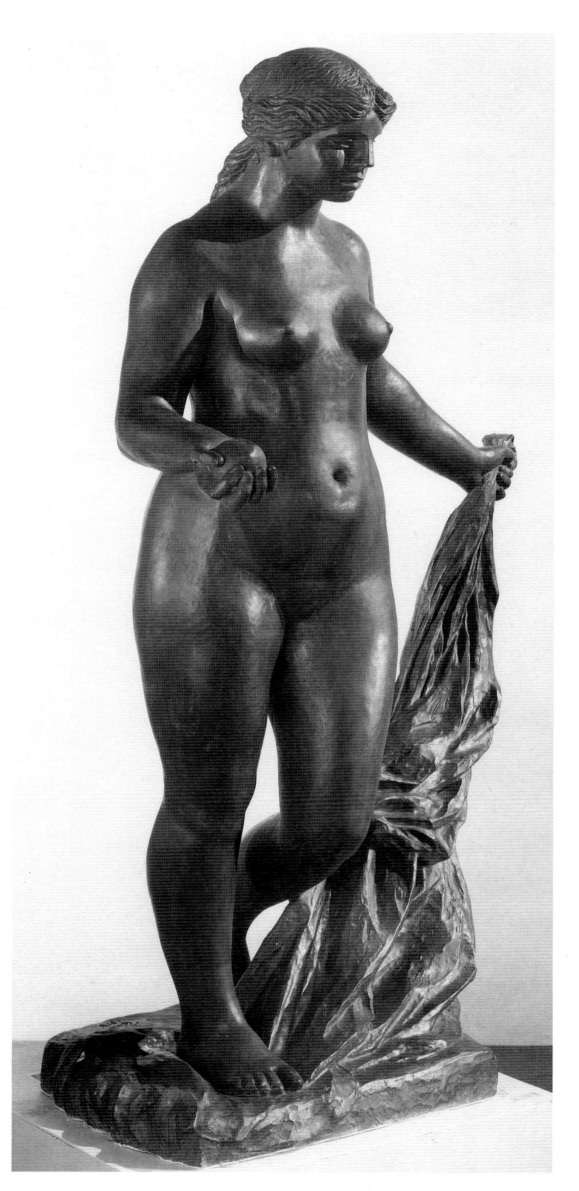

widely read monographs and controlled a large cache of Renoir's work after his death, ensuring his posthumous reputation. In the summer of 1913 Vollard suggested that Renoir attempt sculpture and introduced him to Richard Guino (1890-1973) who had studied with the sculptor Aristide Maillol, whom he suggested would assist Renoir and work under his instruction, effectively acting as his 'hands.'

In a letter written in 1913 to Albert André who published a monograph on Renoir shortly before his death, the artist begged a favor:

There is something you could do for me. I don't even know how it can be done. It would be to find out the exact height from the heel to the top of the head of a Greek statue of a woman, not the Venus de Milo, who is a big martinet, but for example the Venus of Arles or the Medici or some other. One can get this information, I think, from the casts in the Louvre.

The final version of the *Venus Victorious* (page 28) is six feet in height, slightly over life-size, but with a far greater sense of monumentality.

Increasingly, Renoir's subject-matter in his later work was concerned with depicting women. Obviously he would turn to those closest at hand to serve as models, and his late work features members of his household entourage; his children and Gabrielle Renard in particular (pages 153, 163 and 166). Renoir's biographers all testify to his working best when surrounded by women, to whom he could listen as they sang at their work. However, it seems that it was not so much the availability of models that influenced the subject-matter of his late work, but rather that his painting and his desire for the company of women were symptomatic of a more general attitude towards them. Women, and to a lesser extent children, might serve as muses but in a letter written in 1900, Renoir complained to a male friend: 'I'm fine, but I need a man. It's rather boring in the evening.' His mistrust of educated women is well-documented: Jean Renoir reports that his father said: 'I like women best when they don't know how to read; and when they wipe their baby's behind themselves.'

Renoir's obsession with women was noticed by early critics of his work and they must be held at least partly responsible for the terms in which we now perceive the artist's work. In an article on Renoir published in 1894, the writer Gustave Geffroy (1855-1926) established many of the commonly held beliefs about

Renoir's approach to women, both in his art and more generally. Geffroy wrote that Renoir's nudes possessed

the bodies of women, but their faces are almost those of children . . . their eyes and lips are all touched with something strange and unconscious, as are all eyes which see existence anew, all smiling mouths eager to kiss and sing. Their characteristic expressions, both tender and sharp, steal from under bruised eyelids, mouths half open for heedless kisses and cruel bites, they have the untamed grace of sinuous animals and falsely innocent air of schemers, they are close to nature and yet unacquainted with the veneer of civilization. With all of them the characteristics Renoir chose were the low forehead with its implications of niceness and obstinacy, and the slightly heavy jaw implying animal appetite and sensuality . . . which he no doubt sees as some decisive proofs of femininity.

His choice of adjectives ('bruised eyelids,' 'cruel bites,' and 'falsely innocent air of schemers') suggests a degree of violence at odds with the soft animal naïvety of these creatures which Geffroy finds in Renoir's painting. His constant analogy to animals allows the critic to align Renoir's nudes with the realm of the 'natural,' and to conjure up an existence for them in which they exist independently, untainted by the civilizing process of mankind. Their 'otherness' is suggested by their being 'close to nature and yet unacquainted with the veneer of civilization.' For Geffroy, in common with so many others who have written about his paintings, it took Renoir's ability with a paintbrush to 'civilize' these women and turn them into Art. Geffroy, and Renoir, imagined that culture in its widest sense, was a strictly male preserve. Any appeal to the 'natural' qualities of 'femininity' was, in effect, an argument for the preservation of the status quo. By

making this appeal to the 'natural' both writer and critic sought to legitimize what was in fact an essentially prescriptive attitude, in which everyone recognized and accepted his or her place within a perfectly ordered society.

Renoir died on 3 December 1919 in Cagnes, aged 78. His estate, valued at five million francs, was bequeathed to his three sons. The critic Félix Fénéon was at Cagnes when Renoir died and his obituary appeared in the *Bulletin des Artistes* on 15 December:

a month ago he may have caught a chill while painting a landscape in his garden at Cagnes. He had a congestion of the lungs; in the course of his illness, he alluded, but without self-pity, to his probable end. 'I'm finished,' he said. However, this congestion was not the immediate cause of his death. He had a heart attack . . . Jean and Claude were with him when he died.

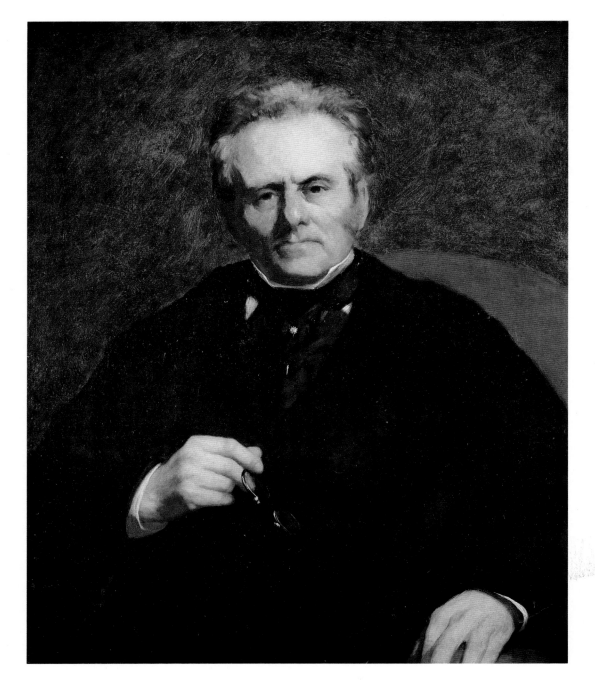

William Sisley, 1864

Oil on canvas
32½×25¾ inches (81.5×65.5 cm)
Musée d'Orsay, Paris

In 1865 Renoir had his first works exhibited at the Salon, after previous failed attempts there. The two paintings he submitted that year were an unidentified *Summer's Evening* and *Portrait of Monsieur W S*. The portrait has been identified as depicting the father of the painter Alfred Sisley (1839-99) whom Renoir had met at Gleyre's studio. It is probable that his friend suggested that Renoir paint his father's portrait as a means of making money. The work which Renoir produced demonstrates that he gratefully realized the implications of this early commission. While the portrait does not idealize the sitter, he has been painted with a degree of gravitas which could only have been flattering. At the same time, the somber nature of the work must have appealed to the Salon jury which accepted this work from

an unknown 24-year old. The painting is a cunning attempt at integrating an acceptable academic style within a more modern frame of reference. The half-length pose, the rather stern expression and the clarity of the features owe something to Ingres' *Portrait of Monsieur Bertin* (in the Louvre) but the contrast of dark and light and the accomplished use of rich velvety black pigment demonstrate that Renoir was influenced by the work of Edouard Manet (1832-83) at this stage in his career.

William Sisley (1799-1870), an Englishman, was director of an artificial flower-importing business who was ruined by the Franco-Prussian war of 1870-71. Renoir has represented him as being rather aloof but the spectacles held in his hand suggest that he is about to address the viewer and makes his manner much more accessible. This work is the first of many portraits of respectable, prosperous clients whom Renoir was keen to satisfy, and which were different from the much more intimate and loosely painted likenesses of friends, such as the *Portrait of Bazille* (page 37).

Potted Plants, 1864

Oil on canvas
51⅛×37¾ inches (130×96 cm)
Oskar Reinhart Collection
'Am Römerholz,' Winterthur

Renoir may have turned to still life in 1864 at the suggestion of Monet or Bazille who both produced paintings of flowers around this time. The still life was often regarded by painters as an alternative to figure painting when models were not available, or to landscape when the weather precluded sketching in the open. Such a view reflects the low esteem in which still-life painting was held in the mid-nineteenth century within academic circles where it was traditionally regarded as being the genre least worthy of a serious artist's attention. Yet Renoir would have been aware that both Delacroix and Courbet painted some fine still lifes and the ambitious and highly finished nature of *Potted Plants* suggests that Renoir regarded the painting as much more than something to occupy his time.

The work is more than four feet in height which is relatively unusual for what is the most domestic of genres, and the attention to texture and detail suggest that much time and effort was spent on it. In addition, there is another, very similar version of the painting using the same objects and painted on the same size of canvas, rather less crisp and finished in appearance, and which is now in Hamburg. This would suggest that the works may have been done for a specific site and perhaps to commission. Alternatively the rather large canvas and the smooth finish may indicate Renoir considered this work for submission to the Salon, as an inoffensive and 'safe' option.

The flowers are all identifiable and were fairly common spring blooms: fluffy white lilac, tulip, hyacinth and the arum lily which dominates the composition. They may have been taken to the studio from the conservatory for they are still in their containers and appear to have been placed on the floor, given the angle from which they have been painted. Renoir has not attempted to suggest that the objects are on display on a table top, as Fantin-Latour did in his paintings of bouquets at this time, but has observed them with the accuracy of a botanist, while controlling the composition with the graceful lines of the arum.

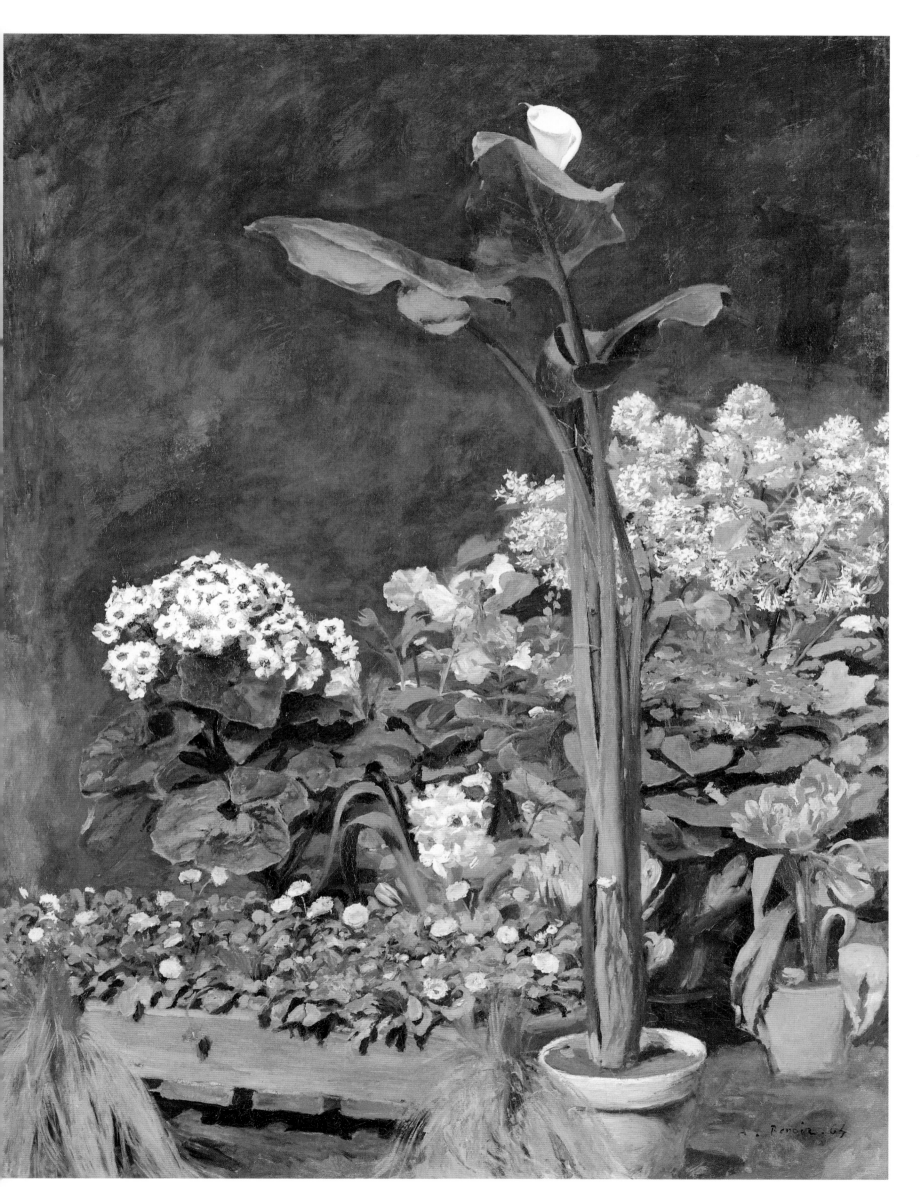

Bouquet of Spring Flowers, 1866

Oil on canvas
39¾×31⅒ inches (101×79 cm)
Fogg Art Museum, Harvard University,
Cambridge, Massachusetts
Grenville L Winthrop Bequest

Albert André's biography of Renoir was published in 1919, six months before the artist's death. In the book Renoir comments on flower painting:

I just let my brain rest when painting flowers. I don't experience the same tension as I do when confronted by the model. When I am painting flowers, I establish the tones, I study the values carefully, without worrying about losing the picture. I don't dare to do this with a figure piece for fear of ruining it. The experience which I gain in these works, I eventually apply to my other pictures.

The quotation is interesting because it indicates that Renoir regarded still-life painting in the same way as other mid-nineteenth-century artists. Because it was not as highly valued a genre as figure painting, less was at stake when an artist painted still lifes and he could afford to take risks with these more informal works.

The sense of experimentation in this work is evident in the thickly impasted surface and particularly the much lighter tone compared with, for example, *Potted Plants* (page 31). However, although Renoir's painting methods may have been exploratory, the final result is detailed and crisp in finish, with the various textures of the flowers, the china vase and the stone slab on which the bouquet rests, clearly differentiated. The work was done for the Le Coeur family, perhaps as a present from the artist thanking his friends for their hospitality at Marlotte in the spring of 1866.

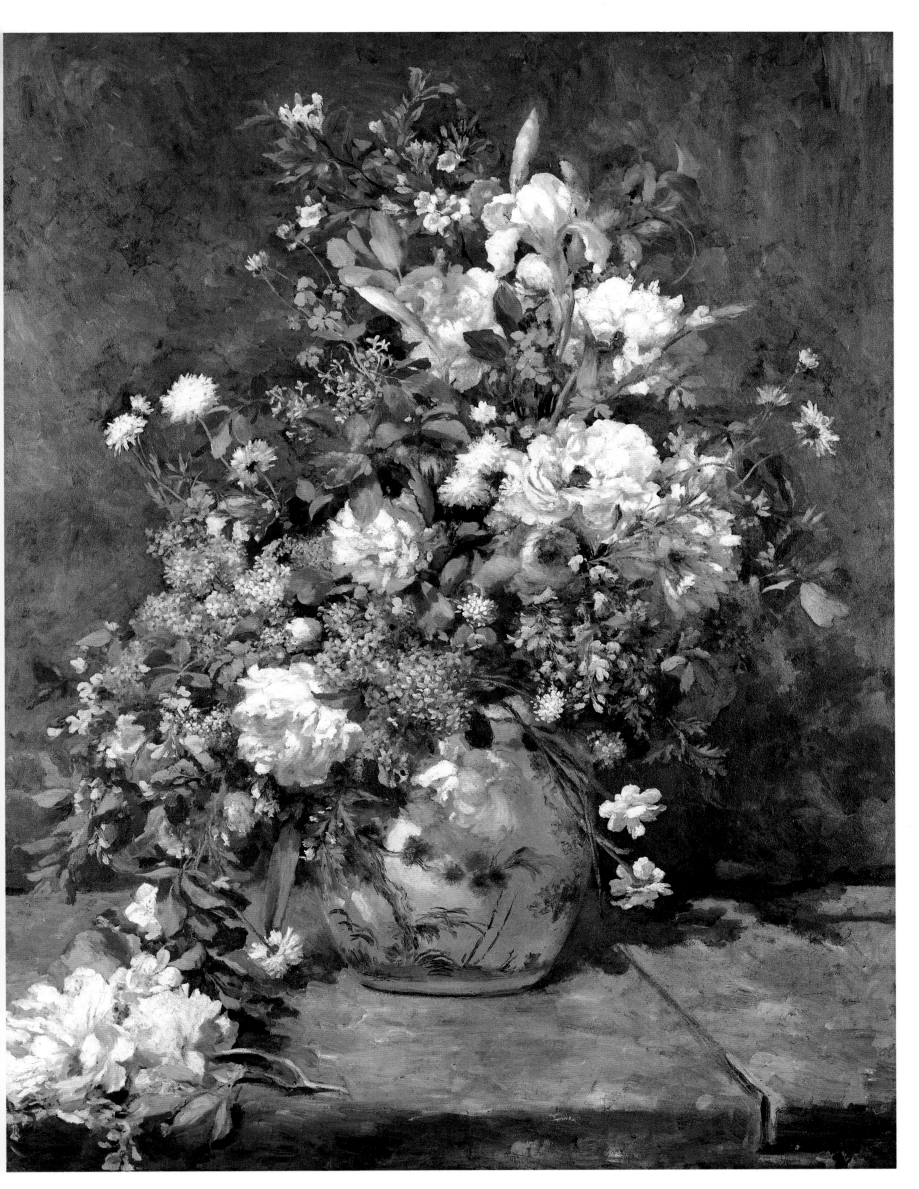

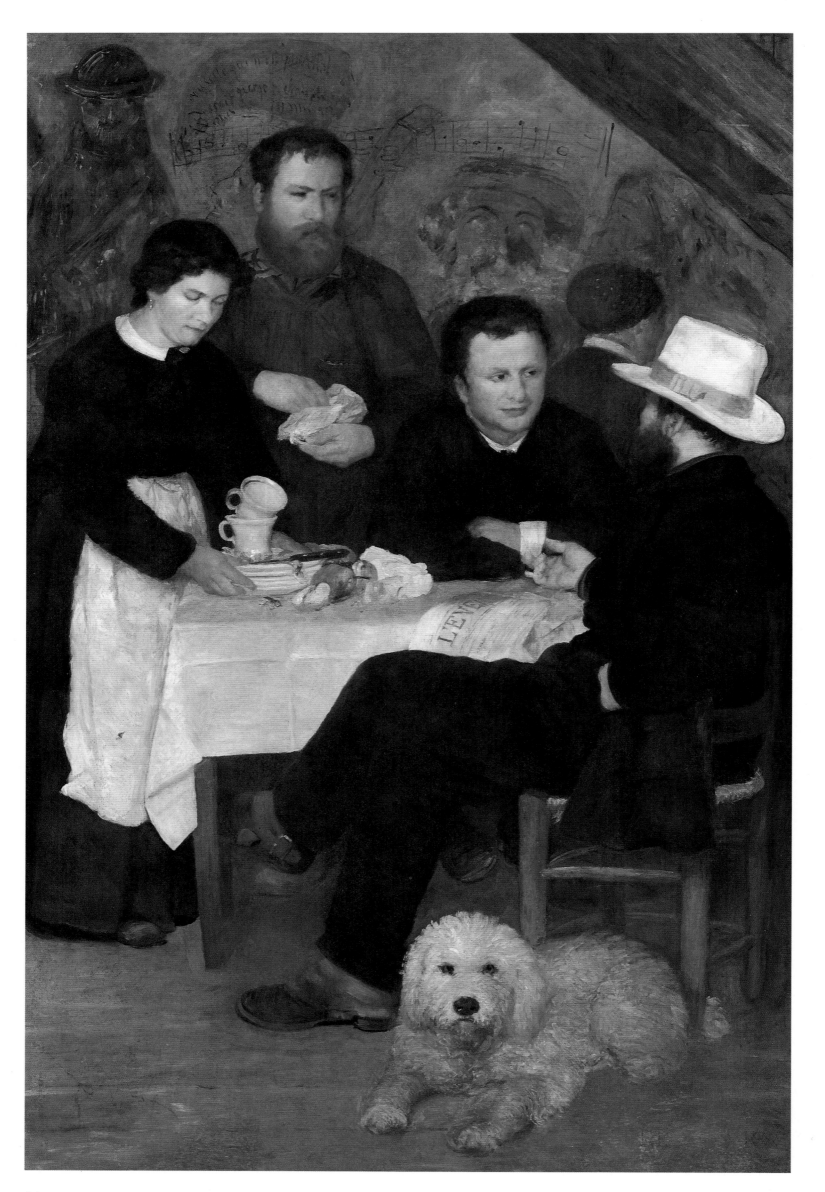

Mother Anthony's Inn at
Marlotte, 1866

Oil on canvas
76¾×51⅙ inches (195×130 cm)
Nationalmuseum, Stockholm

When he was an old man, Renoir's brother Edmond reminisced about Mother Anthony's inn and Marlotte which was 'the meanest village on the edge of the forest [of Fontainebleau], with its modest tavern where Claude Monet, Sisley, Pissarro, and others covered their canvases.'

The characters in the work have been identified in a number of ways. The two women are mother Anthony, disappearing into the background, and her maid Nana. Any identification of the men is more problematic; and different biographers have claimed that they are Jules Le Coeur, Sisley, Monet, Pissarro and Franc-Lamy. The most likely explanation is that the standing figure with the beard is Le Coeur and the man with the hat with his back to the spectator is Sisley. The dog is Toto who appeared in *Jules le Coeur in the Forest of Fontainebleau* (page 36).

The work depicts a traditional postprandial scene. The women are clearing up after a meal and Nana removes crockery and the remains of the dessert pears, while the men settle themselves to chat. The standing man is in the process of rolling a cigarette and the hatted figure is presumably discussing something in the copy of *L'Evénement* which lies prominently in front of him. Emile Zola (1840-1902) who

appears with the future Impressionist painters in Fantin-Latour's *A Studio in the Batignolles Quarter* (page 11) was the literary editor of this newspaper and had used it as a mouthpiece for the more avant-garde strands in contemporary painting, supporting both Manet and Monet.

The work is probably Renoir's first major canvas, with its life-size figures and obvious allusions to traditional prototypes. It is reminiscent of the work of Gustave Courbet (1819-77) in color and handling, and in subject-matter is very similar to his *After Dinner at Ornans* of 1849. However, it is unlikely that Renoir had seen that painting for himself since it had been purchased by the State shortly after the Salon and sent to the museum in Lille. Rather, the subject-matter of the work derives from less specific examples. Two seventeenth-century works in the Louvre which Renoir would certainly have known and which dealt with the theme of the rustic meal were Louis Le Nain's *Peasants' Meal* of 1642 and Rembrandt's *Supper at Emmaus* of 1648. Compositionally, it is the latter which comes closer to Renoir's painting, with the same triangular configuration and the figure on the opposite side of the table sitting with his back to the viewer.

35

Jules Le Coeur in the Forest of Fontainebleau, 1866

Oil on canvas
41¾×31½ inches (106×80 cm)
Museu de Arte de São Paulo

Jules Le Coeur (1832-82) was working as an architect on the reconstruction of the Ecole des Beaux-Arts when he decided to devote himself to painting. He met Renoir, eight years his junior, about 1865, around the same time that he began a liaison with Clémence Tréhot, whose sister Lise became Renoir's model and lover.

Renoir was a frequent guest of the Le Coeur family at their home in Marlotte in the Forest of Fontainebleau between 1865 and 1873 and it was there that he decided to paint this informal portrait of his friend, both as a testament to their friendship, but also as a homage to the landscape painters who were influencing him at that time. In handling, the work is unusual in that Renoir has adopted the practice of working

with a palette knife over large sections of the canvas, presumably in emulation of Courbet. In terms of subject-matter and the *sous-bois* flavor of the work, however, the work is much closer in conception to the Barbizon school of landscape painters, particularly Diaz (1807-76), whom Renoir had met in Fontainebleau.

Although the work represents a landscape, it is demonstrably a studio painting. Still working very much in the traditional method encouraged at Gleyre's studio, Renoir would have made a number of rapid sketches in oil paint in the open air, which he would then have worked up into the much larger, more finished painting in his studio, perhaps over the winter months when there were fewer opportunities for painting out of doors. The heavy earth colors create a rather claustrophobic environment, and the careful placing of Le Coeur and his two dogs is an all too conventional use of *staffage*, intended to give the landscape depth and scale and provide some human interest.

Portrait of Bazille, 1867

Oil on canvas
41⅓×27½ inches (105×70 cm)
Musée d'Orsay, Paris

Renoir exhibited *Frédéric Bazille, Painter Killed at Beaune-la-Rolande* at the second Impressionist exhibition of 1876, a fitting tribute to one of his closest friends from the 1860s who had been killed in November 1870 during the Franco-Prussian war. In the winter of 1866-67 the two had painted portraits of each other, while sharing a studio in the rue Visconti, presumably to save money by only paying for one model's fees (page 7).

Bazille is depicted sitting at a large, heavy studio easel of the kind used when painting large-scale works rather than the much smaller and lighter easel used when sketching out of doors, and depicted in *Monet Painting in his Garden at Argenteuil* (page 72) for example. He is informally dressed and intent on a sketchy still life of a dead game-bird. In fact the painting on which Bazille is shown working is *The Heron*, now in the Musée Fabre in Montpellier. Alfred Sisley worked on the same subject at the same time as Bazille, probably joining the friends in their studio. The canvas in the background has been identified as a snowscape by Claude Monet. The *Portrait of Bazille* is therefore a complex allusion to the four artists who had met at Gleyre's *atelier*, and to three different genres – portraiture, still life, and landscape.

The work was originally owned by Manet, whose name appears alongside it in the catalogue to the second Impressionist exhibition. The older artist may have bought it from Renoir, or it may have been given to him as a gift. Certainly, Manet would have found plenty to admire in the work, the treatment of space in which makes it very close to his own *Portrait of Emile Zola* (Musée d'Orsay, Paris) produced at this time, and the handling, most notably in the loosely painted trousers, has close affinities with his own style. The work may have influenced Manet's *Portrait of Eva Gonzalès* (National Gallery, London), which he showed at the Salon of 1870.

36

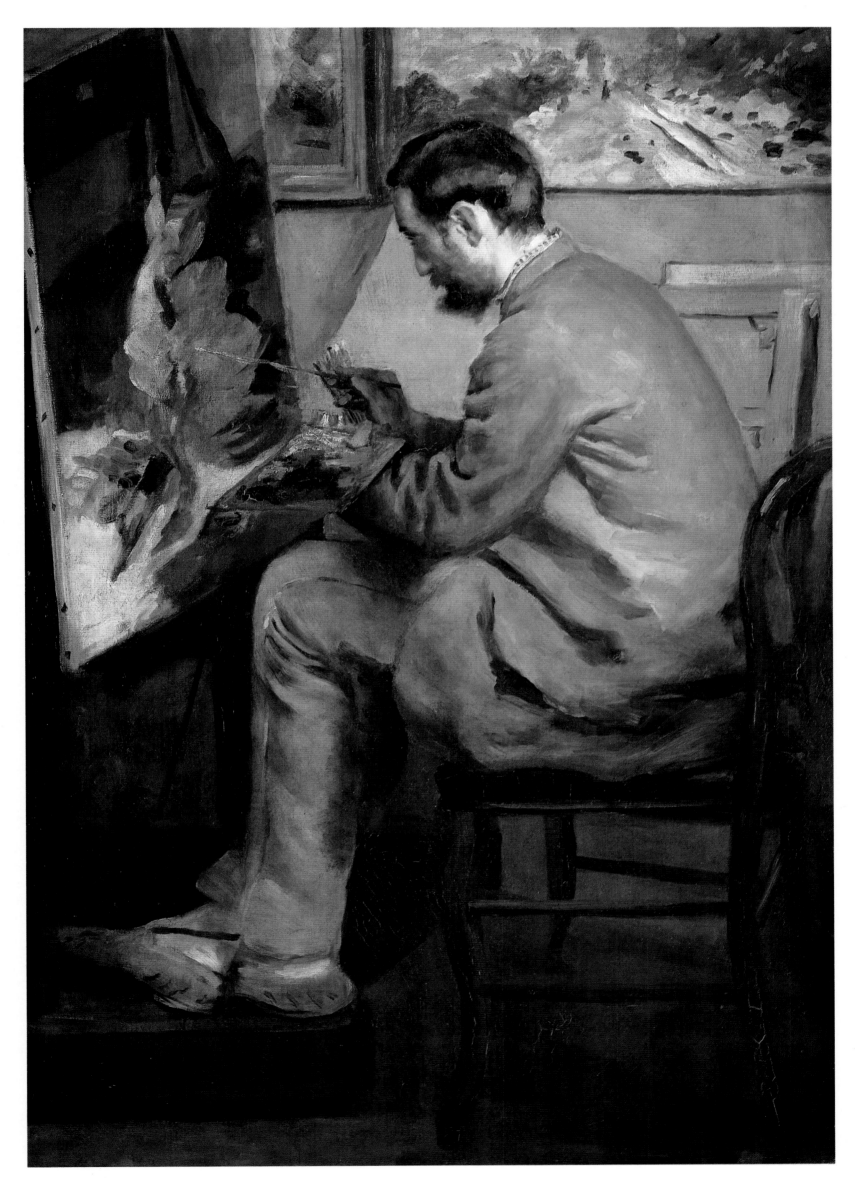

Diana, 1867

Oil on canvas
78½×51 inches (199.5×51 cm)
National Gallery of Art, Washington
Chester Dale Collection

Renoir met Lise Tréhot (1848-1922) at the end of 1865 or the beginning of 1866, and until her marriage in 1872 she was one of his most frequent models, often posing for his ambitious Salon paintings. *Diana* was Renoir's first major Salon submission, a huge, ambitious canvas in which he attempted a mythological subject, that of Diana the Greek virgin goddess of hunting – perhaps suggested by Boucher's *Bath of Diana* (page 9), one of his favorite works in the Louvre. A combination of mythology with female nude was frequently successful at the Salon – Cabanel's *Birth of Venus* (page 10, below) being one of the most popular examples of the genre; but Renoir has ignored that effective formula and has looked instead to Manet's example, particularly his *Déjeuner sur l'Herbe* (Musée d'Orsay, Paris), which he would have known as the most notorious work at the

Salon des Refusés of 1863. In that work, Manet had painted frankly modern male figures with contemporary female nudes, all enjoying a picnic within a landscape setting, and placed them within the conventions of mythological painting to quite startling effect. It was perhaps such allusions that caused the jury to refuse Renoir's work in 1867.

In trying, unsuccessfully, to weld mythological subject-matter to a sturdy, realistic nude, Renoir has also drawn on Courbet's depiction of the naked female figure. The rather heavy nude and the broad treatment of the landscape backdrop (some of it painted with a palette knife) distance this work from Cabanel's suave handling. The mannered *contrapposto* of the figure and the rather obvious use of props, intended to enhance the narrative qualities of the work, betray its studio origins.

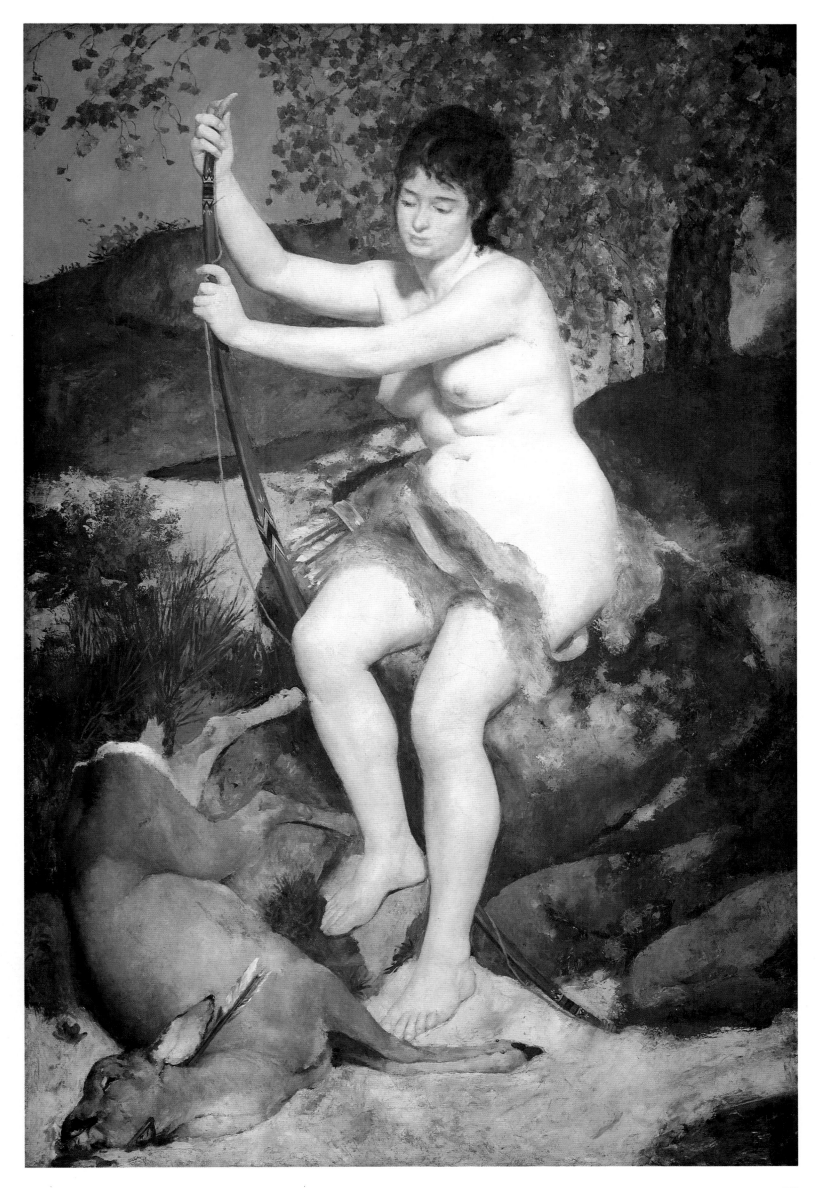

Lise with a Parasol, 1867

Oil on canvas
72½×45¼ inches (184×115 cm)
Folkwang Museum, Essen

In 1873 Renoir sold this painting to Théodore Duret (1838-1927) for 1200 francs along with *Summer* (page 46). The work, for which Lise Tréhot had posed, had been shown at the Salon of 1868, where it earned Renoir his most favorable reviews to date. The critic Zacharie Astruc (1835-1907) praised it for its attention to the effect of light, one of the central tenets of the impressionist style. He wrote 'it is an original image. The painting has great charms: beautifully rendered effects, gem-like delicacy, a general impression that is unified and clear and excellent distribution of light.'

An even closer analsysis of the effects of light in the work was offered by the art critic Théophile Thoré (1807-69):

The dress of white gauze, enriched at the waist by a black ribbon whose ends reach to the ground is in full light, but with a slight greenish cast from the reflection of the foliage. The head and neck are held in a delicate half-shadow under the shade of the parasol. The effect is so natural and so true that one might well find it false, because one is accustomed to nature represented in conventional colors . . . Does not color depend on the environment that surrounds it?

In this rhetorical question he demonstrated his understanding of the way in which this almost scientific attention to color reflexion was increasingly to preoccupy the impressionist painters. It was presumably for that reason that Renoir had dressed *Lise* in a white gown, taking his lead from Monet whose major canvas *Women in the Garden* (Musée d'Orsay, Paris), of 1866-67, had studied the effect of light and colored shadows on white dresses.

The critic Emile Zola (1840-1902) compared Renoir's work with another painting by Monet:

Lise seems to me to be the sister of Claude Monet's *Camille* [now in Bremen]. She is shown facing us, coming out of an alley of trees, balancing her supple body, cooling herself from the burning afternoon heat. She is one of our women, or rather, one of our mistresses, painted with great truthfulness and a timely research into the modern world.

Zola was not so concerned with the technical advancements of the work, but aligned it with more literary Realist works, creating a narrative around the work in order to lend to its appeal for the (apparently exclusively male) Salon-visitor.

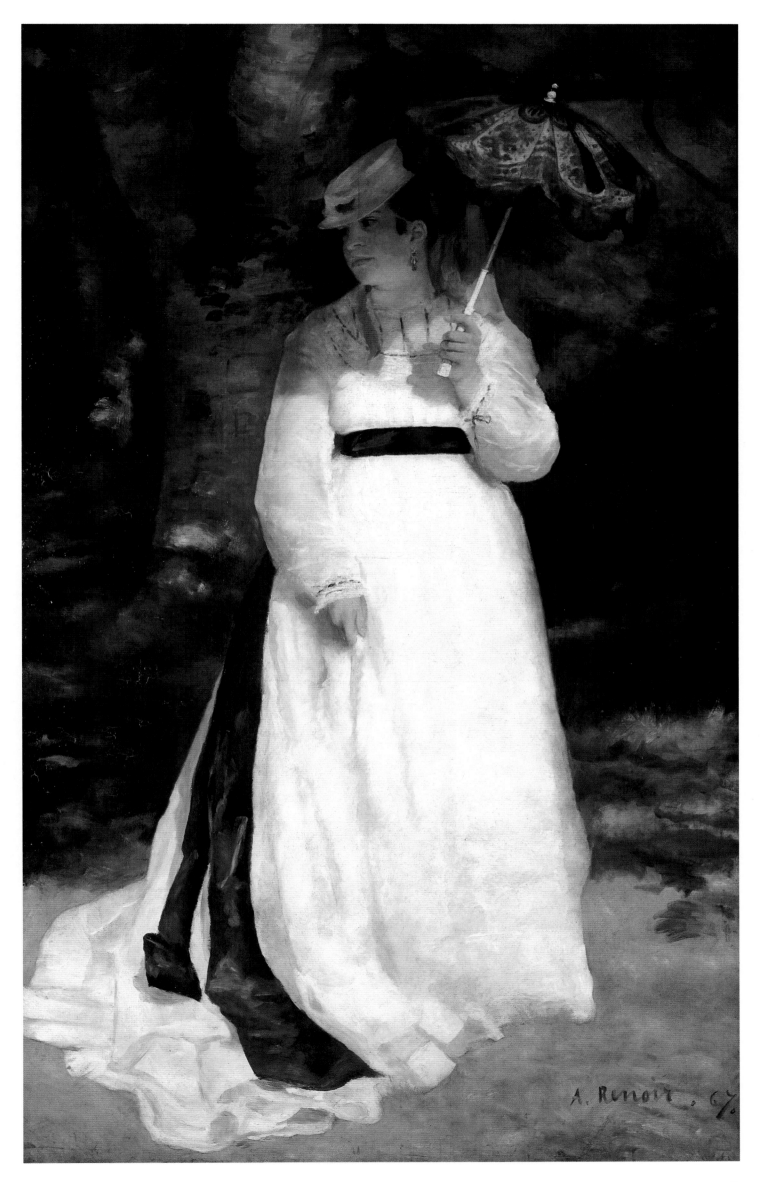

The Pont des Arts, 1867

Oil on canvas
24½×40½ inches (62.2×102.9 cm)
The Norton Simon Foundation,
Pasadena, California

In 1867, the year in which Renoir painted
the *Pont des Arts*, France hosted an International Exhibition, intended to demonstrate to the rest of the world the achievements of Napoleon III's reign and to place
France firmly alongside Great Britain at the
forefront of trade, industry, and culture.
The exhibition was centered on Paris,
which had been spectacularly transformed
into a modern city by Haussmann in the
previous two decades.

In order to paint this work, one of his
first *plein-air* studies in a modern urban environment, Renoir had a short walk from
his studio in the rue Visconti towards the
river Seine. In choosing this site, rather
than a more picturesque one in Montmartre or on one of the old streets on the
left bank, Renoir is lending his support to
the achievements of the Second Empire:
the city is represented as being clean,
spacious, and bright. The work may be
seen as a celebration of the increased
wealth of large sections of the community,
with the fashionably dressed *flâneurs* enjoying a stroll or a trip on one of the pleasure boats (decorated with the French tricolor) on the river.

Renoir has positioned his easel in the
shade of the Pont du Carrousel, and used
the silhouettes of the figures walking
across it as a compositional device in the
foreground of the picture. He is looking
eastwards, along the Quais Malaquais
towards the Pont des Arts and the dome of
the Institut, home of the French art establishment, the Académie. The prominence
of culture in this urban renaissance is
alluded to both there and in the roofs of the
newly completed Châtelet theaters on the
right bank.

This was the first work the dealer
Durand-Ruel bought from Renoir in 1872.

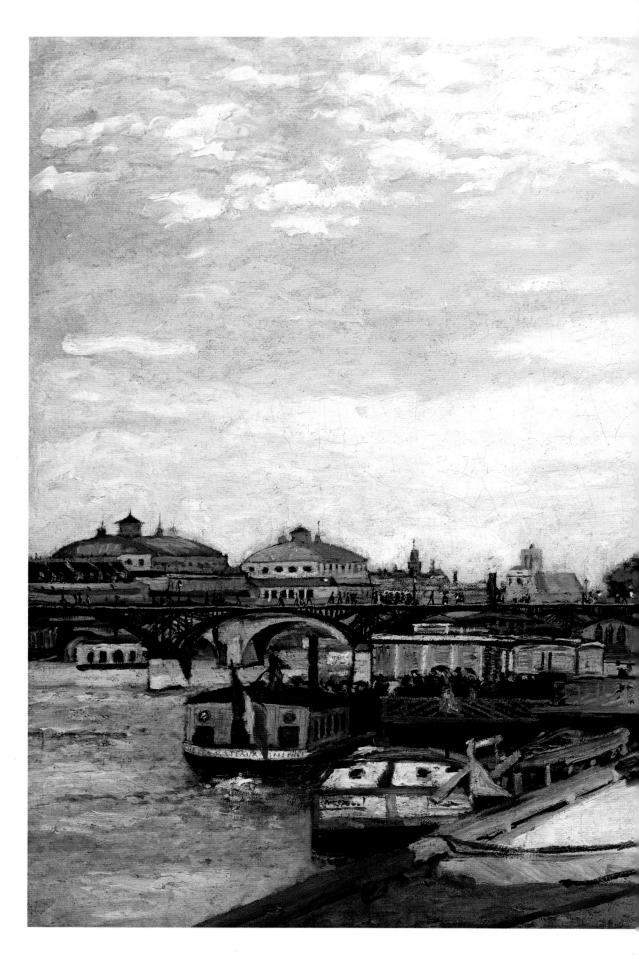

42

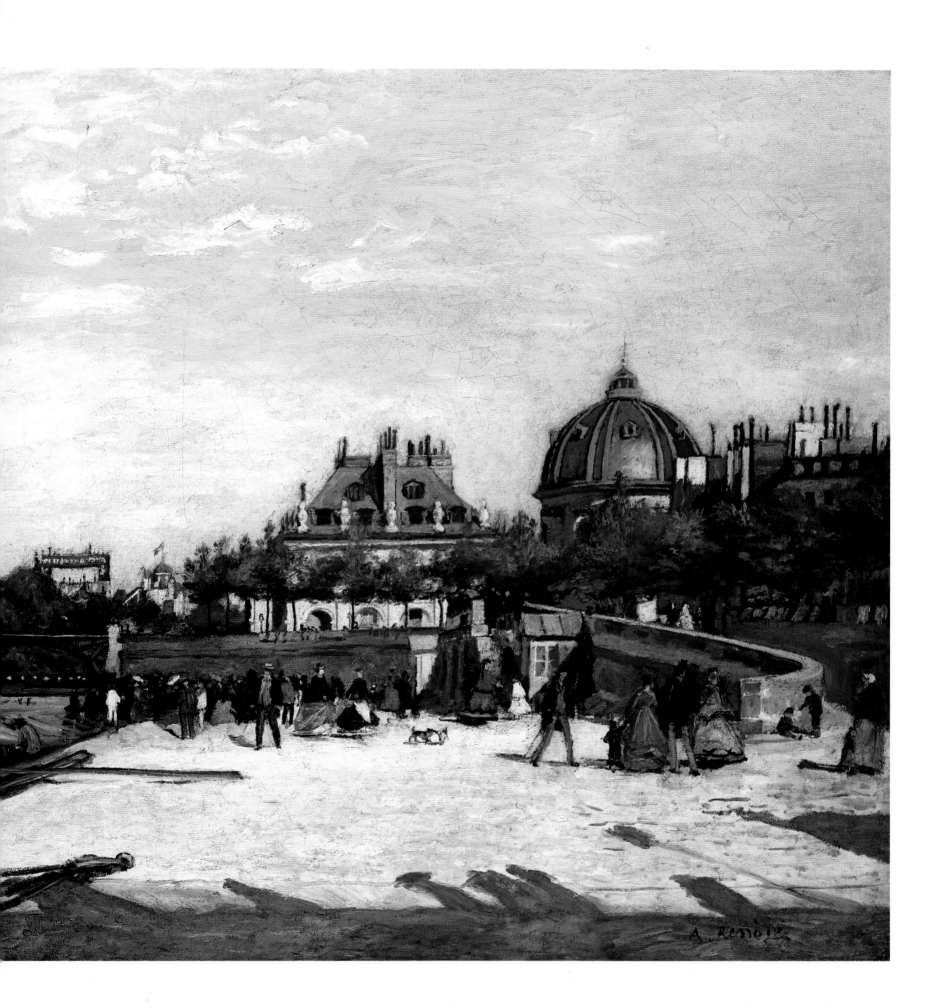

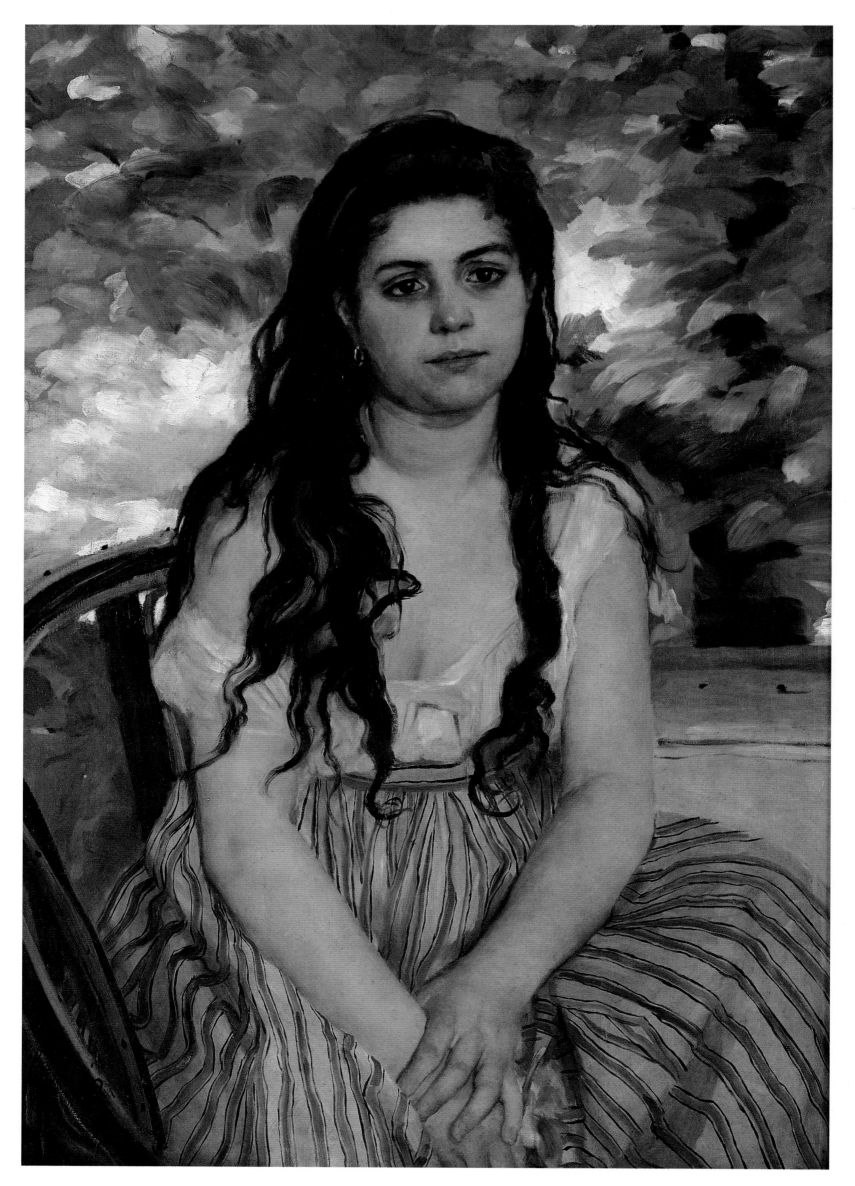

Summer (Lise), 1868

Oil on canvas
35×24½ inches (89×62 cm)
Staatliche Museen Preußischer
Kulturbesitz, Nationalgalerie Berlin

When Renoir exhibited *Summer* at the Salon in 1869 he qualified the catalogue entry by calling it a 'study.' Certainly the landscape background is summarily executed, but the figure of Lise Tréhot is crisply delineated. The word 'study' may also have been used to suggest that the work had been painted in the open air. Nevertheless the smooth surface of the canvas, and the even lighting demonstrate that Renoir was still attached to studio practice for his Salon paintings. The artful way in which her chemise has slipped from her shoulders, her tumbling hair, and her earring mean that the work has often been identified as depicting a gypsy. Renoir has carefully straddled the boundaries between a portrait of the woman with whom he shared his life and a much more general-ized genre piece with romantic associations, which would have lent to its acceptability at the Salon. The rather vague costume means that Lise appears in quite a different guise from the fashionable young woman in *Lise with a Parasol* (page 41); the informality of pose and costume in *Summer* is in marked contrast to Renoir's previous, more ambitious life-size paintings of Lise (pages 39 and 41).

The work was sold to Théodore Duret, who wrote a biography of Renoir, published in 1924. Duret bought it from a dealer in 1873 for 400 francs at the same time as he purchased *Lise with a Parasol*. The latter cost him 1200 francs; presumably the difference in price is attributable to the much larger canvas on which it was painted.

45

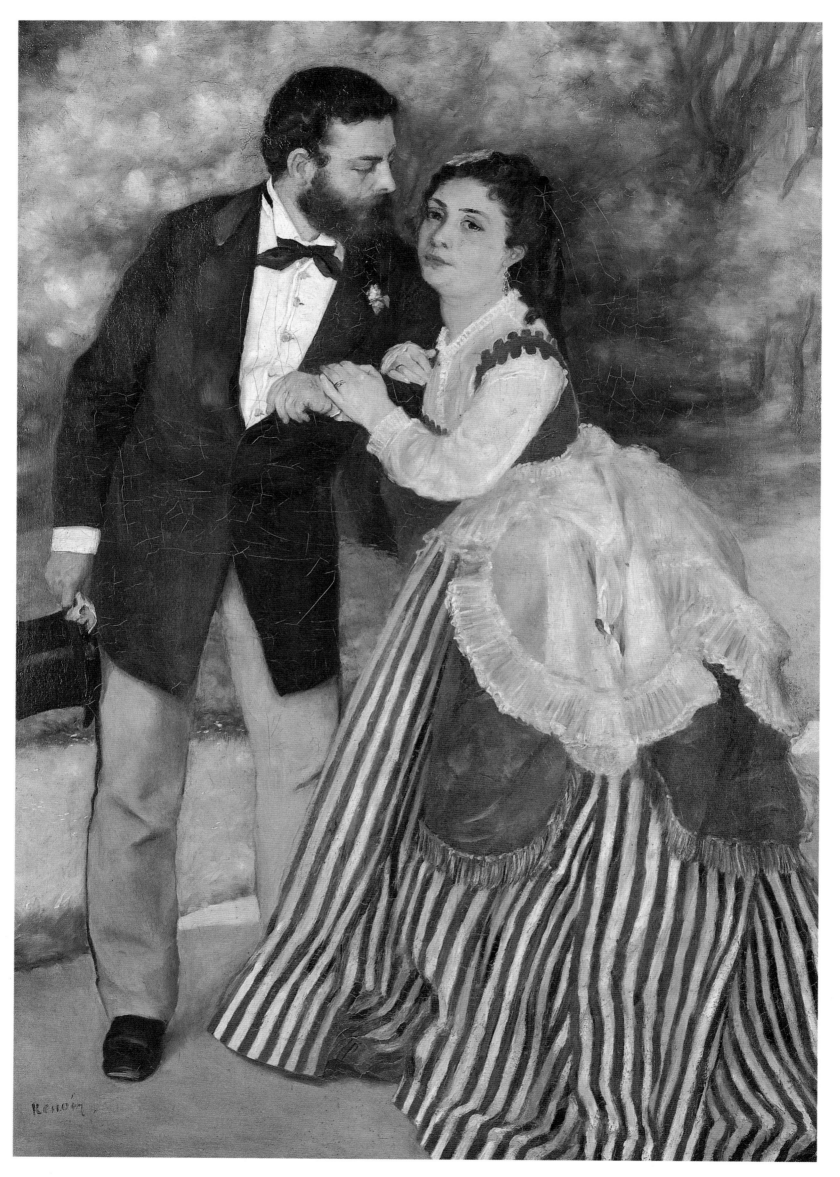

Alfred Sisley and his Wife, c. 1868

Oil on canvas
42⅛×30 inches (107×76 cm)
Wallraf-Richartz-Museum, Cologne

The work has traditionally been identified as a portrait of Alfred Sisley (1839-99) whom Renoir had met at Gleyre's studio, and Eugénie Lescouezec (1834-98), whom he married in 1866. Renoir had painted Sisley's father in 1864 (page 30) and may have included him in *Mother Anthony's Inn at Marlotte* (page 34). Their fellow-students at Gleyre's, Bazille and Monet, also served as models for Renoir (pages 38, 70, and 72). However, this work is much more formal in its conception. The full-length figures in fashionable city clothes seem to be painted standing against a studio backdrop, rather than in the countryside. These aspects of the work, as well as the rather sentimental relationship between the figures, owes something to English portraiture. The work seems to go further than the casual and intimate nature which pervades the portraits of the other Gleyre students.

The way in which the man looks at his companion, her trusting expression and grip on his gloved hand, prominently displaying her wedding ring, suggests that the work is rather a genre scene, a conventional depiction of the happy married couple.

In fact, we do not know that the work does in fact represent Madame Sisley. There are no surviving accounts of her appearance and the young woman looks remarkably like the Lise Tréhot of *Summer* (page 39) and *Lise with a Parasol* (page 41). The similarity to her thick dark hair, well-defined eyebrows, large brown eyes and rather plump face seems to go beyond mere coincidence. Such an identification takes the work beyond that of a double portrait of a friend and his wife, and transforms it into a genre piece for which a professional and an occasional model posed.

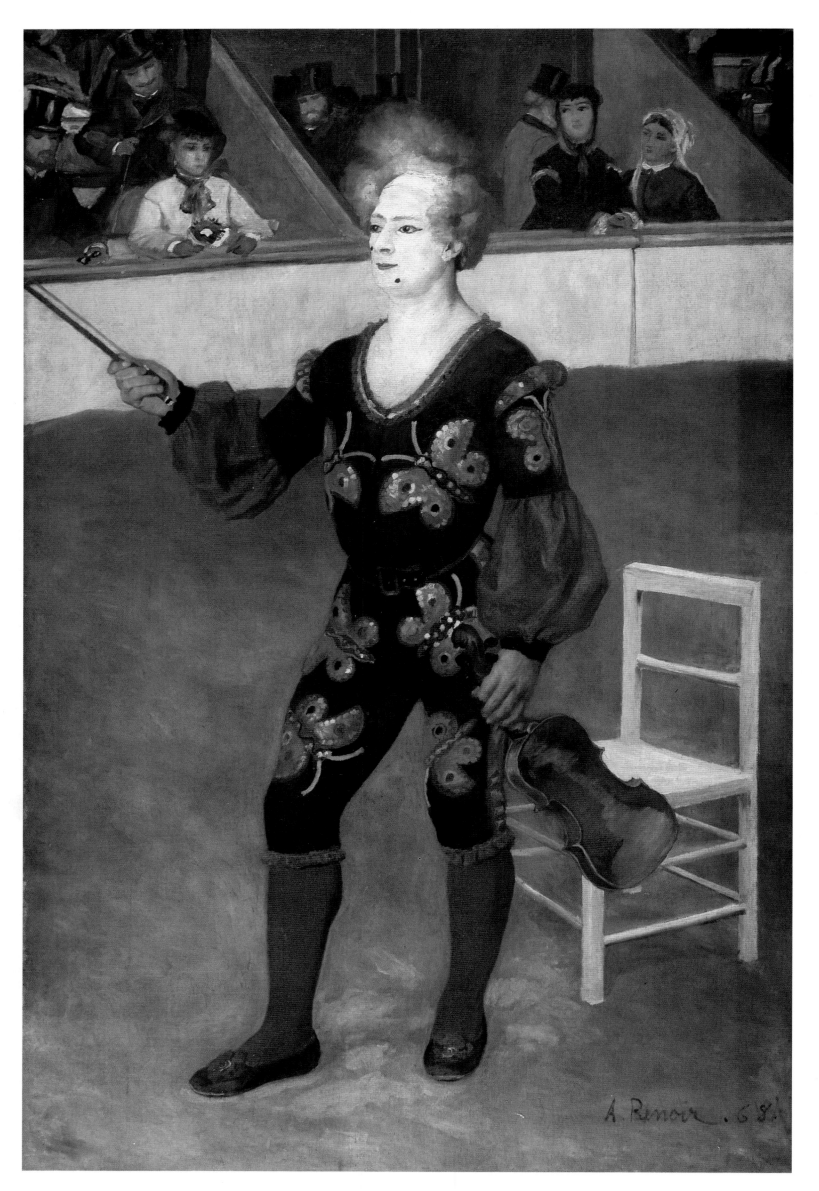

48

The Clown, 1868

Oil on canvas
76×51⅙ inches (193×130 cm)
Kröller-Müller Museum, Otterlo

Renoir apparently accepted this work as a commission in 1868 when he was in need of money. It was originally painted as a signboard for the café of the Cirque d'Hiver on the boulevard des Filles-du-Calvaire, a popular place of entertainment during the Second Empire. The artist had been promised 100 francs but the proprietor went bankrupt and the painting remained with Renoir, until it passed to Ambroise Vollard. The model has traditionally been identified as the clown-musician John Price, who was English. He is wearing a yellow wig and his face has been powdered white and decorated with patches. Renoir has exploited his ornate costume, the rich reds and black, and the bold butterfly design. The legibility and decorative qualities of the work were clearly Renoir's primary concerns. The work's original destination would explain its odd, stiff quality and the model's contrived pose. The discrepancy in scale between the figure of the clown and the white chair behind him, and then the jump from these foreground elements to the figures in the background, demonstrate Renoir's wrestling with the problem of how to reconcile the life-size monumental figure with the background elements. The work is not wholly successful in that respect, but if it was originally intended as a circus sign then the conventions governing such works were clearly quite different from more formal Salon paintings. The work shows the compromises Renoir was forced to make in order to make money.

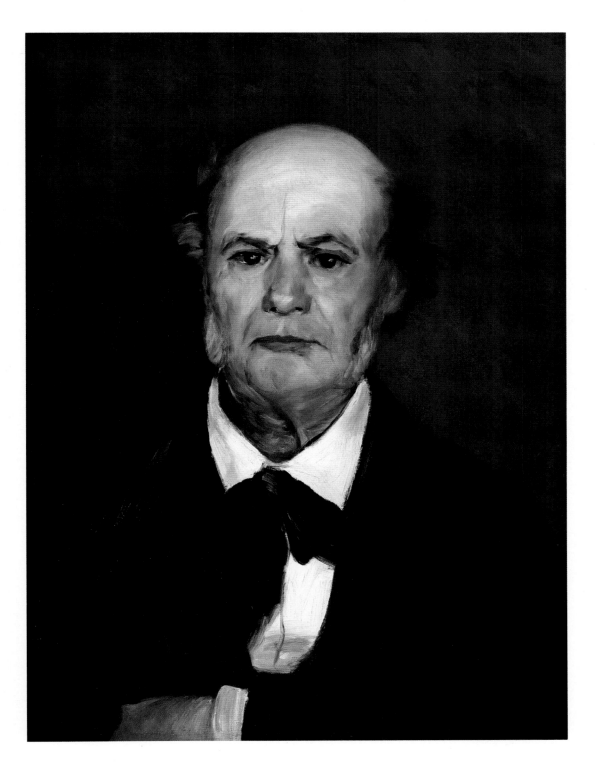

Portrait of Renoir's Father, 1869

Oil on canvas
24×18 inches (61×45.7 cm)
The Saint Louis Art Museum, St Louis, Missouri; Museum Purchase

Léonard Renoir was born in Limoges in 1799 and died in Louveciennes, outside Paris, in 1874. He married Marguerite Merlet (1807-96) in 1828 and the couple had seven children, of whom two died in infancy. After the family moved to Paris in 1844, he continued his trade as a tailor there. This portrait was painted in 1869 in Louveciennes, where Renoir's parents had retired the previous year, and at a time when the artist was living with them. Once again, the availability of model has dictated his choice of subject. The difference between this portrait and that of Sisley's father (page 30), painted in 1864, is due not only to technical developments which had occurred in the intervening five years, but also because the *Portrait of William Sisley* was destined for the Salon, and because the relationship with his own father encouraged a greater informality.

William Sisley is detached from the spectator, sitting in a red armchair and with his spectacles in his right hand. However, for the portrait of his father Renoir has omitted all superfluous accessories and has provided a much closer view of his head and shoulders, encouraging a more intimate psychological relationship with the spectator. The background is left vague and it is difficult to say how far the sitter is from the gray wall behind him. The rich blacks, warm grays, and whites are enlivened with reds, notably around the eyes and nostrils. This coloring, the free brushwork, and the fluid paint are comparable to Manet's work at this point, but also to Dutch seventeenth-century painters such as Frans Hals who enjoyed a revival at this time, with the Louvre acquiring his painting of *The Gypsy Girl* in 1869, although it did not go on display until the following year.

Nymph by a Stream, c. 1869
Oil on canvas
26⅜×48¾ inches (67×124 cm)
National Gallery, London

It has been suggested that this work was painted about 1881, around the time of Renoir's trip to Italy, but recent research would suggest that it fact it was done over a decade earlier. The handling is similar to that in *Portrait of the Artist's Father* (page 49) and the signature is of the style used by Renoir in the late 1860s and early 1870s. The model is surely Lise, who posed for all his large, ambitious paintings of women at this date, and whom he did not see again

50

after her marriage in 1872. The unusual format and the reclining figure also set the work apart. The canvas is the same size as that used for *Woman of Algiers* (page 60) for which Lise posed and which was shown at the Salon of 1870. The works may have been planned as conceptual pendants; depicting the same, rather seductive woman both dressed and nude, one indoors in the harem, and the other outdoors in natural surroundings.

However, if the work is assigned to 1869, or to the following year, then its subject is unique in Renoir's oeuvre at that time. His only comparable paintings of the nude – *Bather with a Griffon* of 1870 (page 59) and *Diana* of 1867 (page 39) were both painted with an eye to the Salon. *Diana* uses mythological subject-matter and the pose of *Bather with a Griffon* derives from classical prototypes and in each Renoir attempts to distance the nude from associations with a contemporary naked woman. *Nymph by a Stream*, on the other hand, despite the pseudo-classical allusions of its title, is of a modern woman, stripped of any mythologizing accessories and set within a credible landscape. A depiction of a nude apparently fusing with the landscape and becoming part of the natural world was something that does not appear to have concerned Renoir again until the 1880s, when the bathers theme began.

La Grenouillère, 1869

Oil on canvas
26×33⅞ inches (66×86 cm)
Nationalmuseum, Stockholm

The bathing spot at La Grenouillère on the river Seine at the Ile de Croissy near Chatou had become fashionable during the Second Empire, when increased wealth had offered more opportunities for leisure activities to a wider cross-section of society. In July 1869, at the time when both Monet and Renoir were painting at La Grenouillère, Napoleon III and the Empress Eugénie visited it, effectively giving the place an imperial endorsement. By that time, according to contemporary reports, the wealthy homeowners who lived in the surrounding area rubbed shoulders with working people who could easily travel there by train from Paris to spend a few hours on a Sunday. The main sporting activities included boating and swimming in the river. Small businesses thrived, renting out boats and swimming suits, and selling refreshments to the tourists. However, as both Renoir and Monet (page 13) show in their paintings, most people simply enjoyed strolling beside the river and crossing the little footbridge to the small artificial island with its single stunted tree.

Aside from his view of the *Pont des Arts* (pages 42-43), Renoir had not really painted any *plein-air* subjects by this time in which the figures are identifiably modern. At La Grenouillère he has abandoned the Forest of Fontainebleau, usual site of his rural landscapes from his time at Gleyre's studio, and has chosen a place which combined elements of the countryside with people who are identifiably fashionable and urban. Certainly, it was a short journey to make each day to the Ile de Croissy from his parents' home in Louveciennes to join Monet who lived nearby in Bougival, but he seems also to be attempting to paint works which are frankly 'modern,' possibly with Monet's encouragement.

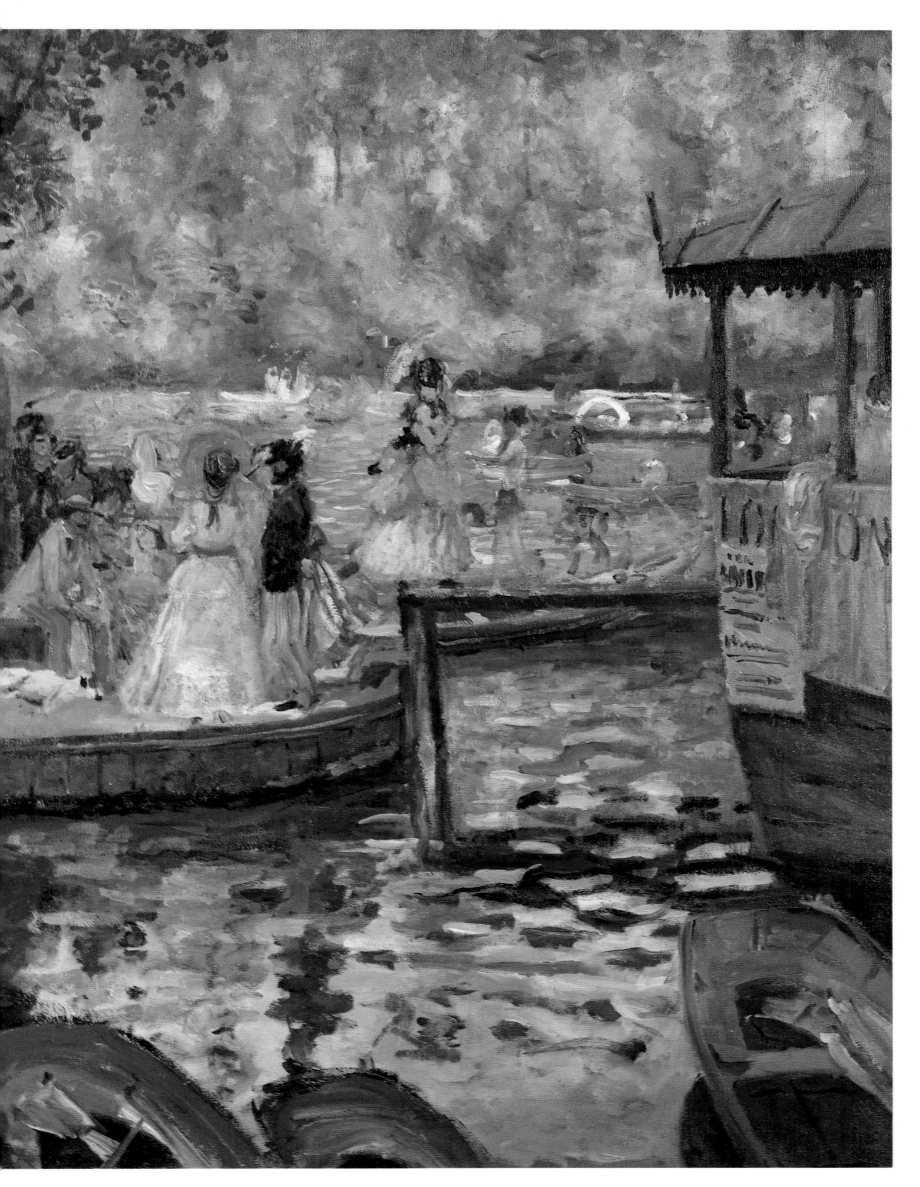

53

La Grenouillère, 1869

Oil on canvas
25½×36⅝ inches (65×93 cm)
Oskar Reinhart Collection
'Am Römerholz,' Winterthur

'I have a dream, a picture of the bathing place at La Grenouillère for which I have made a few poor sketches, but it is only a dream. Renoir who has spent two months here, also wants to paint the same picture.' In this letter to Bazille, written on 25 September 1869, Claude Monet outlined the plans for his next Salon painting. The letter would seem to indicate that the works he had just done at La Grenouillère (page 13) were to be regarded as simply preparatory *plein-air* studies, of the type that he and Renoir had learned to make while at Gleyre's studio in the early 1860s. Our assessment of these works as properly finished paintings demonstrates the way in which our perception of the impressionist style has been responsible for eroding the traditional boundaries between sketch and finished painting. The qualities which we now find in these works – their originality, spontaneity, and daring – were regarded as virtues in a sketch throughout the nineteenth century, but their transposition into a finished painting, particularly one destined for the Salon, was generally proscribed. Monet (and presumably Renoir) was quite clear of the distinction that existed between the two types of work, each with its own validity, but with its own distinct purpose and hence technical conventions.

The works at La Grenouillère are praised today for their rapid execution and with the resulting informal facture – the characteristic 'broken' brushwork; for the higher key and for the generally brighter palette as well as the daringly attenuated objects in the foreground (the boats in both the Renoir and Monet are similar in that respect). However, these 'innovations' were devices which had been used in sketches throughout the century. It is only if the works are regarded as having the status of finished canvases that they may be properly regarded as being revolutionary. The letter from Monet to Bazille would suggest that the development of the impressionist style was rather more evolutionary in character, and the distinction between sketch and painting was only arrived at gradually.

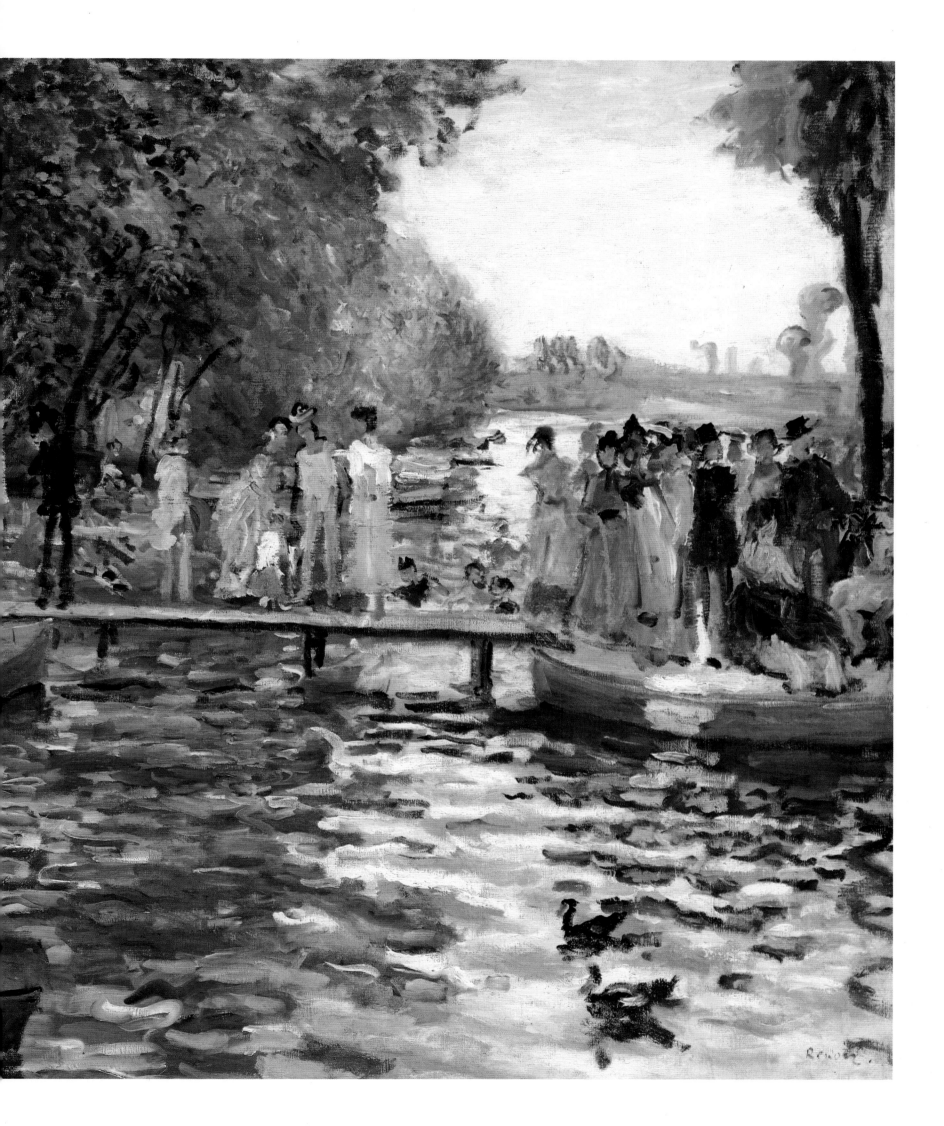

Flowers in a Vase, c. 1869

Oil on canvas
25½×21⅜ inches (64.9×54.2 cm)
Museum of Fine Arts, Boston
Bequest of John T Spaulding

This work was probably painted during the fall of 1869, after Renoir had worked with Monet at La Grenouillère. A very similar version of the same still life by Monet (now in the J Paul Getty Museum in Malibu) combines the flowers and pears with grapes, which suggest a date of around September. The two works also demonstrate that the artists continued to work together after their collaboration at La Grenouillère.

For this painting Renoir has used a standard-sized canvas, a so-called 'size 15,' which was recommended for figure painting. The composition is similar to that of *Bouquet of Spring Flowers* (page 33) – a vase of flowers set at eye-level on a table top in the center of the picture space, against a neutral background. However, in this later work, individual blooms are not as distinct and the emphasis is not on the botanical accuracy found in the earlier work, but on a more general balance of light and shade, with a much freer handling, evidence perhaps of Renoir's landscape painting at La Grenouillère.

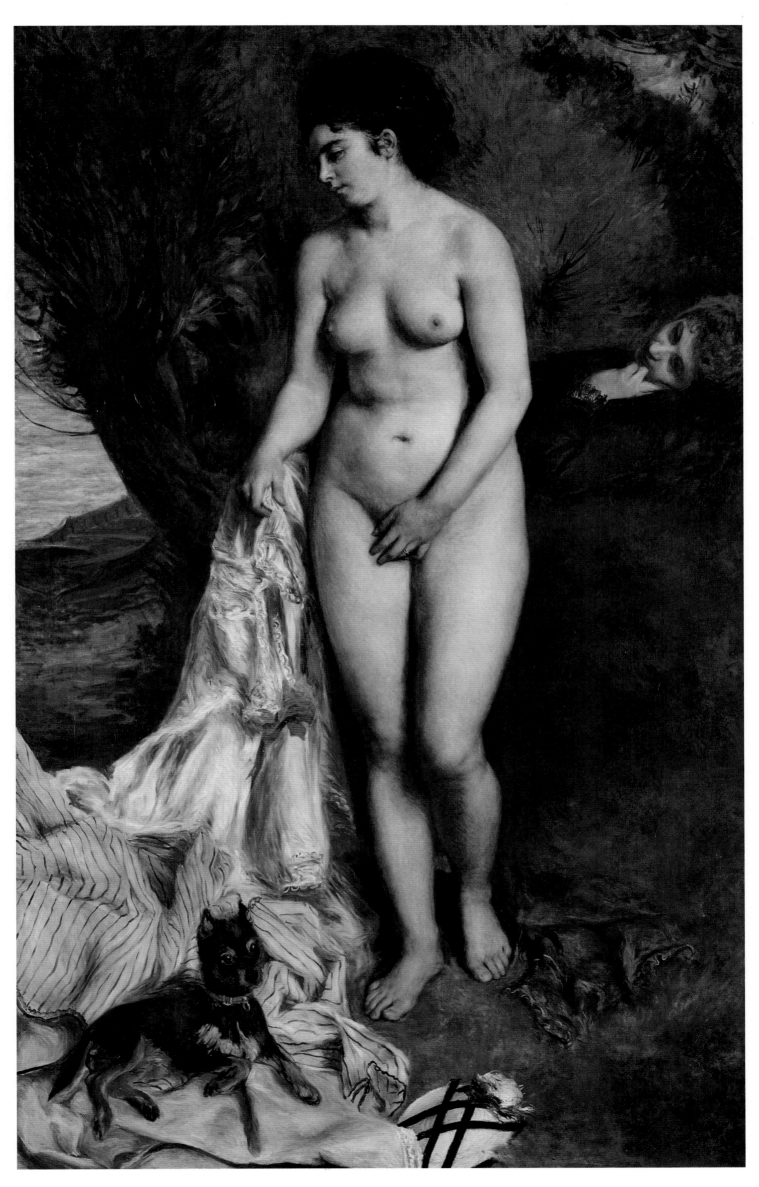

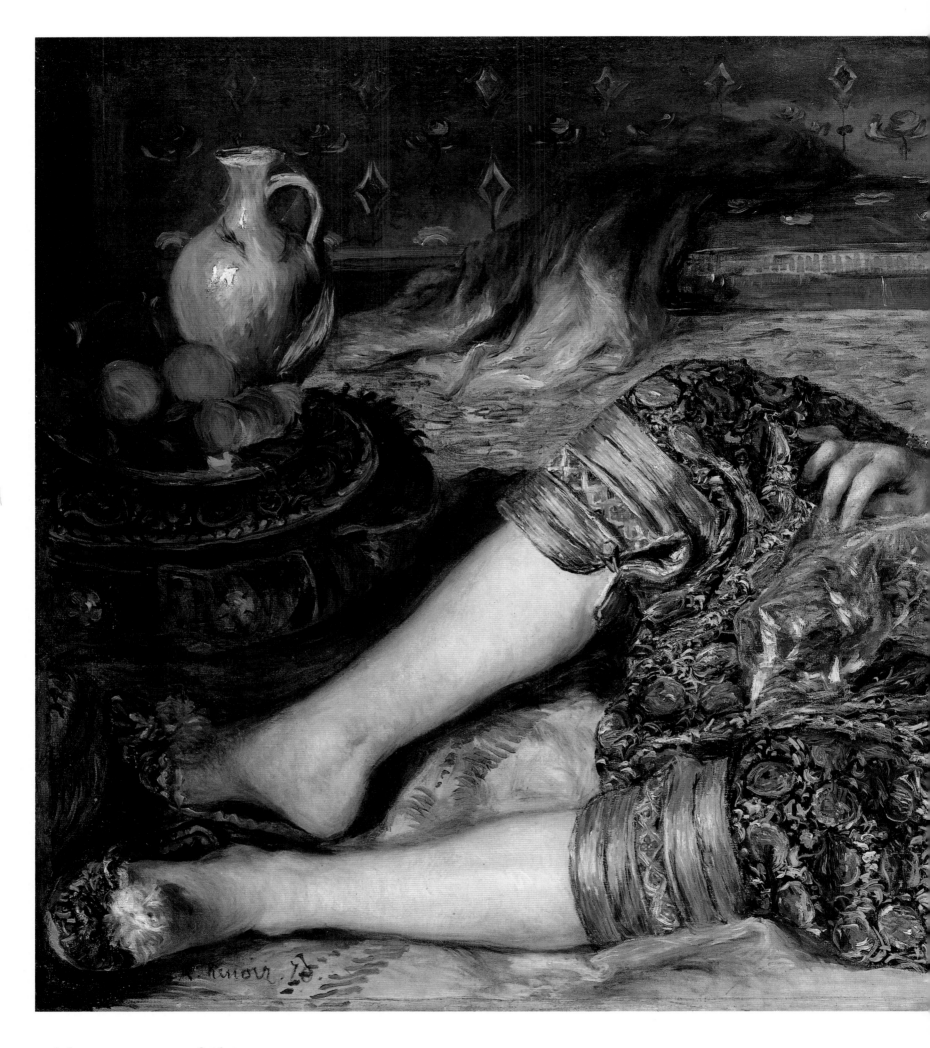

Odalisque: Woman of Algiers,
1870

Oil on canvas
27¼×48¼ inches (69.2×122.6 cm)
National Gallery of Art, Washington DC
Chester Dale Collection

Once again, Lise Tréhot has posed for a large work destined for the Salon, and shown there in 1870. However, the work is less a portrait than a highly conventionalized genre scene. Renoir recognized the popularity of North African subjects at the Salon and has depicted an idealized vision of an odalisque, or slave in a harem, which

owes something to both Delacroix and Ingres and to contemporary perceptions of conditions in France's colonies.

The Turkish Bath by Ingres of 1859-63 had suggested that life in the harem was idyllic, hedonistic, and claustrophobic. Strategically placed still-life elements in his work had underlined the voluptuous

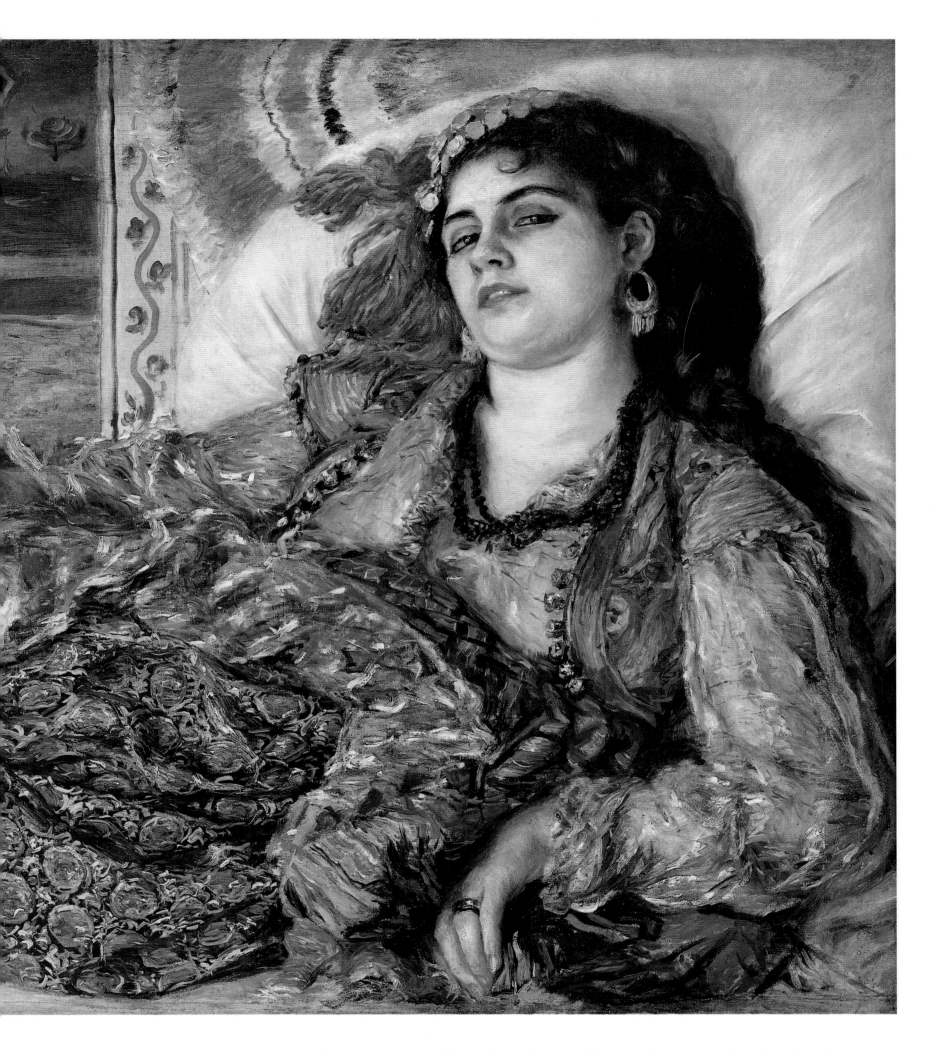

nature of these creatures who inhabited the harem, and their sexual availability was made clear. Renoir found these same qualities in the work of Delacroix and in this painting he has borrowed the hot colors he favored in his Oriental scenes – the oranges, russets, and reds as well as Delacroix's painterly attention to fabric tex- tures (quite different from the crisp deli- neation of cloth in *Summer* [page 46], for example). However, all three artists were, in a sense, working in ignorance. Renoir did not visit North Africa for another ten years and, besides, harems, by their very nature, would have been forbidden places to any Frenchman. The work's exoticism derives more from the cultural appropria- tion that resulted from the colonization of Algeria in 1830, than from any desire to provide an accurate description of life in North Africa during the nineteenth century.

Madame Clémentine Stora in Algerian Dress, 1870

Oil on canvas
33×23⅝ inches (84×60 cm)
Fine Arts Museum of San Francisco
Gift of Mr and Mrs Prentis Cobb Hale in
honor of Thomas Carr Howe, Jr

Clémentine Valensi-Stora (1845/7-1917) was the wife of a prosperous shopkeeper whose business on the fashionable boulevard des Italiens specialized in carpets and Islamic objets d'art. It was probably this which prompted him to commission a portrait of his wife dressed in Algerian costume, and yet there is no sense of Madame Stora passing as a North African woman; she is clearly a masquerading Westerner. Renoir has been at great pains to enhance her white complexion, so much so that she looks to be wearing gloves, and to give her a chic Parisian air. This plundering of other cultures for their picturesque rather than their ethnographic value, was a common feature in French art during the nineteenth century. Two of Renoir's Salon paintings from around this time, *Woman of Algiers* (pages 60-61) and *Parisian Women in Algerian Dress* (page 66) reflect this colonial prerogative.

Compared with the portrait of his father (page 49) from the previous year, the change is quite dramatic. One was a commissioned, and hence rather flattering work, and one was an intimate portrait of a member of his immediate family, done without any regard for payment. Moreover, the portrait of his father owes something to the work of Manet whereas that of Madame Stora is influenced by Delacroix. However, the difference may also be attributable to his sitter – it is inconceivable that Renoir would have painted a man with that same attention to the exotic, and to creating a Romantic mood. Even in 1870, his depictions of women were idealized.

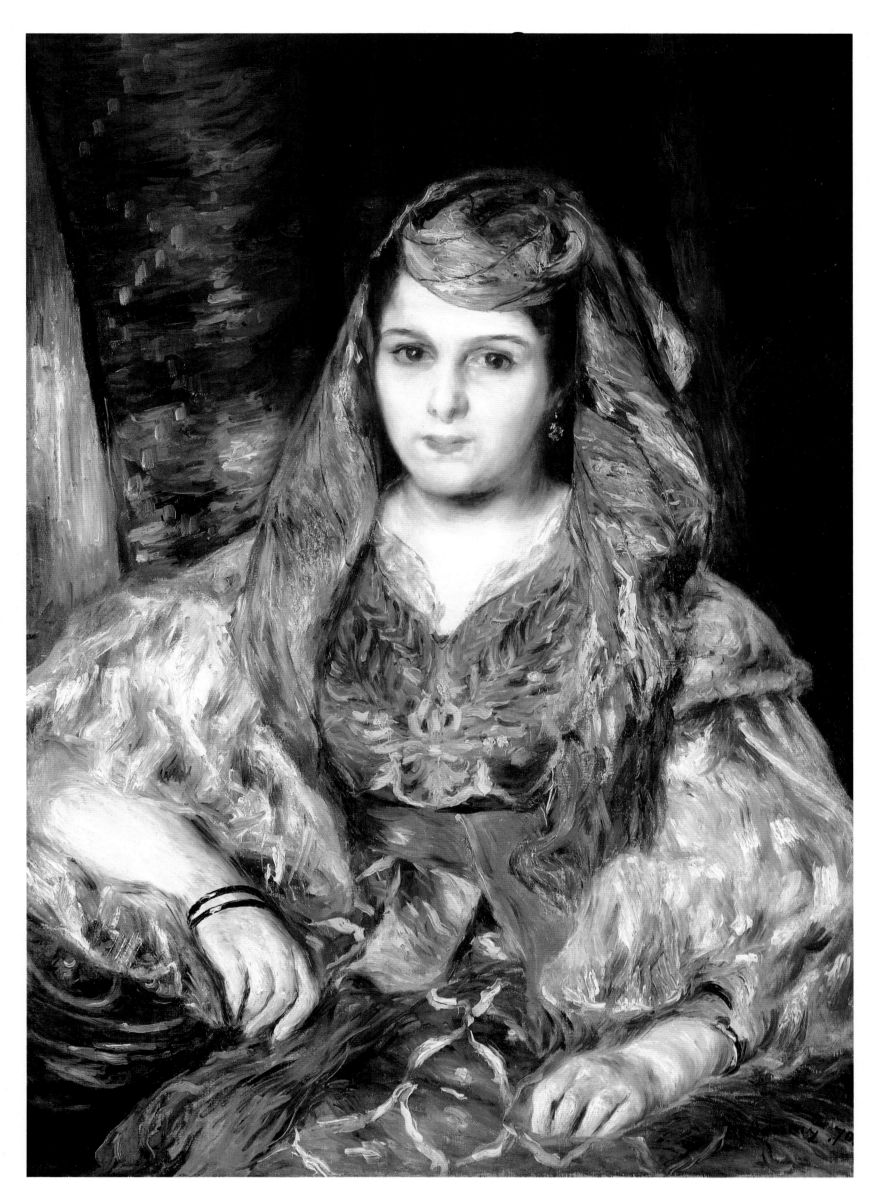

Still Life with Bouquet, 1871

Oil on canvas
29½×22⅞ inches (75×58 cm)
Museum of Fine Arts, Houston

Quite different from his earlier still lifes (pages 31, 33, and 57), this works seems to have been intended both as a homage to Manet and to Oriental artifacts. The plain background which had characterized Renoir's earlier paintings of flowers is replaced here with a rich orange wall on which a picture is suspended, akin to the works in the background of Manet's *Portrait of Emile Zola.* In fact the picture is a print by Manet, called the *Little Cavaliers,* an etching he made after a painting in the Louvre, then thought to be by the seventeenth-century Spanish painter Velázquez.

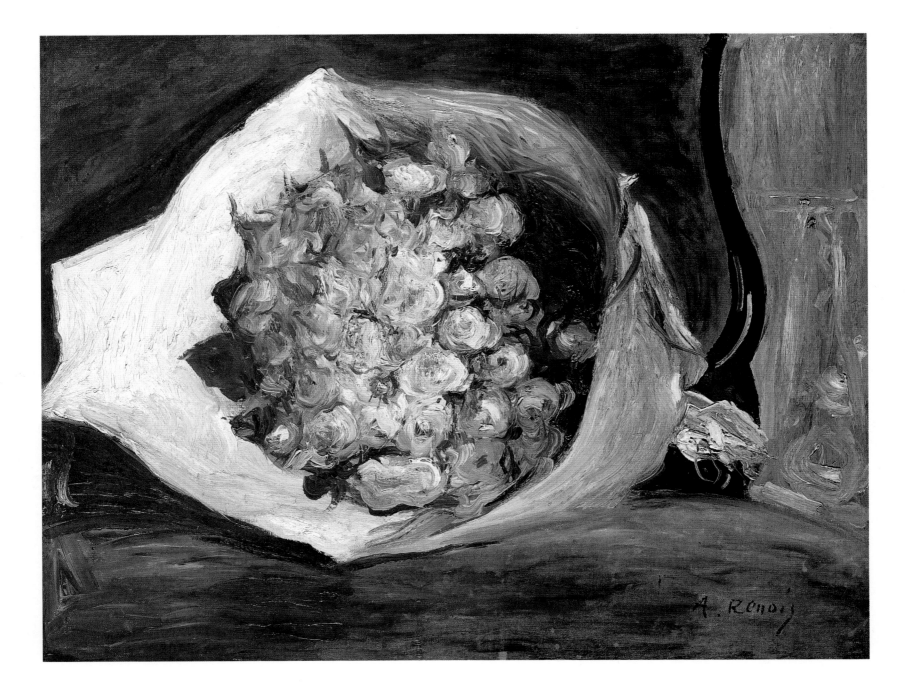

Bouquet in a Theater Box, c. 1871

Oil on canvas
15¾×20 inches (40×51 cm)
Musée de l'Orangerie, Paris

The Chinese vase is similar to that which Manet is painting in Fantin-Latour's painting of *A Studio in the Batignolles Quarter* (page 11, below) and was in fact a fairly common studio prop at that date. The bouquet of roses, still wrapped in paper, bears some resemblance to that in Manet's *Olympia* of 1863 (Musée d'Orsay, Paris). Renoir painted a still life of a similar bouquet, this time without the other accessories, at about the same time (page 66).

The work is also an allusion to the contemporary vogue for things Oriental. Not the 'Orient' that Renoir had already depicted in his North African scenes, which in a sense properly belonged to the artists of the previous generation, immediately after colonization, but rather to the more fashionable Far East. The Chinese vase is joined by a Japanese fan and the spatial ambiguity of the work owes something to the treatment of space in Japanese prints which provided stimulation for experiments with perspective among members of the artistic avantgarde.

The bunch of flowers in this work is quite different in conception from that in Renoir's earlier still lifes such as *Bouquet of Spring Flowers* (page 33). Here the bouquet is still in the paper in which it had been wrapped by the florist, and is lying on its side on the kind of upholstered chair without arms found in a theater box. A bouquet such as this was the common accessory of the fashionable female spectator at the theater, often presented to her by her male companion. The girl in *The Café-Concert* (page 97) holds such a posy. The painting demands an explanation: has the bouquet been abandoned? What of the relationship between the two people who exchanged it? The construction of this kind of narrative approach to a still life was relatively unusual in nineteenth-century France where the emphasis tended to be on verisimilitude, on wealth of texture, and of sensual pleasures (rich colors and the suggestion of fragrance from pretty flowers).

The work owes something to Manet, and in fact the bouquet is very similar to that in his *Olympia*, shown at the Salon in 1865. The black, white, and crimson colors and the flattening spatial effect is found in a number of his works at this time, but the thickly impasted roses are unusual, and may derive from the influence of Delacroix's paintings of flowers.

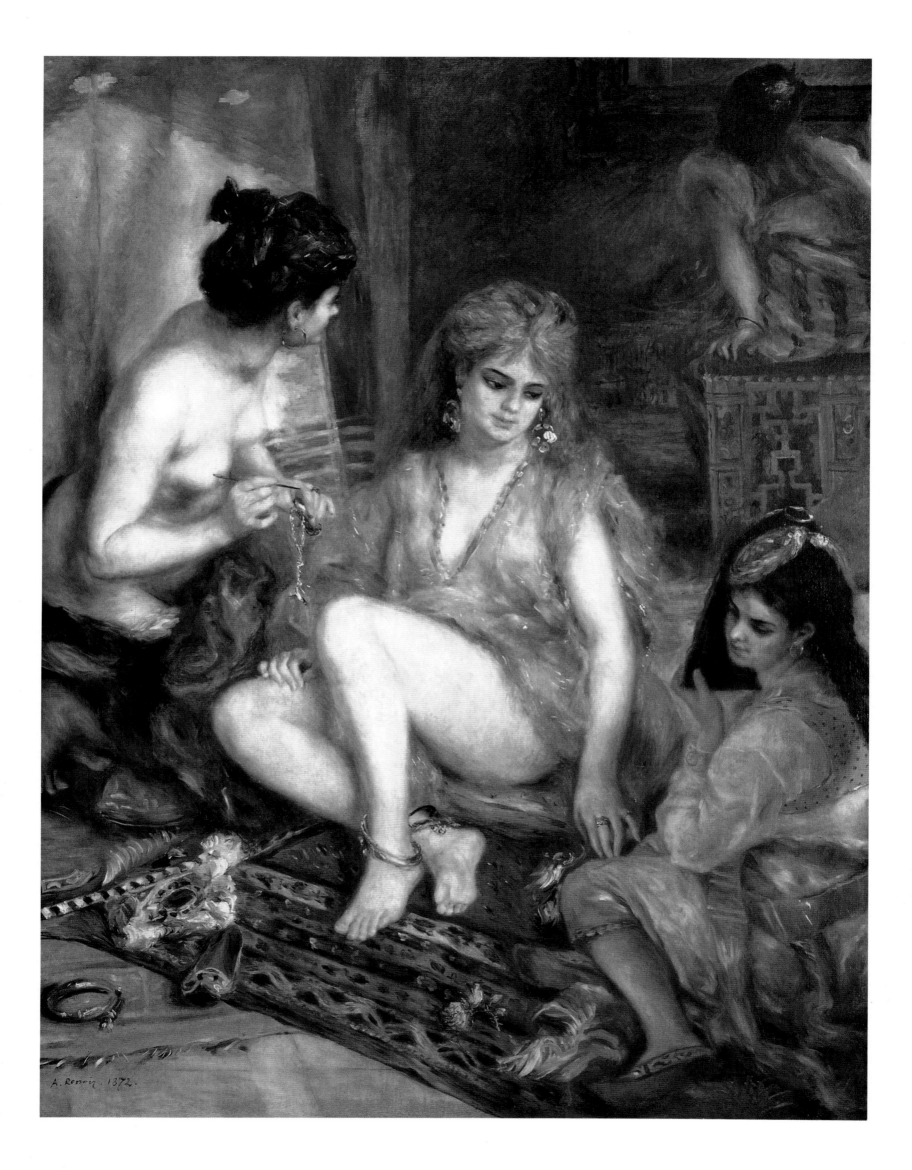

Parisiennes in Algerian Dress,

1872

Oil on canvas
61¾×51½ inches (157×131 cm)
National Museum of Western Art, Tokyo
Matsukata Collection

In *Parisiennes in Algerian Dress*, like *Madame Clémentine Stora* (page 63), Renoir openly acknowledged the fiction that he has created in dressing modern French women in the type of costumes worn in the North African colony. The magnificent blonde woman displaying her thighs and bosom clearly owes little to a real native of Algeria. This figure may have been posed by a model named Fanny Roberts. The woman at the right-hand side may be Lise Tréhot, and given the artificiality of this studio work, she may have been the model for the other dark-haired woman. The composition of the three foreground women and the fourth figure who seems to be recoiling from something in the background, is a free adaptation of Delacroix's *Women of Algiers* of 1834. The

scintillating texture of the rich materials, the feathery brushwork and reliance on warm tones is influenced by Delacroix too, and Renoir has made no attempt to disguise his sources. Despite this, and the popularity of such 'exotic' North African subjects the work was refused at the Salon of 1872.

Because of this set-back, or perhaps because of his technical developments evident in works such as the *Pont Neuf* (page 68), painted just a few months later, Renoir abandonded the overt references to the work of Delacroix about this time, except for the commissioned copy of his *Jewish Wedding* (page 85) of 1875. Shortly after the completion of this work, Lise Tréhot stopped working as his model and married the architect Georges Brière de l'Isle.

The Pont Neuf, 1872

Oil on canvas
29½×37 inches (75×94 cm)
National Gallery of Art, Washington DC
Ailsa Mellon Bruce Collection

Many years after his brother's death, Edmond Renoir gave a vivid description of the subterfuge surrounding the painting of this work.

We established our quarters at the *entresol* of a little café at a corner of the quai du Louvre, but much nearer to the Seine than are the present buildings. For our two coffees at ten centimes each, we could stay at that café for hours. From here Auguste overlooked the bridge and took pleasure, after having outlined the ground, the parapets, the houses in the distance, the place Dauphine, and the statue of Henri IV, in sketching the passers-by, vehicles, and groups. Meanwhile I scribbled except when he asked me to go on the bridge and speak with the passers-by to make them stop for a minute.

Edmond Renoir's reminiscence may perhaps be a little romanticized, as a result of the passing of time. He describes a carefree, bohemian existence in Paris, with the budding artist tenaciously painting the scene in front of one of his favorite cafés and the aspiring writer working furiously alongside him, neither of them having enough money to buy a second coffee. What is problematic about this account are the logistics surrounding the transportation of a fairly large canvas on to the upper level of a café to paint the scene below and only paying twenty centimes for that privilege. In comparison with Renoir's earlier view of Paris, the *Pont des Arts* of 1867 (page 42), this work appears to have been largely worked in front of the motif, but at least some studio work must surely have been involved. Edmond Renoir's description of his waylaying pedestrians in order that they might unwittingly serve as models seems to be substantiated in an examination of the work. The figures do not really cohere into a proper crowd, but seem strangely isolated from each other, with fairly heavy shadows beneath their feet.

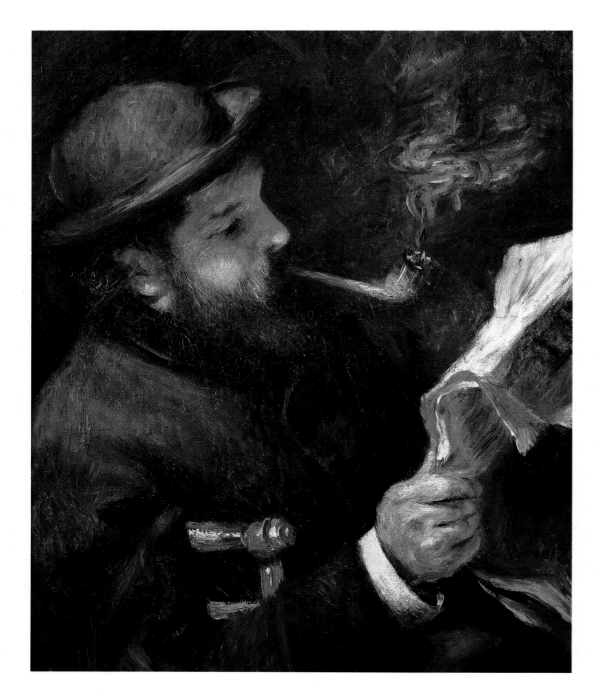

Claude Monet Reading, 1872

Oil on canvas
24×19⅝ inches (61×50 cm)
Musée Marmottan, Paris

One of the original students whom Renoir had met at Gleyre's ten years earlier, Claude Monet (1840-1926) was to remain one of his closest friends throughout the 1870s, and the two occasionally worked together after that date, despite growing domestic responsibilities. Renoir painted a number of works of his friend in the early 1870s (pages 72 and 83) and the two often collaborated at this time. The work is therefore an intimate portrayal of a fellow artist for whom he had to make no compromises. The work is not concerned with making the sitter identifiable, and Monet is shown posed in profile, rather than in the full-face position adopted for works such as the portrait of *William Sisley* (page 30).

A relaxing, post-prandial mood pervades the painting, similar to that in *Mother Anthony's Inn at Marlotte* (page 34) which depicts a bohemian band of artists. Monet is reading the newspaper and has lit his pipe, from which billowing blue smoke creates a sense of movement in the painting. The bearded figure in *Mother Anthony's Inn* rolls a cigarette and his companions discuss the contents of *L'Evénement*, helping identify them as essentially urban figures, transported to the countryside. Monet's social position in this work is much less clear, and it is perhaps revealing that by this time he had turned his back on Paris, and moved to the suburban environment of Argenteuil. The work is painted on a standard size 12 canvas, specially recommended for portraiture.

Riding in the Bois de Boulogne, 1873

Oil on canvas
102½×89 inches (261×226 cm)
Kunsthalle, Hamburg

Part of the rebuilding of Paris included provision of large open spaces on the outskirts of the city, which were used for leisure. The Bois de Boulogne was entirely replanned between 1852 and 1858 from a former royal forest. Its location to the west of Paris meant that it tended to be frequented by the more bourgeois inhabitants of that end of the city. Renoir has depicted one of the most modern of figures, an amazon or lone horsewoman; a type favored by Manet. The woman was Henriette Darras, a friend of the Le Coeur family and the boy on the little pony was Joseph Le Coeur (1860-1904), the nephew of Renoir's friend Jules.

Although a woman riding unaccompanied by an adult male was an increasingly common sight during the Second Empire and Third Republic, it was sufficiently unusual to be a defiantly 'modern' spectacle and this may have lent to the subject's appeal for Renoir. However, at the same time, he has made concessions to tradition. The canvas is huge, indicating that it must have been destined for the Salon from the outset. The handling is rather somber and heavy compared with Renoir's contemporary landscape painting, and there may have been a seventeenth-century precedent. Rubens' cycle of paintings depicting the queen of France, Marie de Medici, included an equestrian portrait (Louvre, Paris). In this work, the queen is shown on a charger, ready to set out for battle: Madame Darras is her nineteenth-century counterpart. Such a blend of tradition and the modern was the forte of Manet, particularly in his works sent to the Salon in the 1860s. It may have been this which led to the work's rejection at the Salon in 1873. Renoir exhibited the work at the *Salon des Refusés* that same year.

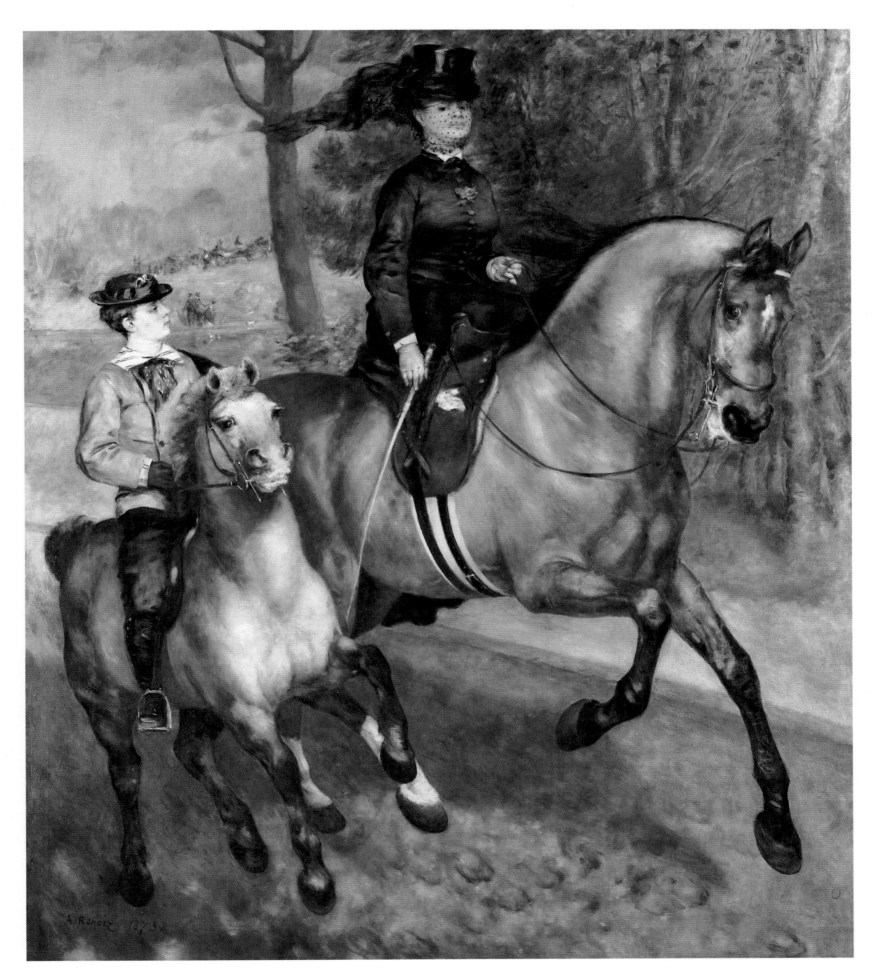

Monet Painting in his Garden at Argenteuil, 1873

Oil on canvas
18⅜×23½ inches
Wadswoth Atheneum, Hartford,
Connecticut
Bequest of Anne Parrish Titzell

In the summer and fall of 1873 Renoir and Monet continued the practice established in the early 1860s at Gleyre's studio and painted together in the open air. Renoir was a guest at Monet's home in Argenteuil, to the north west of Paris, perfectly situated for painting riverside scenes, but within easy distance of the capital by train. The work demonstrates the impressionist painting practice: Monet is working in the open, on a small, white-primed canvas which could be carried about with ease. His light easel was equally transportable, as was the box of paints which lies underneath. A folded parasol, a necessary piece of equipment for landscape sketchers, is beside it. Monet himself is dressed in his working clothes, those which he wore in the previous year's portrait *Claude Monet Reading* (page 70). In the background, just beyond the dense screen of foliage, a glimpse of the new houses which were springing up in Argenteuil, is an indication of the growth in suburban areas, part of the process of industrialization around the capital.

The artists' collaboration resulted in a similarity of technique, particularly evident in this work. The bright, pure pigment and particularly the stacatto brushwork in the foliage which Renoir uses in this work, is very close to Monet's own style at this time. There seems no reason to doubt that both Renoir and Monet finished pictures in the open by this time. The work is the logical outcome of the researches at La Grenouillère four years earlier (pages 12, 52, and 54).

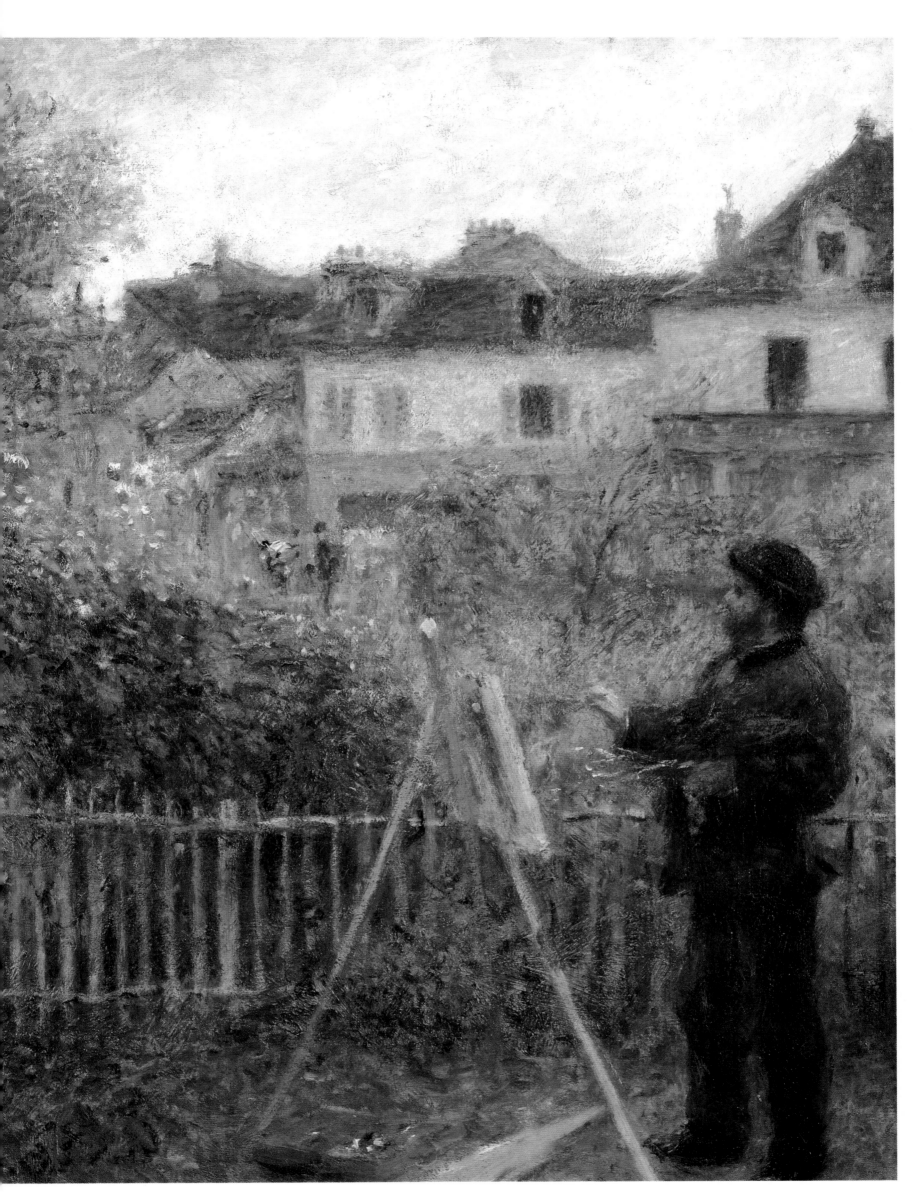

La Parisienne, 1874

Oil on canvas
63×41¾ inches (160×106 cm)
National Museum of Wales, Cardiff

In 1874 the Impressionists held their first exhibition, seven years after the idea had first been proposed. In all, thirty or thirty-one exhibitors contributed to the show, held at 35 boulevard des Capucines in the former premises of the photographer Nadar. Renoir was one of the main organizers of the first Impressionist exhibition and seven of his works were included; six oil paintings and one pastel. *La Parisienne* was number 143 in the catalogue. The work depicts Henriette Henriot, an actress at the Théâtre de l'Odéon and one of Renoir's favorite models between 1874 and 1876. She is elegantly dressed, and despite the absence of background, the gesture of pulling on a glove seems indicate that she has paused on her way out.

The subject of a fashionable young woman, depicted life-size and full-length was not so different from successful Salon paintings of the 1860s, such as *Lise with a Parasol* (page 41). However, the much looser handling and in particular the vibrancy of tone is in marked contrast to the earlier painting. In a diary entry of 1898 the artist Paul Signac (1863-1935) who, as a neo-impressionist, had a particular interest in color, described the effect of color reflexions in *La Parisienne*:

The dress is blue, an intense and pure blue which, by contrast, makes the flesh yellow, and by its reflection, green. The interaction between the colors is admirably captured. It is simple, fresh, and beautiful.

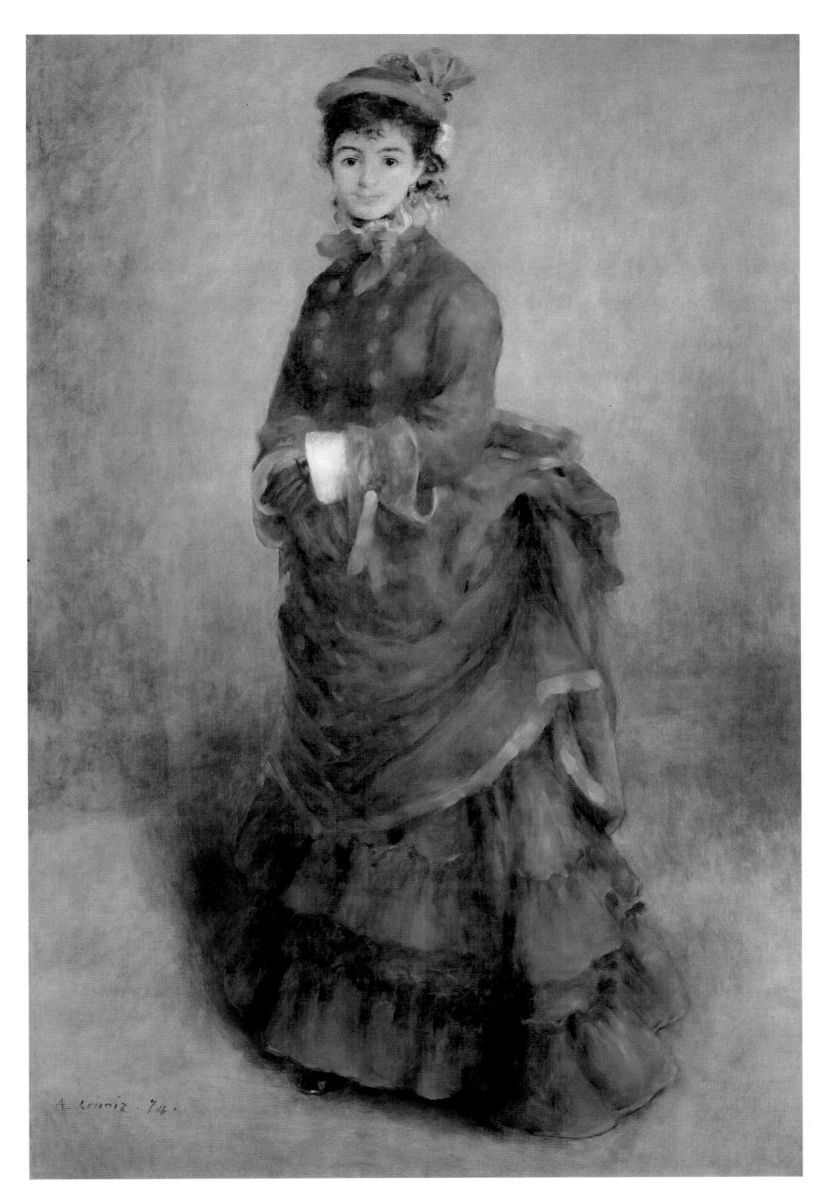

Dancer, 1874

Oil on canvas
56⅛×37⅛ inches (142.5×94.5 cm)
National Gallery of Art, Washington DC
Widener Collection

Number 141 in the catalogue for the first Impressionist exhibition was the *Dancer*, like the *Parisienne* (page 75) a full-length representation of a single figure, posed against an indistinct background. Some critics were hostile to Renoir's work. Louis Leroy, the writer who coined the term 'Impressionism' in a review in *Le Charivari* on 25 April 1874 wrote 'what a pity . . . that the painter, who has a certain understanding of color, does not draw better; his dancer's legs are as cottony as the gauze of her skirts.'

However, some critics wrote more favorable reviews such as the one which appeared in the *L'Artiste* on 1 May:

the *Dancer* is an original conception, a kind of fairy molded in earthly forms. Nothing is more alive than her bright and tender rosy skin. On this the heap of gauze that makes up her dress somehow delightfully blends with her luminous and tender tones. This is Realism of the great school, the one that does not feel forced to trivialize nature to interpret it.

The subject was an unusual one for Renoir. Although he painted various scenes representing spectators at the theater or the café-concert (pages 79 and 97), he tended not to venture behind the scenes, preferring to use a number of actresses as models in the guise of Parisiennes. There is nothing theatrical about the young dancer, however, despite her stance. Renoir has not exploited the contrived gestures or effects of gas-lighting that Degas favored.

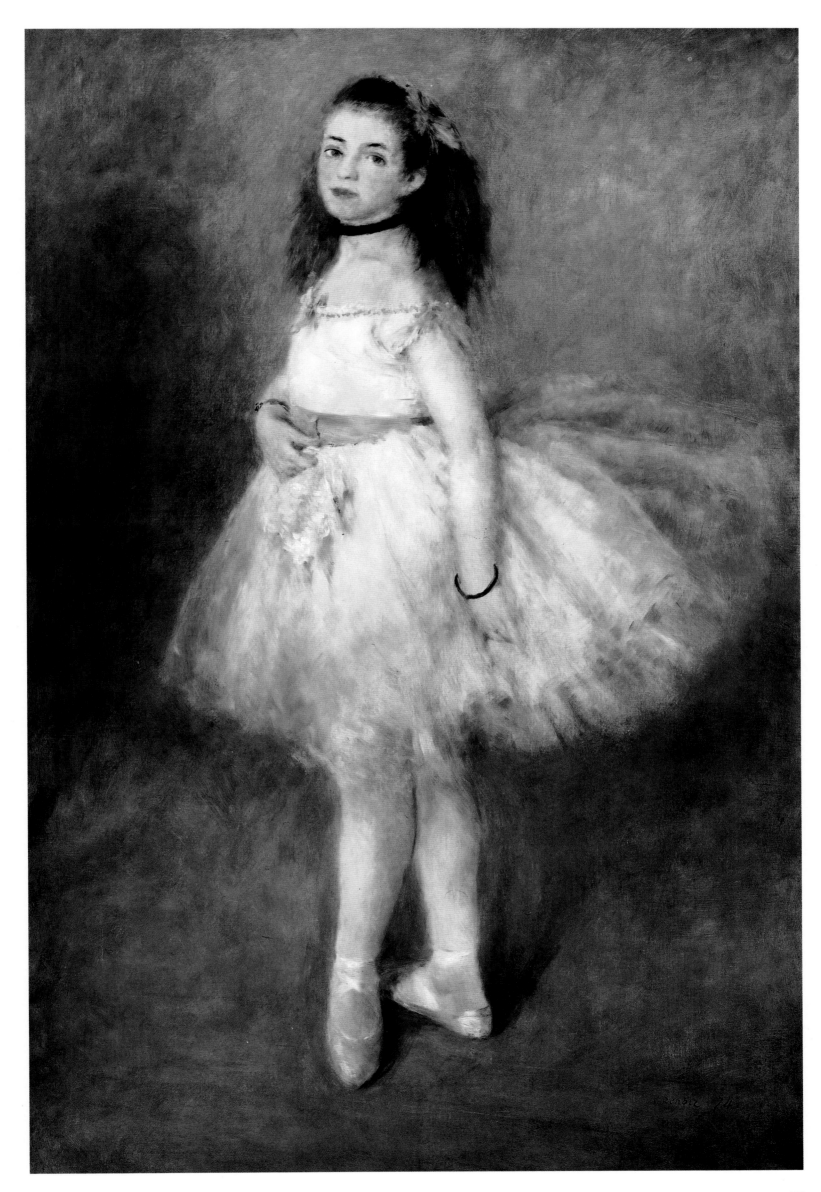

La Loge, 1874

Oil on canvas
31½×24¾ inches (80×63 cm)
Courtauld Institute Galleries, University of London

The single most important building of Haussmann's replanning of Paris, strategically located on the great boulevards, was Charles Garnier's Opéra. Ironically, it was not completed until 1875, during the Third Republic, the year after Renoir painted his best-known representation of theater-goers. It was estimated that towards the end of the Second Empire theaters in Paris could accomodate 30,000 spectators a night, and that was not counting circuses or the more informal cafés-concerts. In *La Loge* Renoir has chosen to depict one of the most representative aspects of modern urban leisure.

The elegant couple are sitting in a *loge* or theater-box, engaged in the popular pursuit of surveying the other spectators and attracting attention, and perhaps some envy, themselves. In fact this is not a double portrait that Renoir has painted, but rather a genre scene for which his brother Edmond and a popular Montmartre model Nini, nicknamed 'gueule de raie' or 'fishface' posed. The two are dressed as members of the bourgeoisie, in evening clothes and Nini wears jewels and flowers and holds a fan in her gloved hand. Both are equipped with opera-glasses, essential for observing their fellow-spectators, as much as the performance. That we are looking at someone with wealth is underlined by the fact that opera boxes were rented by the season, and were an indication of their occupants' social status. Typically that status was considerably enhanced if one could display a beautiful female companion in one's box. Renoir recognized this affirmation of social oneupmanship and it is the woman who presides in the foreground of his composition. It is significant that Renoir has painted a genre scene of members of the class to which he could only aspire in 1874. There is a smaller version of the work, which may have served as a sketch, but was probably a much freer copy made after the exhibition and intended for sale. After *La Loge* was shown at the first Impressionist exhibition it was bought by the picture-dealer Père Martin for 425 francs.

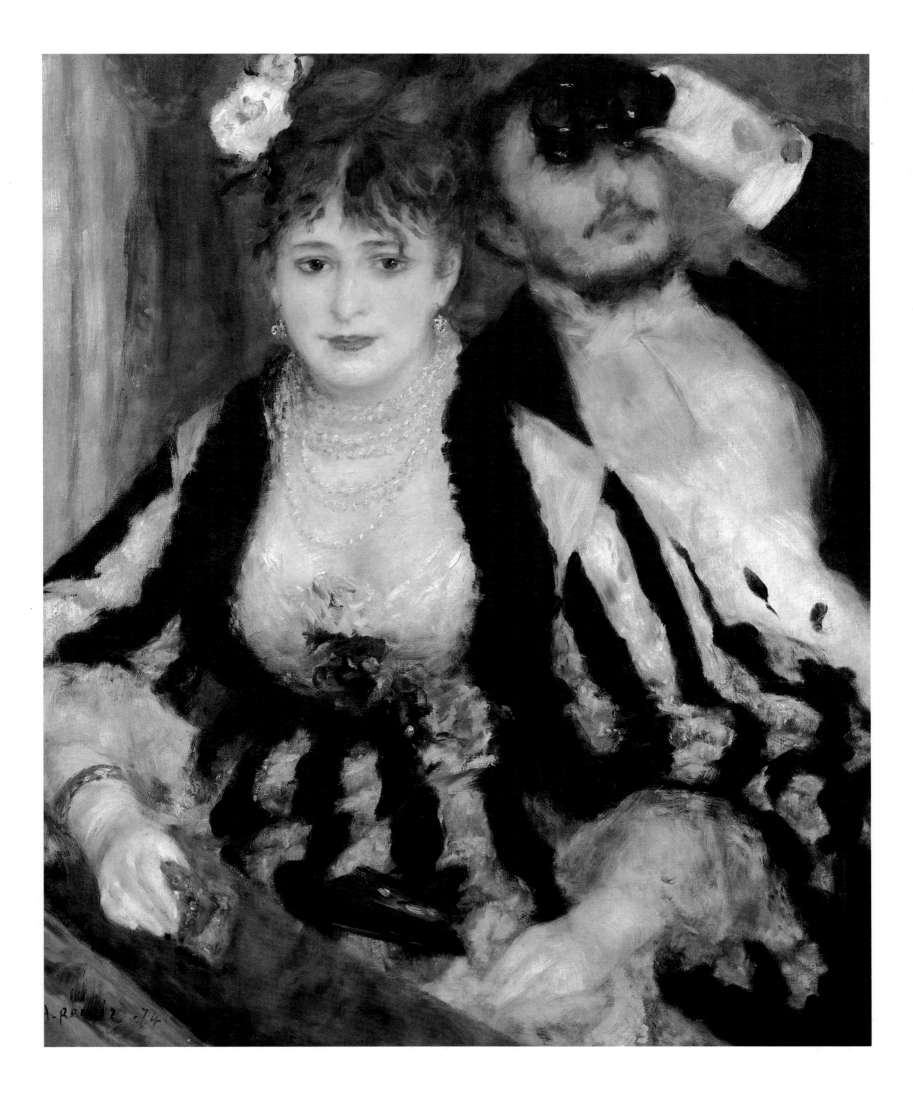

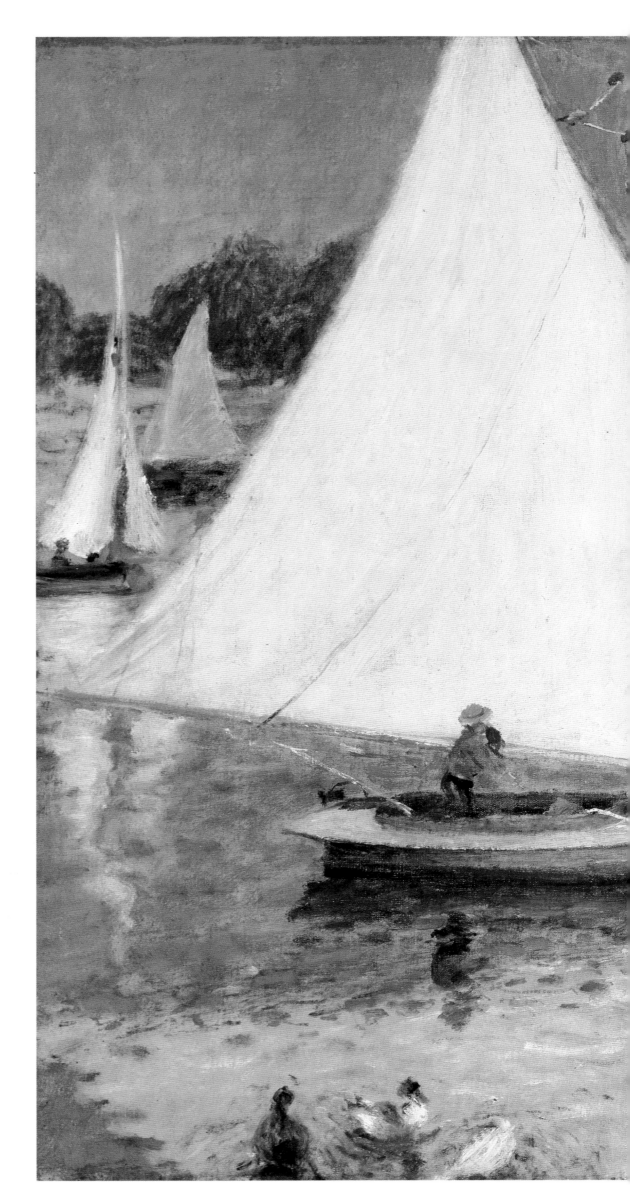

The Seine at Argenteuil, 1874

Oil on canvas
19⅝×23⅝ inches (50×60 cm)
Portland Art Museum, Portland, Oregon

The first Impressionist exhibition was a financial disaster and the limited company that the group of friends had established was forced to liquidate. That summer Renoir and Monet continued their practice of working together on landscape painting. Once again, they worked at Argenteuil where Monet had moved in 1872 from Paris. They were joined that summer by Edouard Manet who painted his most impressionistic works, adopting some of the *plein-air* practices of his younger companions, and in *Monet Working in his Floating Studio at Argenteuil* (page 15, above) providing us with a visual record of the impressionist credo.

Argenteuil in the 1870s combined easy accessibility to Paris (and hence dealers, exhibitions and all the other trappings of a cultural milieu) and a seemingly pleasant rural existence, focused on the river and particularly its boats, which have formed the motif for this work. Once again, Monet painted an almost identical work, using the same composition and colors (it is now in a private collection). The great expanse of the central sailboat acts in both works with the daring of an abstract shape, and providing a counterpoint to the rippling surface of the water. Renoir has not abandoned the anecdotal effect of the two figures who converse in the middle distance. In addition, he has used the little jetty on which one of the men stands as the spectator's means of entering the picture space. Judging from their elegant costumes, the two men are Sunday visitors or leisured residents, for whom sailing is a pleasant hobby. In neither this work, nor in Monet's version, are the boats used for transporting cargo or as workboats. For those such as Renoir and Monet who visited Argenteuil the river was simply another site of leisure.

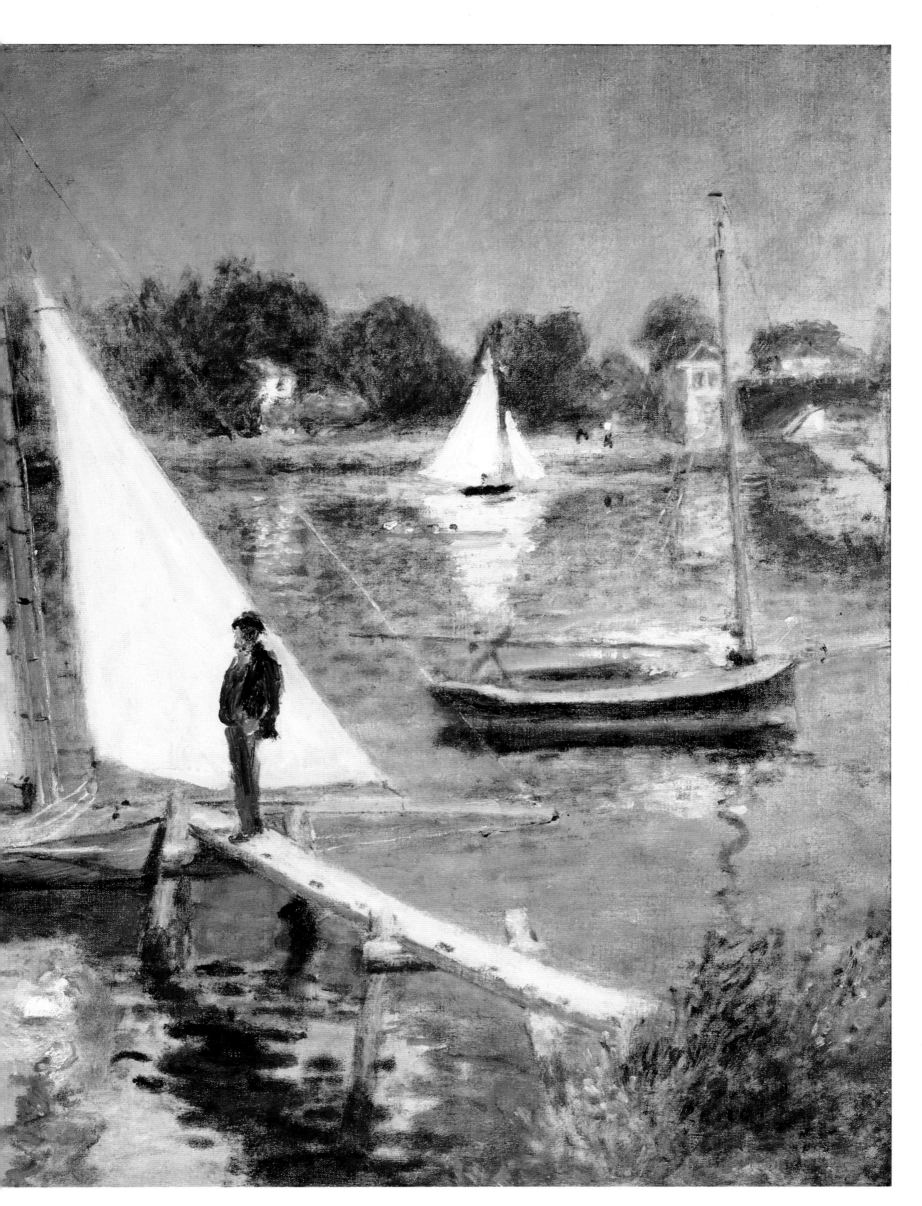

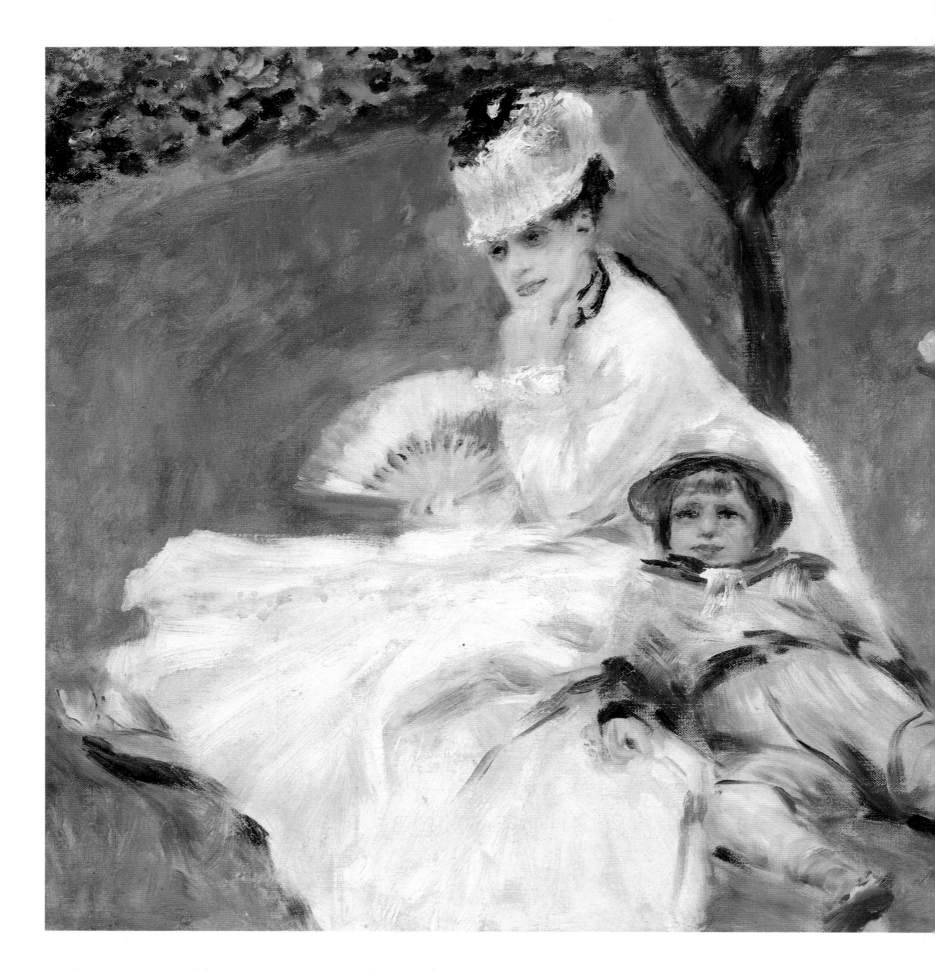

***Madame Monet and her Son
Jean in the Garden at
Argenteuil,*** 1874

Oil on canvas
19⅞×26¾ inches (50.4×68 cm)
National Gallery of Art, Washington DC
Ailsa Mellon Bruce Collection

Renoir has represented the figures of
Camille Doncieux and Jean Monet from
above and the effect is of a very enclosed
environment. In this very flat, two-dimen-
sional picture space he has used the kind of
spatial ambiguities that French artists
found in Japanese prints. Indeed, the dec-
orative aspect of the work is quite stunning
and all of the objects contained within the
picture space are carefully balanced. The
rooster is introduced to this end and the
red of its comb reacts to dramatic effect
with the bright green grass. However, the

claustrophobic space suggested in this
composition may have been influenced
more by Monet's changing attitudes to the
natural world, than by any formal innova-
tions. Whereas in the 1860s Monet had
pioneered working in the open, particu-
larly in an urban setting, and had en-
couraged Renoir to do likewise, in the
1870s he had gradually withdrawn from
depictions of a specifically modern world,
first to suburban Argenteuil and then,
paradoxically, to the increasingly con-
trolled environment of his own making in

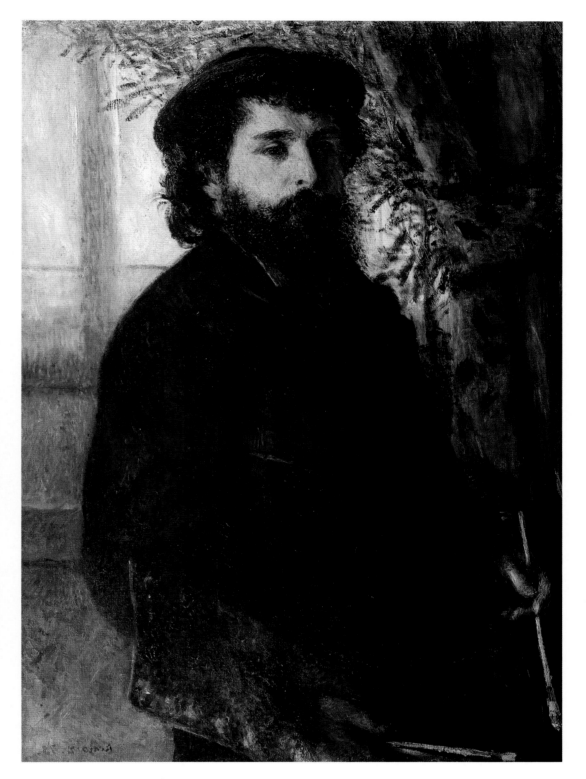

Portrait of Claude Monet, 1875
Oil on canvas
33½ × 23½ inches (85 × 60 cm)
Musée d'Orsay, Paris

At the second Impressionist exhibition in 1876, Renoir exhibited 19 works, including a *Portrait of Monsieur M,* which belonged to the collector Jean Dollfuss who had commissioned a copy of Delacroix's *Jewish Wedding* (page 85) from Renoir in 1875. Hidden behind the initials was his old friend Claude Monet, and the painting may well have been this one, which had been painted the previous year, or perhaps the portrait of *Claude Monet Reading* (page 70). That the work was a portrait of Monet we know from Emile Zola's review of the show

in a Russian journal. He wrote:

Renoir is above all the painter of human faces. A range of light tones dominates his work, the transitions between them arranged with a marvellous harmony. His work is like Rubens illuminated by the burning sunlight of Velázquez. The portrait of Monet which he exhibits is excellent.

Dressed in the same working clothes as he had worn in the previous two portraits by Renoir (pages 70 and 74), Monet is posed *contre-jour,* but with his face illuminated from the righthand side, probably in his house at Argenteuil. He is holding a palette and brushes, demonstrating that even an arch-impressionist continued to paint indoors on occasion.

his garden at Giverny. It was in that manner that Renoir had depicted him the previous summer in the portrait of *Monet Painting in his Garden at Argenteuil* (page 72). Although *Madame Monet and her son Jean in the Garden at Argenteuil* is the same size as that work, in terms of style they are quite different. In the earlier work, Renoir has been influenced by the short, curling brushstrokes of his friend's work at that time, whereas in this work there is the quite discernible influence of Manet in the very much broader handling.

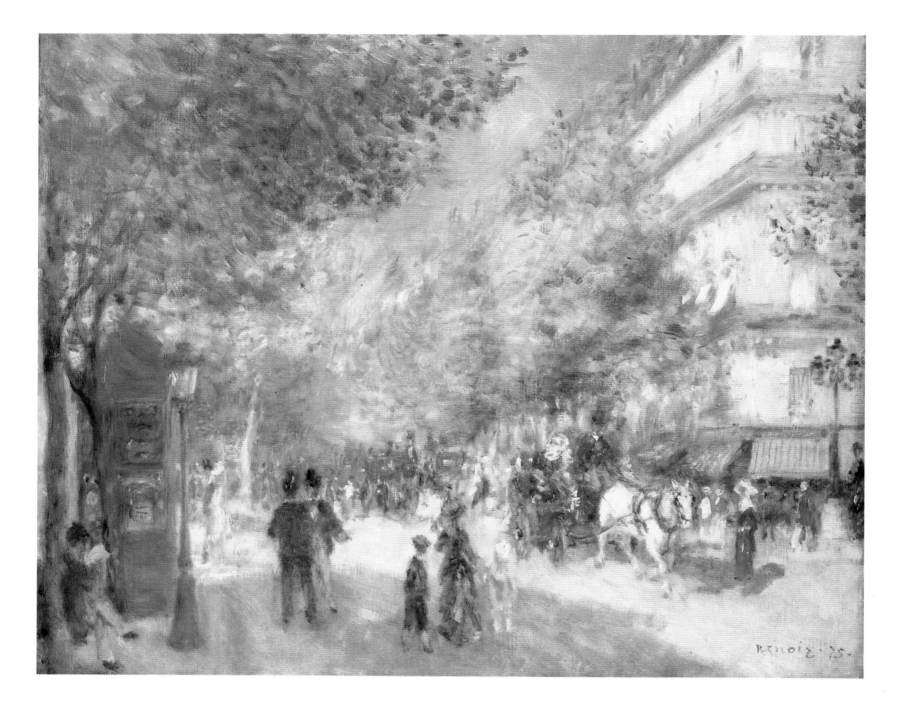

Les Grands Boulevards, 1875

Oil on canvas
20½×25 inches (52.1×63.5 cm)
Philadelphia Museum of Art
The Henry P McIlhenny Collection in
memory of Frances P McIlhenny

In 1875 Renoir moved into a new studio on the rue Cortot, but continued to live at the same address on the rue Saint-Georges, from where it was a short walk to paint the great boulevards. These were a major part of Haussmann's rationalization of the city center, stretching north-eastwards past the Opéra, which finally opened in 1875, and comprising a number of long, wide avenues, including the boulevard des Capucines in which the first Impressionist exhibition had been held. The boulevards were only a short distance from the Gare Saint-Lazare, and hence ideally suited for business commuters.

Renoir has painted the trappings of modern urban life – the gas street lamps, the horse and carriage, fashionable shops with canopies and in the left foreground a Morris column, used for displaying advertisements. However, he has quite literally drawn a veil over all of this, with a fluffy screen of trees which masks the urban uniformity and effectively prevents the vista which was the hallmark of the great boulevards. The crispness of the *Pont des Arts* (page 42), even of the *Pont Neuf* (page 68), has gone and the foliage helps create an image much closer to that which he had been painting in the suburbs around Paris.

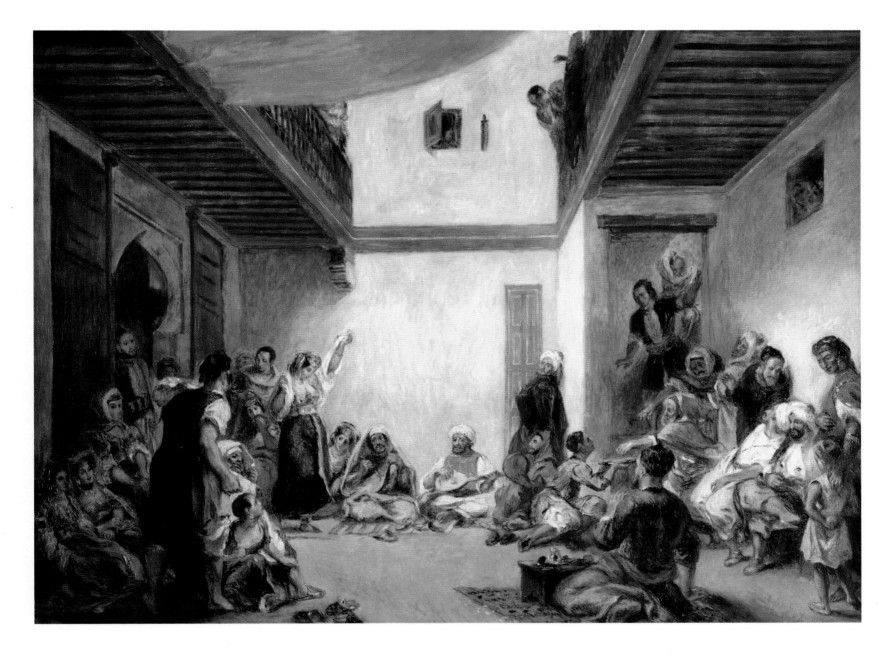

Copy of Delacroix's 'Jewish Wedding,' 1875

Oil on canvas
43×57 inches (109.2×144.8 cm)
Worcester Art Museum, Worcester,
Massachusetts

In 1875 Renoir met two important patrons, Victor Chocquet (page 88) and Jean Doll-fuss who commissioned this work from him. Dollfuss was a native of Alsace and a wealthy industrialist who, like Chocquet, was interested in the work of Delacroix (1798-1863). Consequently, he asked Renoir to paint a copy of his *Jewish Wedding in Morocco*, then in the Louvre, for 500 francs.

Like a number of other French nineteenth-century artists, Renoir was interested in North African scenes, and had already painted a number of fairly free interpretations of life in Algeria (pages 60 and 66), for exhibition at the Salon, which drew on Delacroix's representations of the exotic French colony. It may have been there that Renoir's North African scenes first came to Dollfuss' attention, since one

of the purposes of exhibiting at the Salon was to attract potential clients. Renoir did not go to Algeria until 1881 and much of the flavor of North Africa in his works owed a direct debt to his study of the work of Delacroix, not only in incidental details such as costume and furnishings, and in exotic customs (like this wedding), but also in the much richer coloring and looser brushwork. However, by 1875 Renoir seems to have exhausted North African subjects and had become interested in the art of the Far East, both for subject-matter (pages 64), and for the type of ordering of the picture space that Western artists found in Japanese prints (page 82). The *Jewish Wedding*, a faithful copy of the original, seems to have been a business undertaking at a time when Renoir would have gravitated towards a different subject.

Snowscape, c. 1875

Oil on canvas
20×26 inches (51×55 cm)
Musée de l'Orangerie, Paris
Collection Walter et Guillaume

While the other landscape Impressionists, particularly Sisley, Monet and, to a lesser extent, Pissarro, often painted snowscapes, seeing in them an opportunity to exploit the effects of color reflexions on a white surface, Renoir only painted one major work of a snowy landscape – the *Skaters in the Bois de Boulogne* of 1868 (private collection). Towards the end of his life he confided in Vollard that 'snow is the leprosy of nature. I could never stand the cold; as a matter of fact, there was only [one] canvas of a winter landscape. . . . I recall two or three other studies.' This fairly small *Snowscape* must be one of those studies.

The work is fairly unusual in Renoir's oeuvre, because it contains no people, perhaps confirming its status as a 'sketch,' of the type he had learned to paint at Gleyre's. There are, however, some houses in the background. The handling is very similar to that which Renoir seems to have adopted under Monet's influence in works such as *Monet Painting in his Garden at Argenteuil* (page 72), with its small, darting touch. The landscape is not carpeted with thick white snow but the remaining touches reflect the blue sky which has caused it to melt. Patches of orange paint contrast with the blue of the sky and its reflexion on the ground, animating the canvas and enhancing the colors.

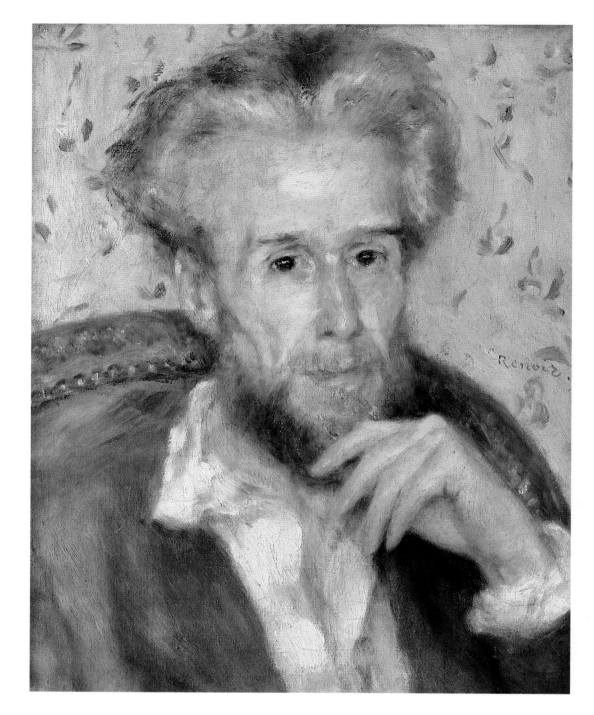

Portrait of Victor Chocquet, 1875

Oil on canvas
18⅛×14⅛ inches (46×36 cm)
Oskar Reinhart Collection
'Am Römerholz,' Winterthur

Included in the catalogue of the second Impressionist exhibition was the name of one of the most important early collectors of their works, Victor Chocquet, who gave Monet and Pissarro leave to exhibit one work apiece from his collection. In addition, no fewer than six of Renoir's exhibits belonged to him. Number 214 in the catalogue, *Head of Man*, has been identified as a portrait of Chocquet and it may have been this version which was exhbited in 1876.

Victor Chocquet was born in Lille in 1821 and died in Paris in 1891. He worked as a minor civil servant in the Ministry of Finance in Paris, preferring to remain there rather than seeking promotion in the provinces. In June 1857 he married Augustine Marie Caroline Buisson whom Renoir also portrayed (page 89). His meeting with Renoir seems to have occured in 1875, perhaps as a result of the auction at the Hôtel Drouot at which Renoir, Morisot, Sisley, and Monet tried to recover some of the losses suffered at their first Impressionist exhibition. At that time Chocquet was a an avid collector of Delacroix's work, but eventually he built up an impressive collection of Impressionist paintings. The catalogue of his collection, sold after his widow's death in 1899 shows that he owned 14 works by Renoir, and as many as 36 or 37 by Cézanne, who was rapidly established as his favorite painter among the Impressionist group.

Compared with the formally dressed male sitters of earlier portraits (pages 30 and 46) Victor Chocquet is shown relaxing at home, in contemplative mood, his sensitive fingers stroking his beard. The dainty rosebud wallpaper in the background is quite different from the indistinct and shadowy backdrops of earlier portraits.

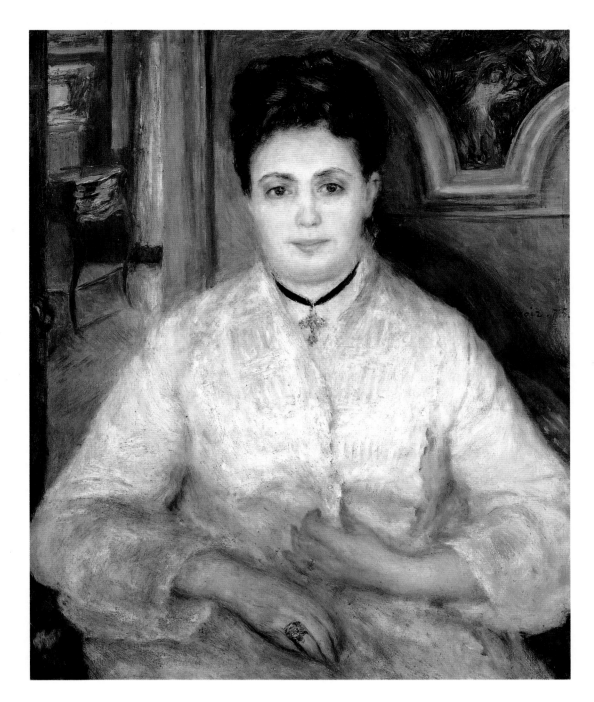

Portrait of Madame Chocquet,

1875

Oil on canvas
29½×23⅝ inches (75×60 cm)
Staatsgalerie, Stuttgart

Shortly after their meeting, perhaps as a re-
sult of the auction at the Hôtel Drouot in
1875, Victor Chocquet wrote to Renoir,
asking if he would paint a protrait of his
wife, Caroline (1837-99). Chocquet stip-
ulated that Renoir include a Delacroix in
the background of the work. The work was
painted in their apartment on the rue de
Rivoli overlooking the Tuileries, which
was full not only of paintings and sketches,
but furniture and *objets d'art*, some of
which are visible in the room in the back-
ground of the painting. The Delacroix
sketch has been identified as *Numa and
Egeria*, the frame of which provides an
echo of Caroline Chocquet's head and
shoulder.

Edmond Renoir later gave an account of
his brother's method of painting portraits

He worked with such a prodigious virtuosity
that a portrait required just one sitting. The
model would leave his place and come and look
at the canvas and find the painted image very
like him, very good; but he expected to return.
Auguste accepted this of necessity, but he had a
bad time pretending to retouch the picture,
occasionally satisfying himself with perfecting
the background and certain details of the dress,
without at all modifying the face.

Renoir explained to Edmond, who had
himself posed for *La Loge* (page 79), that
because of a face's mobility and its ever-
changing expressions, a portrait had to be
painted in one sitting if it were to catch a
sense of personality and retain a degree of
freshness. This rapid execution has paid
off in his depiction of Madame Chocquet,
particularly in the transparent fabric of her
dress.

The Swing, 1876

Oil on canvas
36¼×28¾ inches (92×73 cm)
Musée d'Orsay, Paris

One of the works from the original Caillebotte bequest to the Musée du Luxembourg which went on display in 1897, *The Swing* was first shown at the third Impressionist exhibition in 1877. Although it uses the same subject as *Lise with a Parasol* (page 41) of a young woman under trees, with sunlight streaming through the foliage, the effect is quite different. Here the use of the complementaries orange and blue and dabs of pure color, makes the earlier work appear muddy in comparison, the result of its having been painted in the studio. Several critics commented on these bright patches of pigment. The critic in *L'Evénement* wryly alluded to the 'greasy stains on the figure's clothing,' and Louis Leroy writing in *Le Charivari* was similarly scathing when he described the 'picture of a young girl on a swing covered with azure pom-poms. I hope you like pom-poms, for the painter has scattered them all over, in the sky, the trees, and on the ground.'

While these critics implictly recognized that these dabs of color were the outcome of a more attentive approach to nature based on sensory observation, few critics openly acknowledged this, preferring instead to plead incomprehension. The writer Roger Ballu was critical of the color patches but credited Renoir's motive as 'slavishly representing nature ... he has tried to render the effect of full sunlight falling through foliage on to the figures.'

On the other hand, a quite different interpretation of the work was offered by Georges Rivière in the journal *L'Impressionniste*, produced to coincide with the exhibition itself, and to which Renoir gave his tacit approval. Rivière described the mood of *The Swing* as being one of

tranquillity, in the center of a large park ... here one feels the absence of all passion. These young people are enjoying life in superb weather, with the morning sun filtering through the leaves; what do they care for the rest of the human race? ... one finds here something of the voyage to Cythera, with a character peculiar to the nineteenth century. It is the same spirit, the same French taste, whose tradition was just about lost in the midst of dramatic paintings inaugurated by Greuze and David ... one must go back to Watteau to find a similar charm to that found in *The Swing*.

This comparison with the *fêtes galantes* of the eighteenth century which Renoir admitted to admiring from his student days, suggests that even in 1876 he was beginning to withdraw from depictions of modern urban life, to the representation of a self-contained world controlled by the artist. While most writers were critical of Renoir's slavish realism, Rivière stood apart in finding in his work a mood which was essentially idealizing.

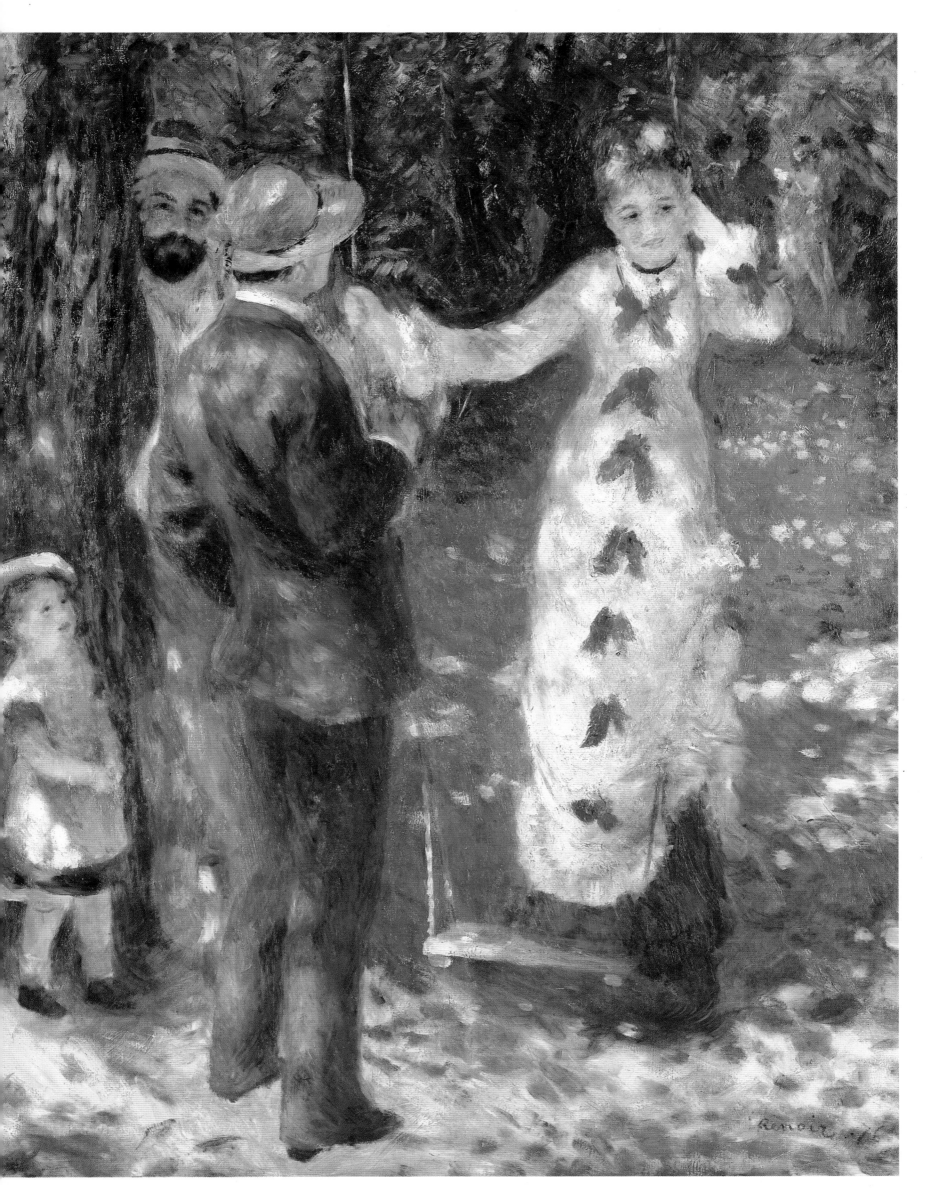

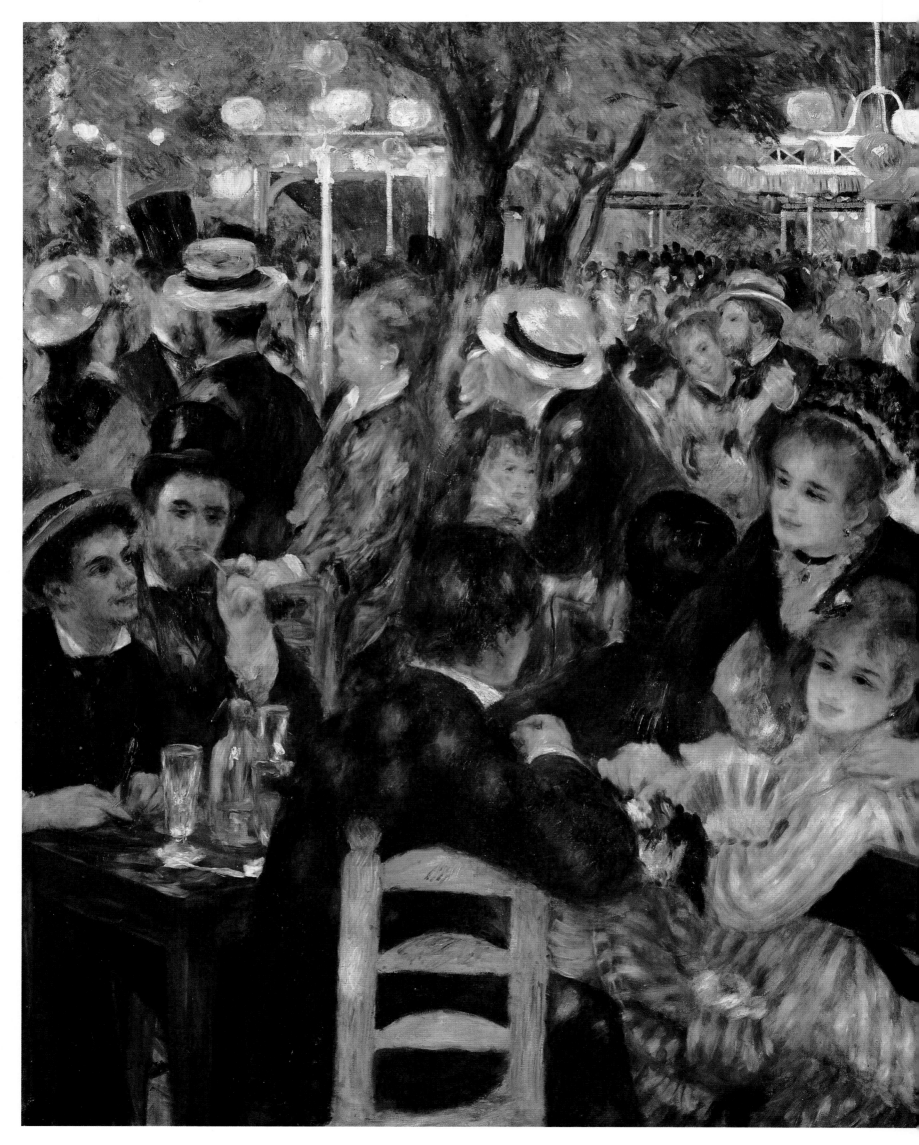

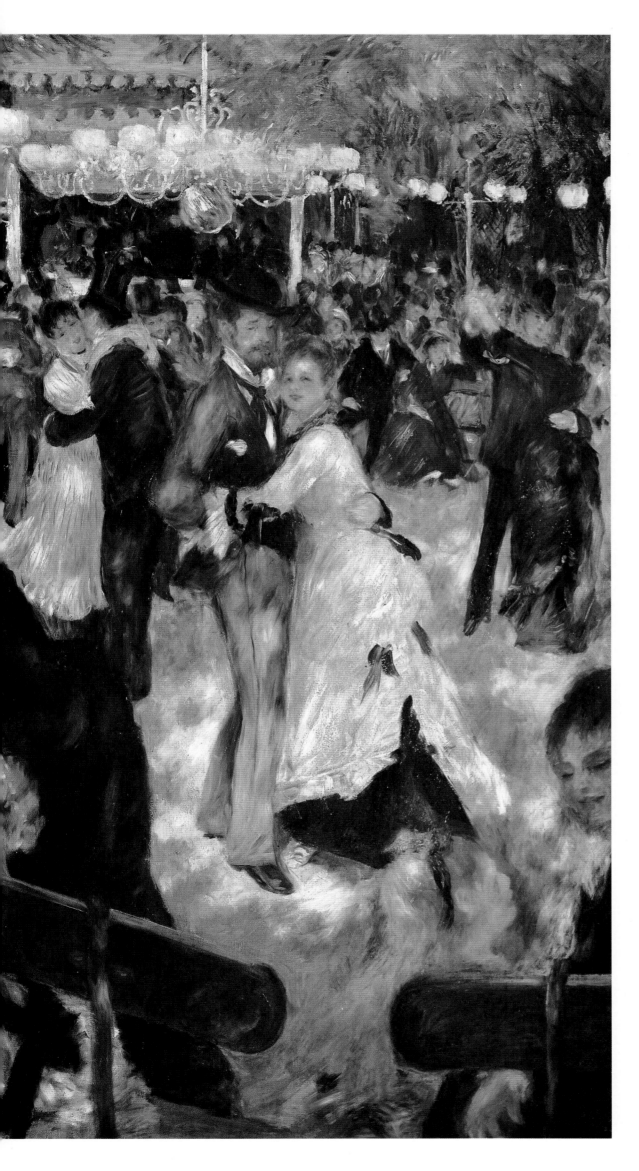

The Ball at the Moulin de la Galette, 1876

Oil on canvas
51½×68⅞ inches (131×175 cm)
Musée d'Orsay, Paris

Much of what we now know about Renoir's work on the *Moulin de la Galette* derives from the account left by the civil servant and writer Georges Rivière, who knew him well at this time, and is himself included in the painting as one of the three foreground gallants drinking at the table. According to Rivière the artist would enlist the help of friends in carrying his canvas from his studio in the rue Cortot to the Moulin, situated on the summit of the Butte Montmartre on the rue Lepic. The Moulin de la Galette took its name from one of the old windmills which contributed to the rather rustic atmosphere which still prevailed in Montmartre at this time. The establishment was run by Debray and his son, and every Sunday afternoon young people from the north of Paris congregated in the dance-hall and in the courtyard behind it in fine weather. Dancing could continue after dark, as the courtyard was fitted out with gas lights, suspended from a trellis above the heads of the dancers. Most of the figures in Renoir's work, rather than being habitués of the Moulin were in fact portraits of his friends, with the occasional professional model posing for him.

In his review of the work in the journal *L'Impressionniste* which accompanied the third Impressionist exhibition of 1877, Georges Rivière referred to it as 'a page of history, a precious and strictly accurate portrayal of Parisian life.' That he should have stressed its realism is odd given the interpretation he attached to *The Swing*, and knowing the very painstaking working method Renoir had adopted. In fact, the work's 'realism' was very contrived — a number of preparatory studies exist for the work, including at least one oil sketch of the entire scene. It may have been this work which Rivière helped the artist carry to the Moulin, rather than the much larger final version. Moreover, the scene which Renoir has painted is not an authentic representation of the clientele of the Moulin, but rather a scrupulously organized series of portraits.

93

Path through the Long Grass,

1876-77
Oil on canvas
23¼×28¾ inches (59×73 cm)
Musée d'Orsay, Paris

Renoir has positioned his easel at the foot
of a hill, and is looking towards a path, on
which a woman with a red-lined parasol
and a child with a hat descend towards
him. The work has a rapid touch and is
painted with a limited palette which would
suggest it has been executed solely in front
of the motif, and in a single sitting. Thin
paint application is enlivened by thickly
impasted areas, particularly in the white of
the path, which has been carried over into
the figures, and in the dense foliage in the
foreground. The juxtapostion of the com-
plementaries green and red contributes to
the lively effect of the work. Black has been
completely eliminated from Renoir's
palette by this time, although he retained it
for portraits of elegant sitters, such as
Madame Charpentier and her Children
(page 98) and *La Loge* (page 79). *Path
through the Long Grass* which would have
been regarded as a sketch merely ten years
earlier, demonstrates the extent to which
Renoir's conception of landscape painting
had changed since his student days at
Gleyre's studio.

The Café-Concert, 1876-77
Oil on canvas
25½×19⅝ inches (65×50 cm)
National Gallery, London

During the Second Empire legal restrictions which had been imposed prohibiting anyone wearing theatrical costume outside properly licensed theaters were repealed, with the result that there was a relaxation in the kinds of entertainment that could be staged in smaller venues, and a resulting growth in the café-concert. This was a place of popular entertainment where people would go to eat and drink and where the staged show was often of secondary importance. The informal approach of both performers and clientele meant that the café-concert was quite different from the chic opera, frequented by the bourgeoisie. The couple depicted in *La Loge* (page 79), expensively and elegantly

dressed in evening attire, belong to a different social milieu from that inhabited by the two young women in *The Café-Concert.* Certainly, they have adopted some of the fashions of their counterparts; the foreground woman is holding a bouquet and her companion is using opera glasses: the spectacle was as much provided by the audience. However, their costume is much less ostentatious than that of the opera-goers, possibly because they are attending a matinée rather than an evening performance. On the other hand, the painting's alternative title, *The First Outing,* implies that what we are witnessing here is the début of a young girl, accompanied by an older chaperone.

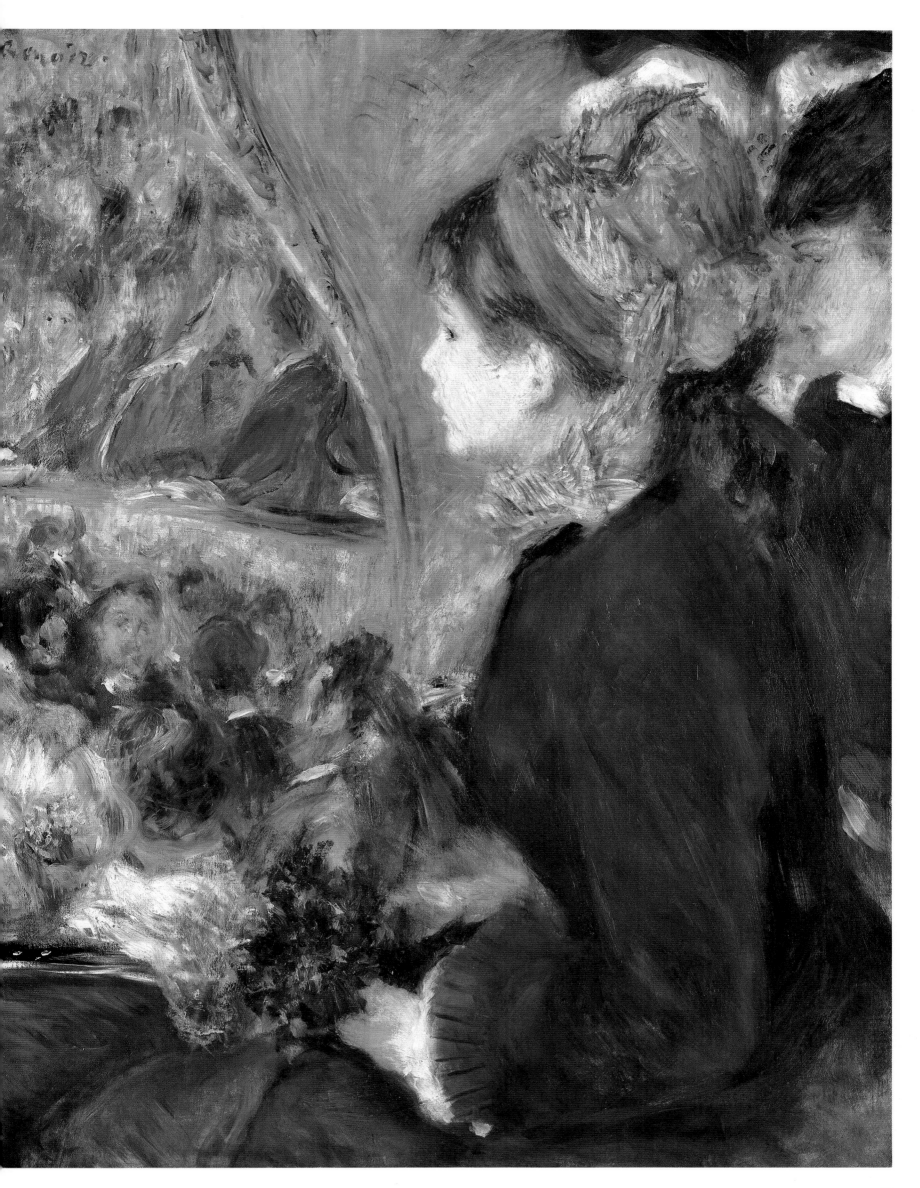

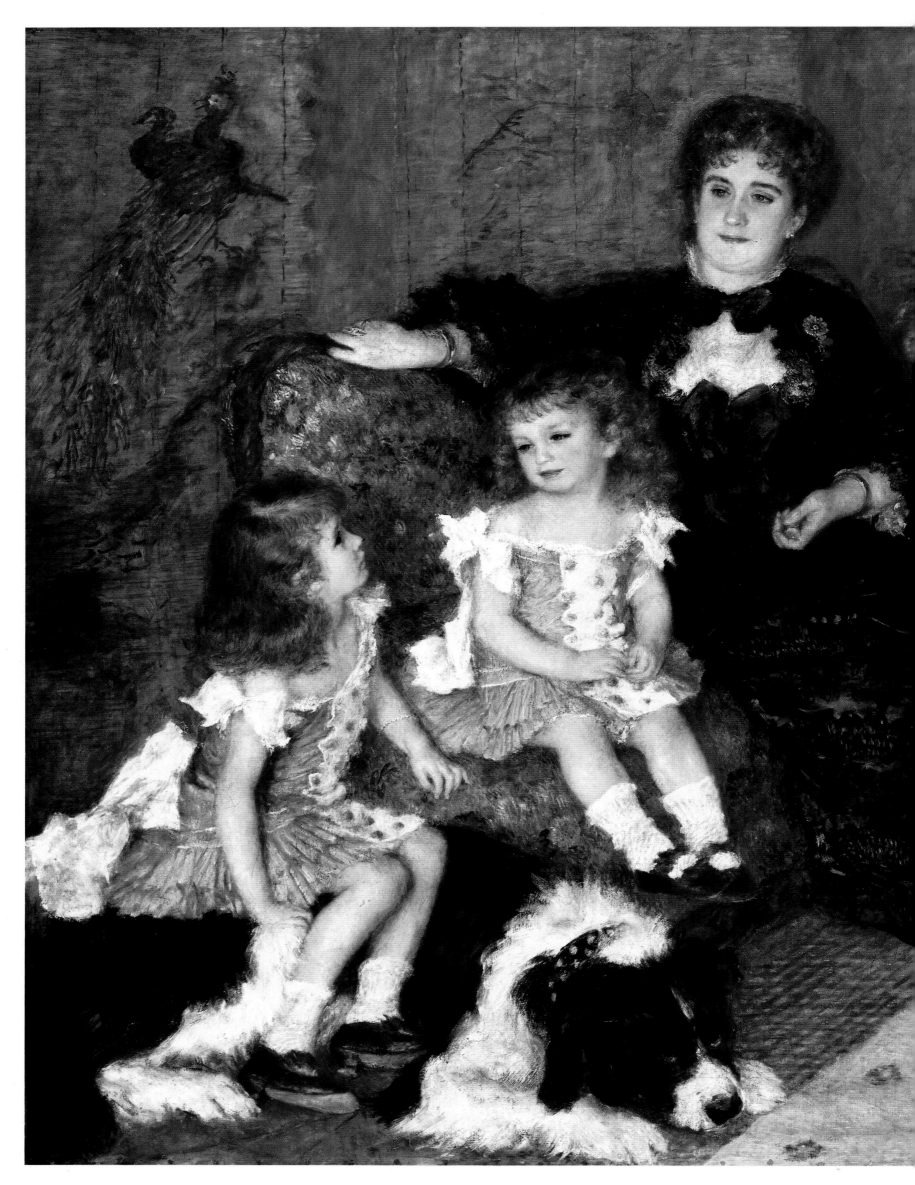

Madame Charpentier and her Children, 1878

Oil on canvas
60½×74⅞ inches (153.7×190.2 cm)
Metropolitan Museum of Art, New York
Wolfe Fund, 1907, Catharine Lorillard
Wolfe Collection

Renoir's first unqualified success at the Salon, in 1879, was this portrait of one of the most influential and fashionable figures in Paris in the 1870s and 1880s. That the work was critically well-received and the canvas well-hung at the Salon was as much due to the intervention of his patron as to any compromise in Renoir's technique. Marguerite Lemonnier (1848-1904) had married the publisher Georges Charpentier (1846-1905) in 1872, and at the beginning of the Third Republic hers was the most fashionable pro-government salon in Paris. It attracted a number of writers, many of them published by her husband, including Zola, Flaubert, Maupassant, Turgenev, the artist Manet, and the politician Léon Gambetta. Renoir was a regular from 1876.

Following the example of the *Portrait of Madame Chocquet* (page 89) Renoir has painted Marguerite Charpentier in an identifiably domestic environment. The small Japanese drawing room of their apartment on the rue de la Grenelle provides a colorful, and fashionable, backdrop for the three figures and the large dog. The two children are her elder daughter Georgette, then aged six, who is sitting astride the long-suffering pet, and her son Paul, then aged three and dressed exactly like his sister, down to his golden ringlets. The relationship between the three figures is made clear by the exchange of looks and by the use of gesture.

In April 1879, shortly before the Salon opened to the public, Georges Charpentier founded the weekly journal *La Vie Moderne*, devoted to art, literature, and society gossip and for which Renoir provided a number of illustrations. Charpentier paid the artist 1000 francs for the portrait of his wife and children, and in 1907 the English critic and artist Roger Fry who was director of the Metropolitan Museum in New York paid 84,000 francs for it.

The Wave, 1879

Oil on canvas
25½×39 inches (64.8×99.2 cm)
The Art Institute of Chicago
Potter Palmer Collection

Gustave Courbet (1819-77) painted innumerable representations of *Waves* throughout his career, and it may have been those works that influenced Renoir to paint this seascape. Courbet's work had been included in a comprehensive retrospective of 300 Barbizon paintings at Durand-Ruel's gallery the previous year. Like Courbet, Renoir has removed any sense of the anecdotal, and the landscape has not even been given a sense of scale or humanity by the introduction of boats or figures. However, unlike Courbet's rather tempestuous seascapes, Renoir has painted a tranquil scene.

The artist has used a standard size 40 canvas, recommended for seascapes, slightly shorter in height than the equivalent landscape canvas. The thick impasto used by Courbet is evident here, particularly in the crest of the waves.

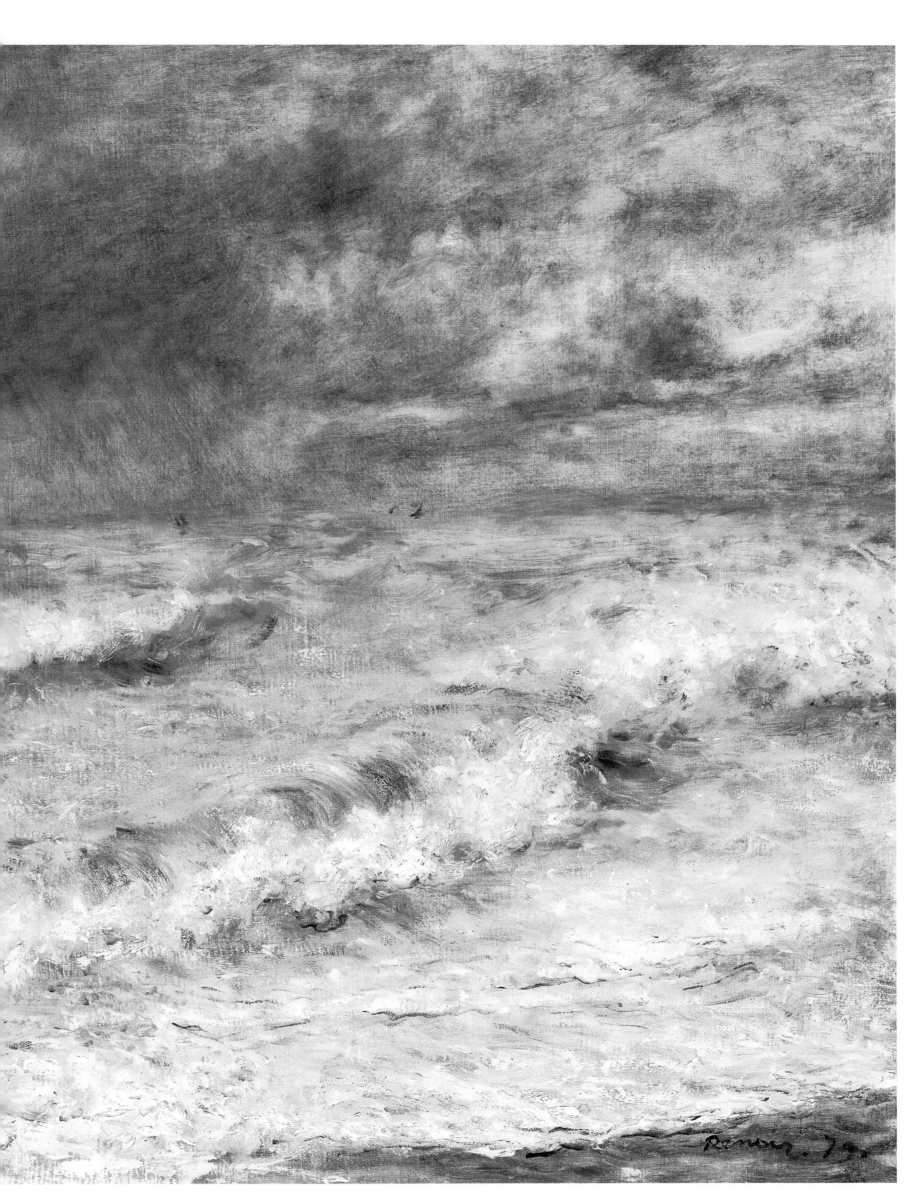

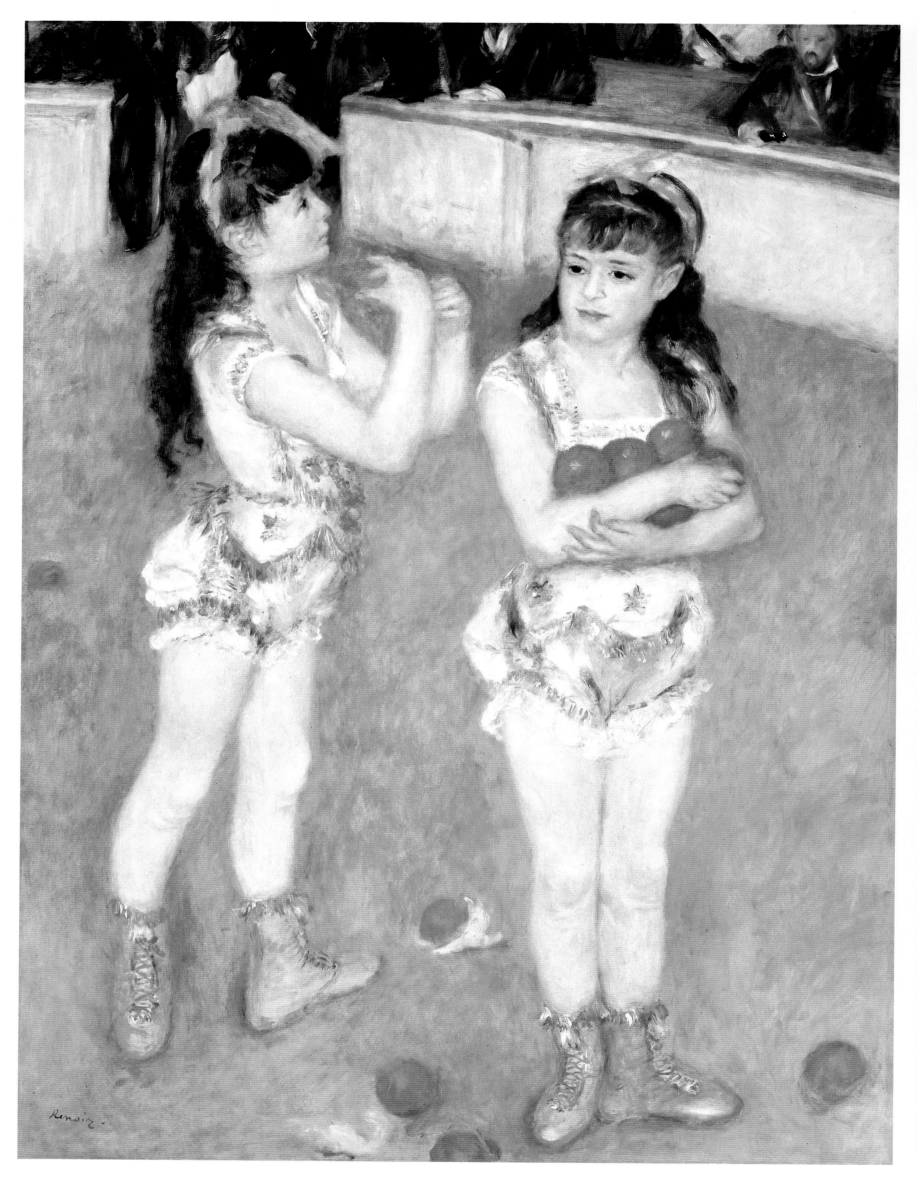

Jugglers at the Cirque Fernando,
1879

Oil on canvas
51¾×39⅙ inches
The Art Institute of Chicago
Potter Palmer Collection

After the success of *Madame Charpentier and her Children* (page 98) at the Salon of 1879, Renoir was convinced that the Salon was preferable to the independent Impressionist show for establishing his reputation and for attracting patrons and collectors. Despite Durand-Ruel's pleas, he refused to participate in what was to be the penultimate group show in 1882 and the dealer exhibited works from his own collection of Renoirs. The catalogue listed 25 works by Renoir but there were two others on display in the rue Saint-Honoré, including this one. The work has been identified from contemporary criticism. Gaston Vassy wrote 'Renoir is also showing two poor little *Saltimbanques* who were born with too short legs. To console them the artist has given them hands that are too long, full of great oranges.'

The little jugglers, who were also gymnasts, were Francisca and Angelina, daughters of Fernando Wartenberg the owner of the Cirque Fernando on the rue des Martyrs on the outskirts of Montmartre. The circus was on a fixed site and although it was built of wood, it retained the circular shape of its original tent, which is evident from the shape of the ring in the background. Compared with his earlier representation of circus life *The Clown* (page 48), the disparity between foreground and background in *Jugglers at the Cirque Fernando* is no longer evident. Renoir has retained *The Clown*'s rich colors and decorative patterns, accentuating the rather theatrical poses of the two girls and making their white flesh contrast sharply with the orange of the sawdust ground and the fruits.

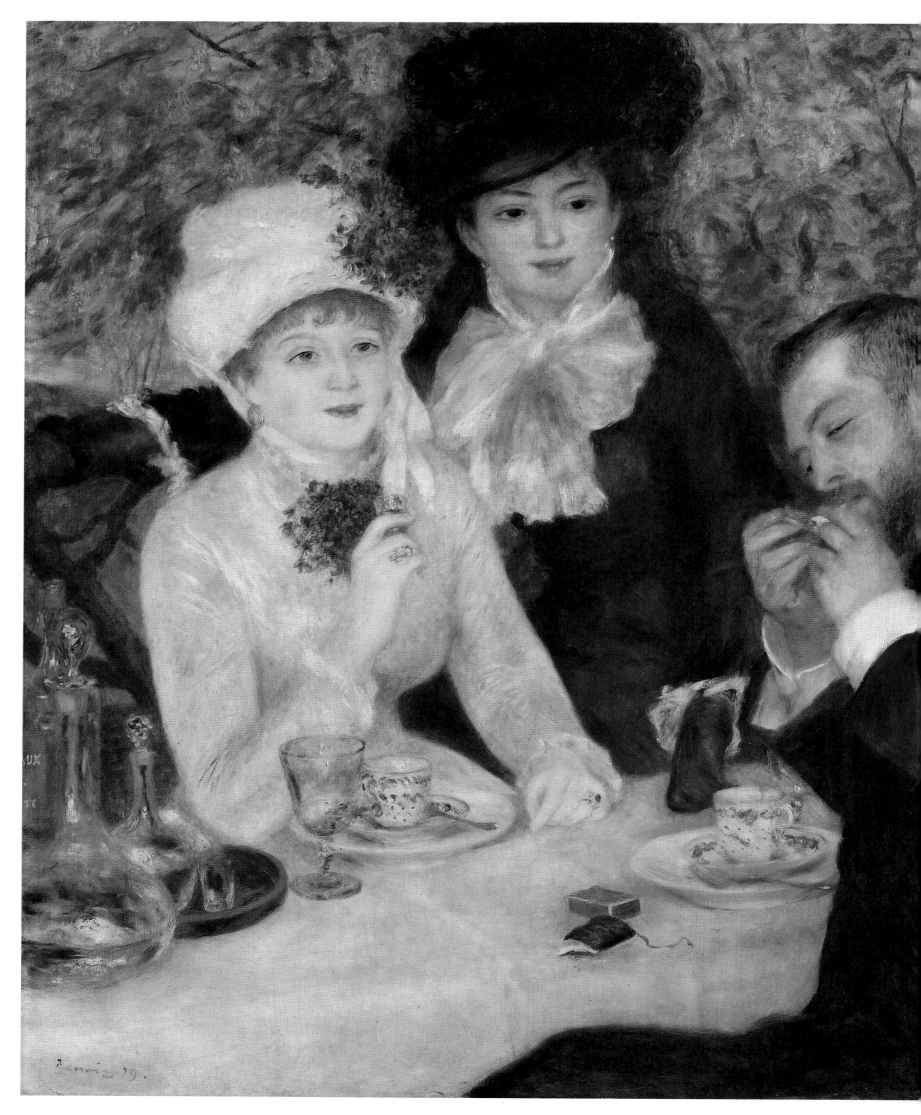

The End of the Lunch, 1879

Oil on canvas
39⅛×32¼ inches (99.5×82 cm)
Städelsches Kunstinstitut, Frankfurt

Renoir's brother Edmond and the actress Ellen Andrée posed for this work: it is not known who the dark-haired woman was. Once again, Renoir has depicted a scene of relaxation following a meal. Coffee has been served, the blonde woman is holding a liqueur glass, and her companion is lighting a cigarette. They appear to be dining out of doors, perhaps on a terrace attached to a restaurant. Renoir has reveled in depicting the still-life objects on the white linen; in juxtaposing the black and white costumes of the two women and the masterful way in which he has attenuated the male figure. The way in which his body is cut in half by the picture frame, in an apparently arbitrary fashion, gives a sense of immediacy and spontaneity to the work.

This was a device Renoir had already used to great effect in the figures to the lefthand side of the *Moulin de la Galette* (page 92). The man occupies only a fraction of the picture space compared with the two women, yet their attention (and ours) is directed towards him as he draws on his cigarette. The two seated figures may be married (the blonde woman wears a ring) and they appear to have been joined by the second woman only at the end of their meal, since she stands with her arm resting on the chairback behind her friend and is still wearing gloves. The tension involved in any such reading of the painting is heightened by the effect of the table top which separates the figures, and is at odds with its otherwise tranquil atmosphere.

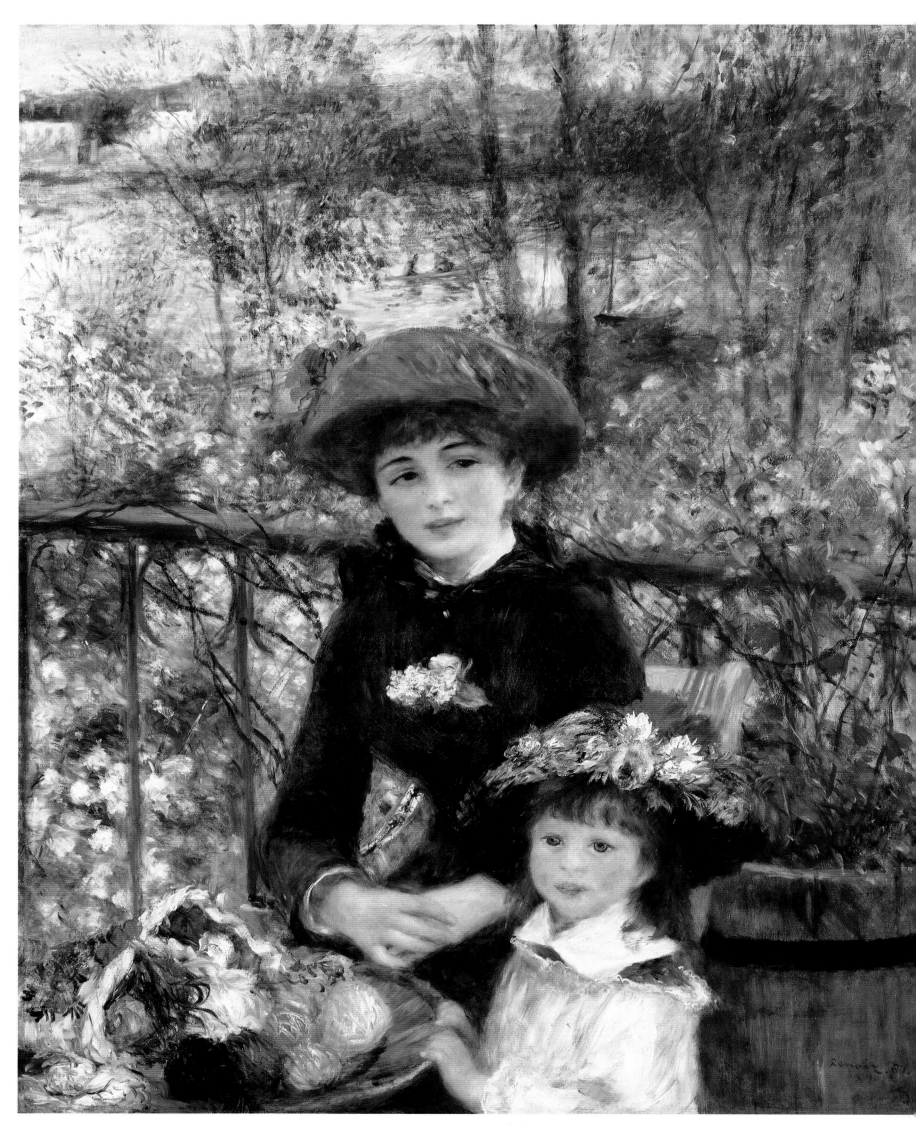

On the Terrace, c. 1879

Oil on canvas
39½×39⅞ inches (100.5×81 cm)
The Art Institute of Chicago
Mr and Mrs Lewis Larned Coburn
Collection

This work may have been painted at Chatou, near La Grenouillère, where Monet and Renoir had painted in the open air ten years previously. Compared with these earlier works (pages 52 and 54), the development in Renoir's impressionist technique is evident. *On the Terrace* uses a much higher key and white is freely mixed with the other colors, to achieve a greater luminosity. Earth tones and blacks have disappeared and the shadows are brilliantly colored. The color complementaries, already evident in the greens and reds used in *La Grenouillère*, play across the canvas and the main pairing now is blue and orange. The brushwork is much freer, and while the rippling brushwork had been confined mainly to the water and foliage in the earlier work, the surface of the entire canvas is now enlivened. Yet at the same time the compositional structure which had been evident in the pictures of *La Grenouillère* has not been sacrificed. The trellis which separates the diners from the river holds the picture together and prevents any lack of coherence between foreground and background.

In other respects, some of Renoir's concerns have remained the same. He is still interested in chronicling the pursuit of leisure within a suburban environment, and the three characters relaxing in the foreground are contrasted with the figures who play energetically in the background. The work's affinity is with other scenes of the end of a meal, a favorite subject which began with *Mother Anthony's Inn at Marlotte* (page 35) and was to culminate with the large-scale *Luncheon of the Boating Party* (page 112).

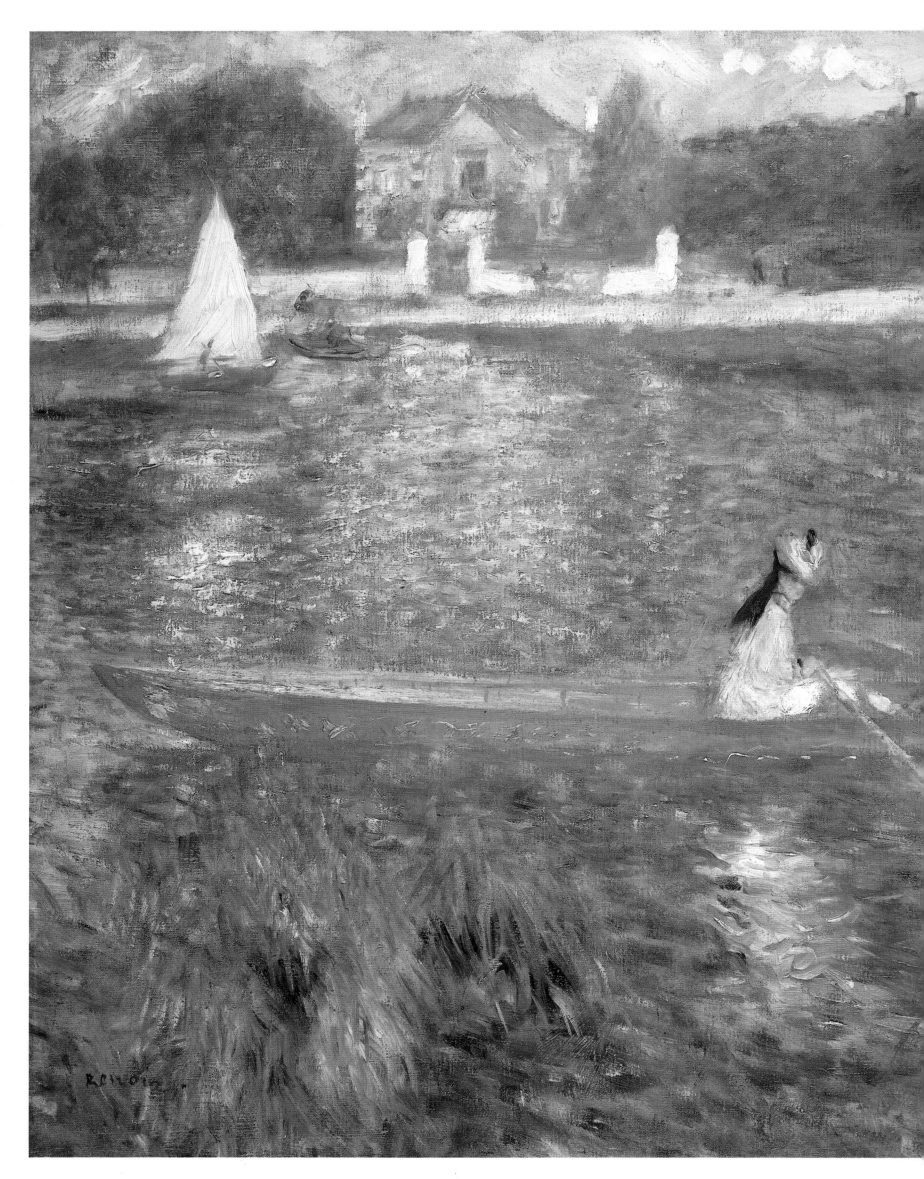

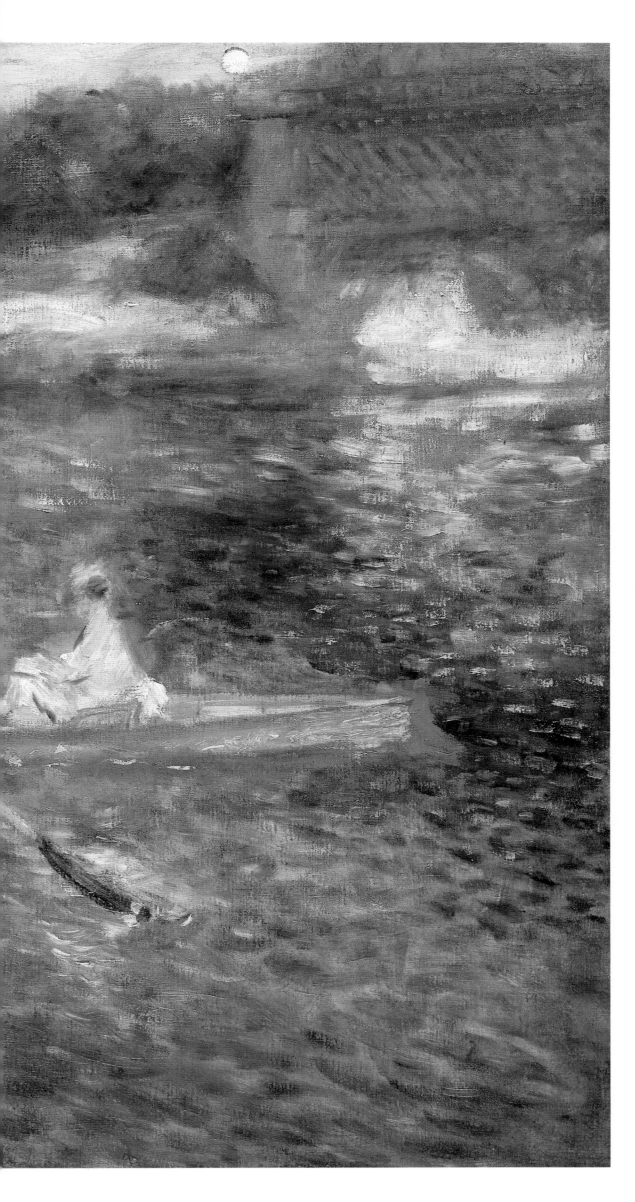

The Skiff, c. 1879

Oil on canvas
28×36¼ inches (71×92 cm)
The National Gallery, London

Although this work is sometimes referred to as *The Seine at Asnières*, the location has not been identified, but the river is clearly the Seine and the area is a pleasant, wealthy suburb, to judge from the house in the background. The two women in the skiff are one of a number of tourists who have come here to enjoy some free time, and there are other pleasure craft in the background of the painting. At the upper right-hand-side of the work is a railway bridge and what looks like fluffy white clouds in the upper center of the picture is in fact smoke from the train which conveys the tourists to this spot. The train, powered by steam, is placed with ironical proximity to the skiff, worked by the two women. The skiff was a popular two-person craft with room for one passenger who rowed, and the other who steered with a rudder.

The contrast of complementary blue and orange evident in *On the Terrace* (page 106), is pushed to the colors' greatest intensity and their juxtaposition means that they constantly react with each other, so that the effect on the viewer is of a restlessness, despite the tranquility of the subject-matter. The sense of shimmering heat and rippling in the water was the logical outcome of the impressionist style, and the picture surface hovers between tremendous vitality and total disintegration.

The Skiff seems to epitomize the impressionist style: a work produced in the open; the use of saturated pure colors and a carefree, timeless scene. The train, symbol of encroaching industrialization, is the only sinister element in the work and Renoir has hardly acknowledged its presence, preferring to push it to the top of picture and crowning it with a halo of feathery cloud.

Irène Cahen d'Anvers, 1879

Oil on canvas
25½×21¼ inches (65×54 cm)
E G Bührle Collection, Zurich

With the success of *Madame Charpentier and her Children* (page 98) at the Salon of 1879, Renoir was in great demand as a society portraitist. *Irène Cahen d'Anvers* (1872-1963) and a double portrait Renoir painted of her sisters the following year (page 115) are two of the best examples of the genre. Commissioned by the subject's father, a wealthy Jewish financier, Renoir has painted a work which is far removed from the more personal and informal landscapes he painted at the time, such as *The Skiff* (page 108). It is no coincidence that *The Skiff* was first owned by Victor Chocquet (page 88) one of Renoir's most en-lightened patrons, who admired the apparent spontaneity, vivid color, and loose handling of such a landscape.

Mademoiselle Cahen d'Anvers is depicted almost in profile, her hands clasped demurely in her lap, wearing a white dress and with her magnificent red hair spread like a curtain around her shoulders. Renoir has reverted to the indistinct background of early paintings like *Portrait of the Artist's Father* (page 49) rather than the more informative decorative background found in works such as *Madame Charpentier*, in which the objects surrounding her help establish her status and taste. While the face and hands are crisply delineated, the child's dress and hair have been painted with a much looser style, helping establish a compromise between the Salon and impressionist conventions.

Place Clichy, c. 1880

Oil on canvas
25½×21¼ inches (65×54 cm)
Fitzwilliam Museum, Cambridge

Despite the fluency of the handling, the thin paint which appears only to have skimmed the surface of the canvas in the background figures, and the dramatically cropped foreground figure, the work is far from spontaneous. There are several preparatory studies, both drawn and painted, for the young woman and for the background figures. The apparent sketchiness of *Place Clichy* was only achieved with careful planning. The jump from foreground to background figures may have been influenced by contemporary photographs; their fluffiness suggests not only distance but also gives a sense of movement as they go about their business. The foreground woman is much more fully realized than the other figures, not only in her features, but also in the texture of her coat, treated with color striations, and in the impasted feather in her bonnet.

The work has sometimes been identified as the Place Pigalle, but Renoir has deliberately left the location vague, much as he did in *Les Grands Boulevards* (page 84). The urban environment depicted in the work, the top-hatted men, the horse-drawn omnibus and the sidewalk as well as the crowd itself, is one of the last representations of the city, which ceased to concern Renoir, particularly after his visit to Italy in 1881.

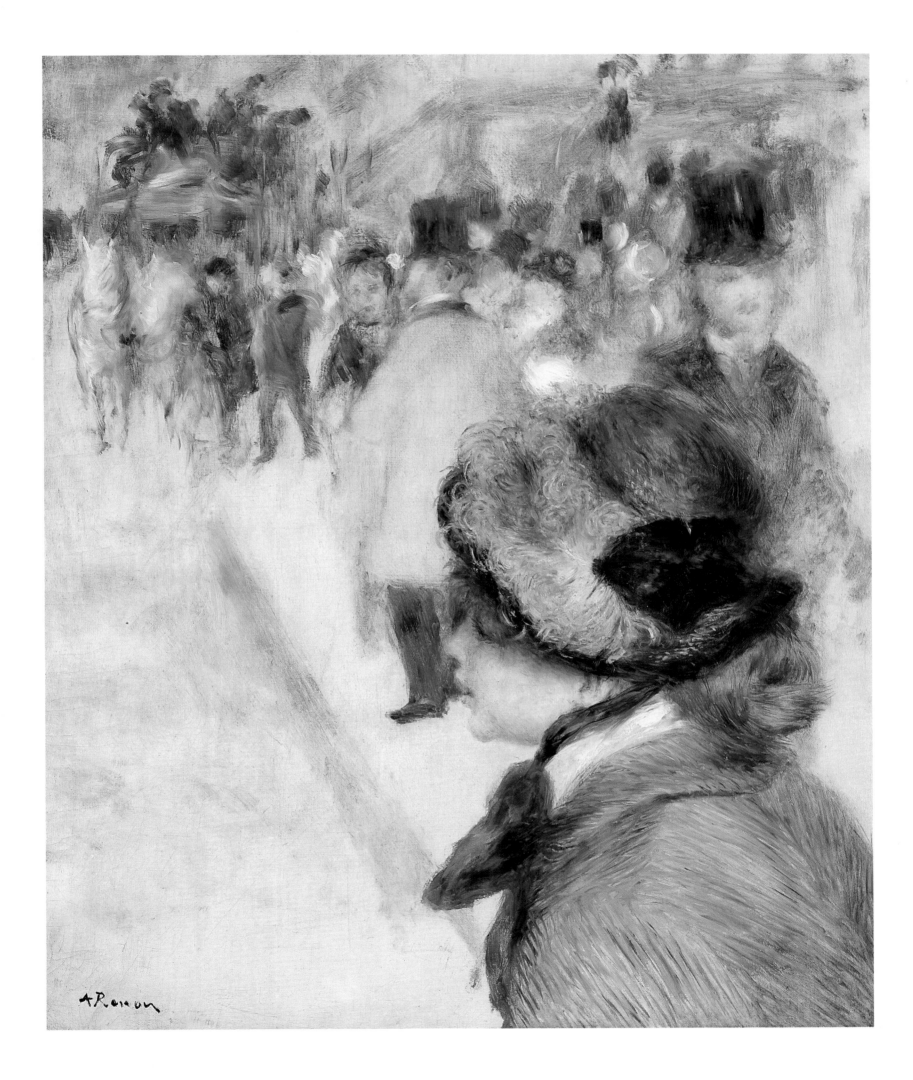

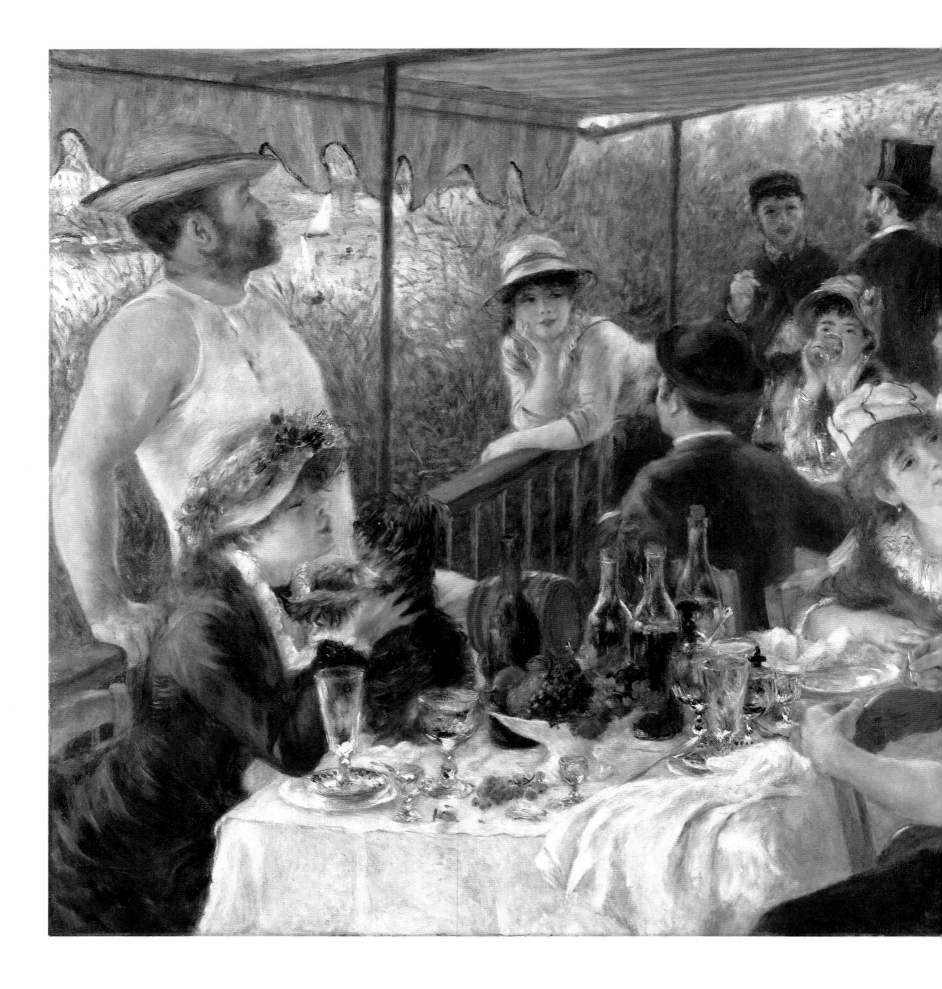

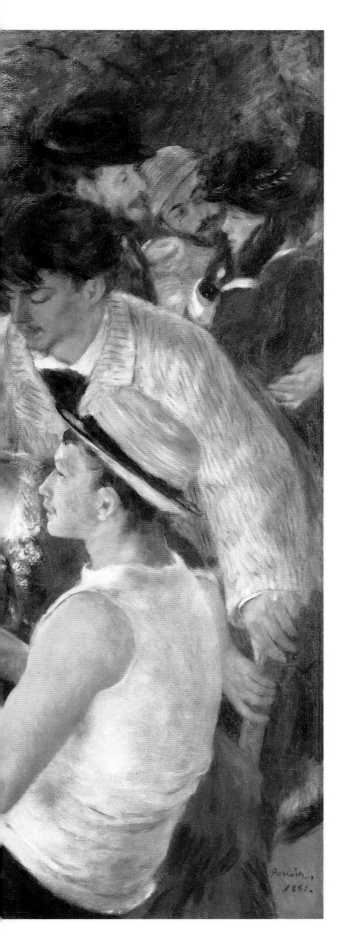

The Luncheon of the Boating Party, 1881

Oil on canvas
51×68 inches (129.5×172.7 cm)
The Phillips Collection, Washington, DC

Both Renoir and Monet exhibited at the Salon of 1880, preferring to submit their works to the jury rather than exhibit with their friends at an independent group show. The critic Emile Zola supported their defection, acknowledging that one could only attract the kind of reknown that would guarantee a proper income at the Salon and singled out Renoir's pragmatism in this respect. He wrote at some length in his reviews of that year's Salon about both the individuals, and the aim of the Impressionist group, describing the influence it had had on the French school.

They decided to leave the studio where painters have been cooped up for centuries, and go and paint in the open air, a simple enough action, the effects of which have been considerable. In the open air light is not constant, and consequently there are various effects which variegate colors and radically transform the appearance of things. This study of light . . . is what one terms impressionism, because a picture therefore becomes the impression experienced in front of nature.

However, according to Zola, 'the man of genius is not yet born' to put this theory into practice. Zola's advice to produce more finished works, seems to involve retaining some of the more superficial aspects of the impressionist style, and combining them with a subject-matter which comes closer to his own literary Naturalism, with its emphasis on modern life. Renoir may have risen to this implicit challenge when he began the *Luncheon* that summer.

The canvas is almost the same size as *The Ball at the Moulin de la Galette* (page 92) painted four years previously, and forms its conceptual pendant. Both are crowd scenes, composed of portraits of male friends consorting with female models, apparently enjoying leisure time. While the *Moulin* was an urban scene, however, the *Luncheon* is suburban. In the summers of 1879, 1880, and 1881 Renoir returned to favorite haunts on the river Seine and painted a number of scenes of boating (page 108) and oarsmen and their female companions. The site for this work has been identified as the terrace of the Restaurant Fournaise at Chatou overlooking the river.

Renoir appears to be wrestling with the problems posed by *plein-air* painting which Zola and other critics had noticed in the impressionist style. The device of the striped awning which frames the upper part of the painting may be an attempt to resolve the effect of fleeting sunlight and help unify the distribution of light and shade. The painting is more conventionally composed than the *Moulin*, with mirror images of the oarsmen in sleeveless shirts and straw boaters (the right-hand one was modelled by Caillebotte) and by the young woman with the dog who faces into the picture space. This model has been identified as Aline Charigot (1859-1915), Renoir's future wife. The work was sold by Durand-Ruel to the banker Balensi for 15,000 francs, though he may not have paid for it since it was back with the dealer by 1882.

Pink and Blue: The Cahen d'Anvers Girls, 1881

Oil on canvas
46⅝×29⅛ inches (119×74 cm)
Museu de Arte de São Paulo

Before setting off for Algeria in March 1881, Renoir seems to have put his affairs in order, and indicated to friends that he wished to have this work sent by proxy to the Salon that spring. It does not seem to have been displayed there, but the fact that its intended destination was the Salon is evident from the style adopted.

In 1880 Renoir had painted Louis Cahen d'Anvers' eldest daughter (page 110) and the following year the banker commissioned a double portrait of his two younger daughters, Elisabeth (1874-1945), who is dressed in blue, and Alice (1876-1965), wearing pink. Renoir has used the same style in painting the two younger girls that he had already used successfully for Irène —

a fairly crisp style for their faces and hands, and a much softer, more sensuous touch for their expensive lace frocks and satin sashes. The children's rather serious expressions, the emphasis given to their doll-like appearance and the interest given to texture is reminiscent of seventeeth-century paintings of children, particularly those by the Spanish painter, Velázquez. The extent to which Renoir may have compromised in these representations of the children of the *haute bourgeoisie* (and Madame Charpentier's children [page 98] are similar) is evident when we compare these works with the very much more relaxed poses and attire used in depictions of his own children (page 153).

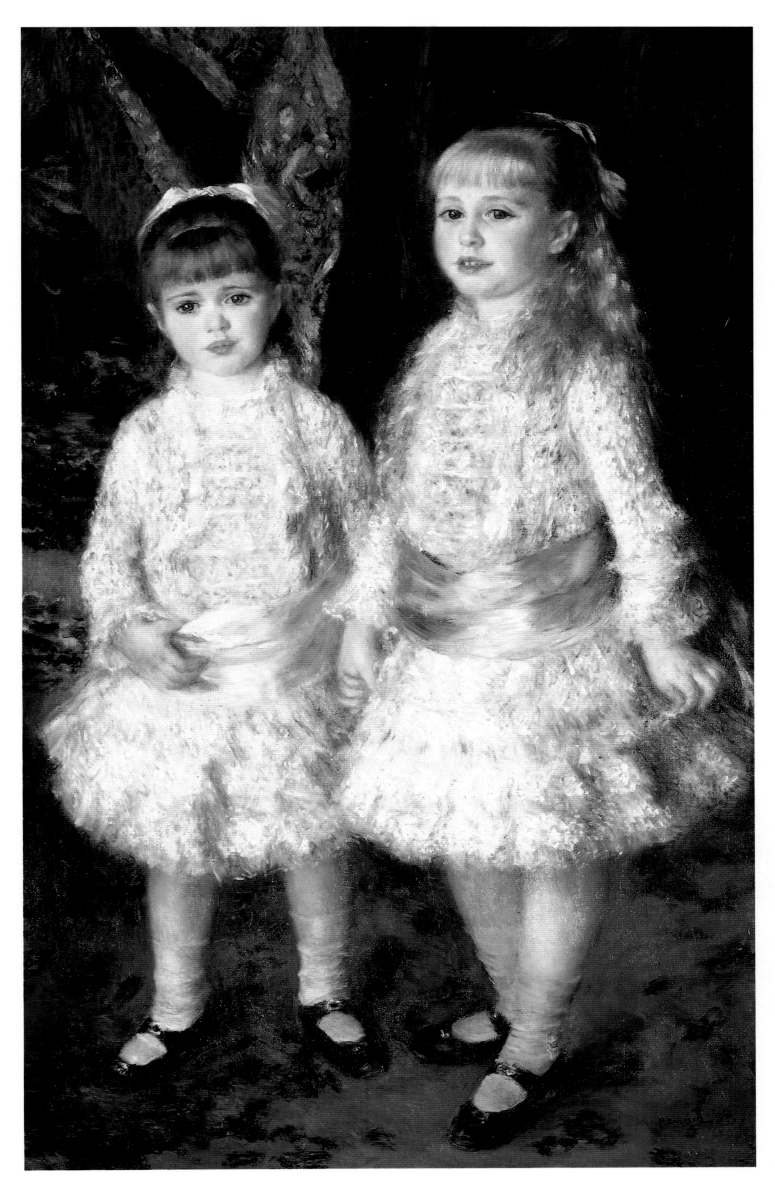

Venice: Piazza San Marco, 1881

Oil on canvas
25¾×32 inches (65.4×81.3 cm)
The Minneapolis Institute of Arts
John R Van Derlip Fund

Renoir's first proper stop in Italy in the fall of 1881 was in Venice, where he stayed from late October through to early November. While he was there, he painted at least eight works, all of them of famous landmarks such as the Grand Canal and the Doge's Palace, or of quaint customs such as gondoliers. That he should have chosen such sites suggests that the works were done with an eye to the market back in Paris. Durand-Ruel later bought some of his Venetian works and included two in the Impressionist exhibition of 1882 where they were fairly well-received. He does not seem to have acquired the *Piazza San Marco.*

Renoir has exploited the heavy gilding on the façade of San Marco and painted it in full sunlight. The yellows and oranges are juxtaposed with the mauves and blues in the shadow cast by the building on the righthand side of the picture space, which helps resolve the composition. The building seems to have been one of Renoir's favorites, and when he explained the theory of irregularity to his son he selected it as an example of fine architectural craftsmanship. According to Jean Renoir his father told him:

Don't be afraid to look at the great masters of the best periods. They created irregularities with regularity. Saint Mark's cathedral in Venice: symmetrical, as a whole, but not one detail is like another.

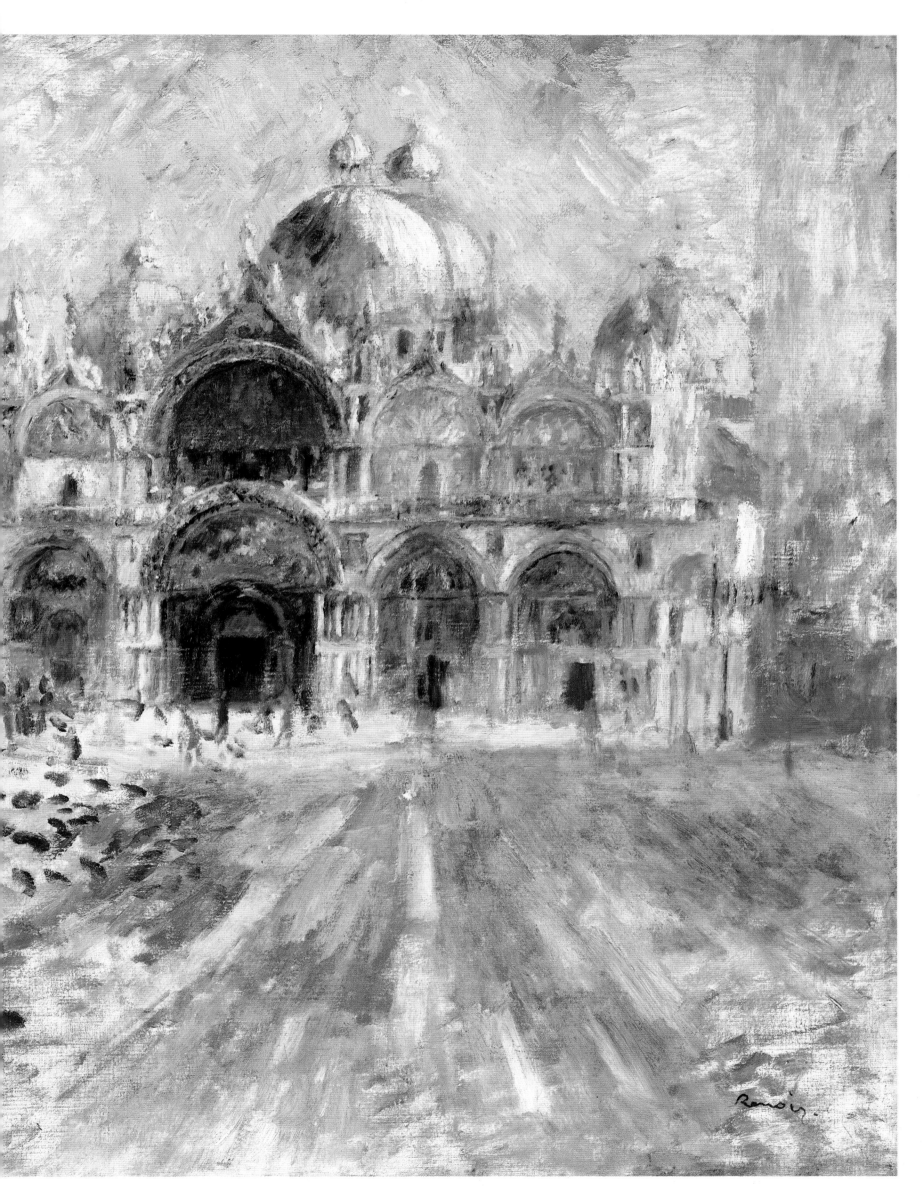

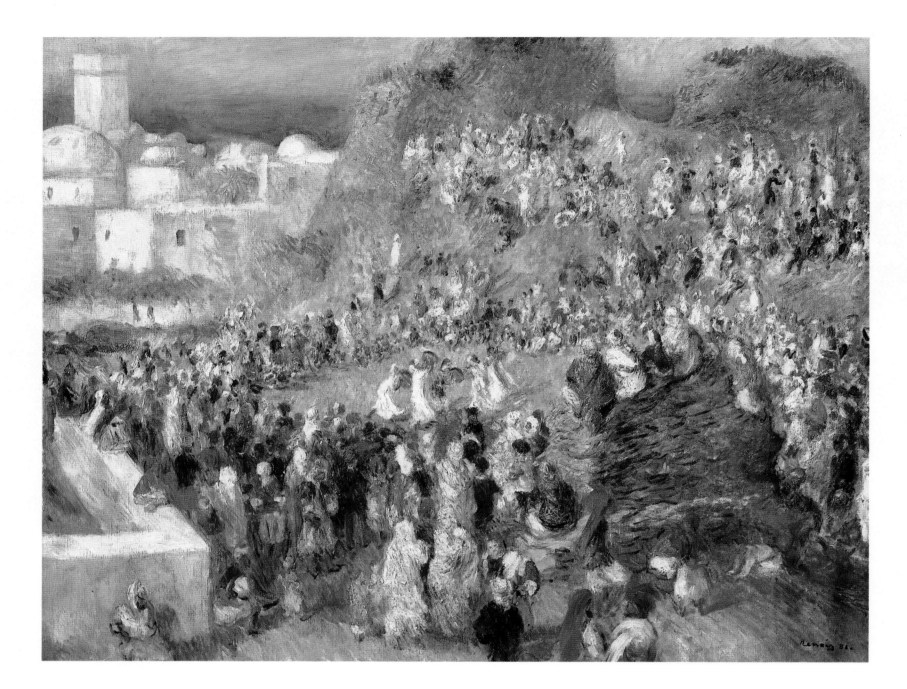

Arab Festival, Algiers, 1881

Oil on canvas
28¾×36¼ inches (73×92 cm)
Musée d'Orsay, Paris

Like a number of French artists throughout the nineteenth century, notably Delacroix (1798-1863) and Fromentin (1820-76), Renoir was fascinated by North African subject-matter, and what was seen as its exoticism. He had already painted a number of genre scenes (page 66) and portraits (page 62) in which he drew on a vision of the Orient which by the 1860s and 1870s had become somewhat clichéd. However, it was not until 1881, when his reputation and his income were secured, that he began a series of travels, which included two trips to the French colony. He does not seem to have been disappointed by what he found there, the picturesque subject-matter, the quality of the light and, as he wrote to his patroness Madame Charpentier, scenery which was 'incredibly rich and green, a dense, dense green.'

The subject has been identified in various ways. The figures may be worshippers visiting the mosque in the background who are clustered around a group of religious fanatics, engaged in some unidentified rite. Alternatively, their writhing movements may mean that they are performing a dance and entertaining the crowd. However, whatever they are doing they seem to be performing a ritual which is what would have attracted Renoir. The work is the only one of its kind in which he seems to have sought out deliberately exotic subject-matter. The handling, with its thick impasto, is reminiscent of Delacroix, although the emphasis on white is unusual. As he later said to Jean Renoir 'in Algeria I discovered white. Everything is white, the burnouses, the walls, the minaret, the road.'

Fruits of the Midi, 1881

Oil on canvas
20×25¾ inches (50.7×65.3 cm)
The Art Institute of Chicago
Mr and Mrs Martin A Ryerson Collection

After the constricting style he was forced to adopt for society portraits such as *Pink and Blue* (page 115), before leaving Paris in the spring of 1881, one can almost sense Renoir's relief as he indulged in a series of informal and unostentatious still lifes, such as *Fruits of the Midi* and *Onions* (Sterling and Francine Clark Art Institute, Williamstown, Massachusetts), both painted in 1881. The two works are very similar in conception and both use the same white-covered round table and indistinct, striated backgrounds. Both rely on the humblest of subject-matter, none of the hothouse flowers or references to *japonisme* which had characterized Renoir's earlier still lifes (pages 31 and 64).

The artist has concentrated on the jewel-like colors of the purple egg-plant, the capsicums, tomatoes, and pink-skinned onions and provided a counterpoint with the colored shadows on the table-cloth. To a Parisian the fruits may have been exotic, but they were commonplace in the Mediterranean, and the ingredients for the celebrated ratatouille.

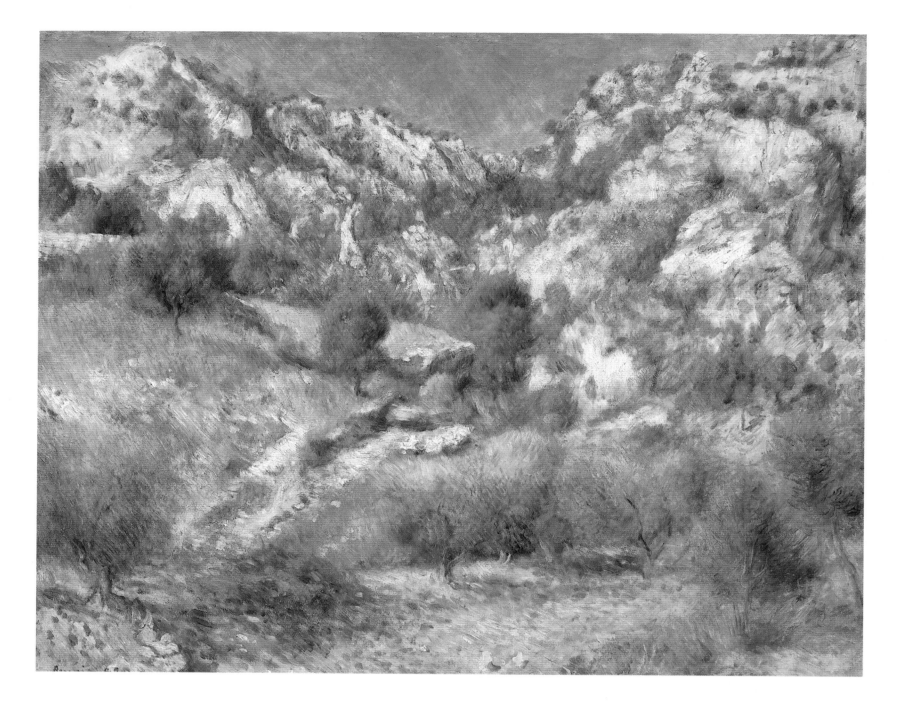

Rocky Crags, l'Estaque, 1882

Oil on canvas
26⅛×37⅞ inches (66.5×81 cm)
Museum of Fine Arts, Boston
Julia Cheney Edwards Collection

Towards the end of January 1882, Renoir returned to France from Italy and stopped off at Marseilles to paint with Cézanne. He stayed in the Hôtel des Bains in the village of L'Estaque, one of Cézanne's favorite spots throughout the 1870s and 1880s. The two painted a number of works together, and *Rocky Crags, L'Estaque* shares certain spatial similarities with Cézanne's *Mountains at L'Estaque* (page 21), painted around this time. This was an unusual motif for Cézanne to have adopted; his works at l'Estaque tended to look out across the Gulf of Marseilles, with the foreground pierced by the chimneys of the tile-factories that provided the main industry in the area. This view does not appear to have interested Renoir who positioned his easel with his back to the sea and painted the mountains which Emile Zola described in his short story *Naïs Micoulin*, published in 1884:

The village, its back against the mountains, is traversed by roads that disappear in the midst of a chaos of jagged rocks . . . Nothing equals the wild majesty of these gorges hollowed out between the hills, narrow paths twisting at the bottom of an abyss, and slopes covered with pines and with walls the color of rust and blood. Sometimes the defiles widen, a thin field of olive trees occupies the hollows of a valley, a hidden house shows its painted façade with closed shutters. Then again, paths full of brambles, impenetrable thickets, piles of stones, dried-up streams, all the surprises of a walk in the desert. High up, above the black border of the pines, is placed the endless band of the blue silk of the sky. . . . When this dried-out country gets thoroughly wet . . . it takes on colors . . . of great violence; the red earth bleeds, the pines have an emerald reflection, the rocks are bright with the whiteness of fresh laundry.

The vivid colors which Zola described are exploited to the full by both Cézanne, in his *Mountains at L'Estaque,* and Renoir in this painting.

Wagner, 1882
Oil on canvas
20⅞×18⅛ inches (53×46 cm)
Musée d'Orsay, Paris

The composer Richard Wagner was born on 22 May 1813 and died on 13 February 1883, the year after this portrait was painted. Renoir met him in Palermo on 14 and 15 January, at the time when he was finishing *Parsifal*, and he agreed to sit for the artist for 35 minutes. Despite the common anti-German feeling which existed in France as a result of the Franco-Prussian war of 1870-71, Renoir, like Bazille, was an enthusiast of Wagner's music. In a letter he wrote to a friend at this time, Renoir described the painting:

it would have been very good had I stopped sooner. But then my model lost some of his gaiety and became stiff. I paid too much attention to those changes. . . . Afterwards Wagner asked to see it and he said 'Ach! Ach! I look like a Protestant minister,' which is true.

The critic Gustave Geffroy gave a slightly different interpretation of the work in 1894:

Lips tightly closed, pink and childlike, the long narrow blue eyes gleaming in a broad placid face, enigmatic, ageless, like a placid and unforgettable Scandinavian god.

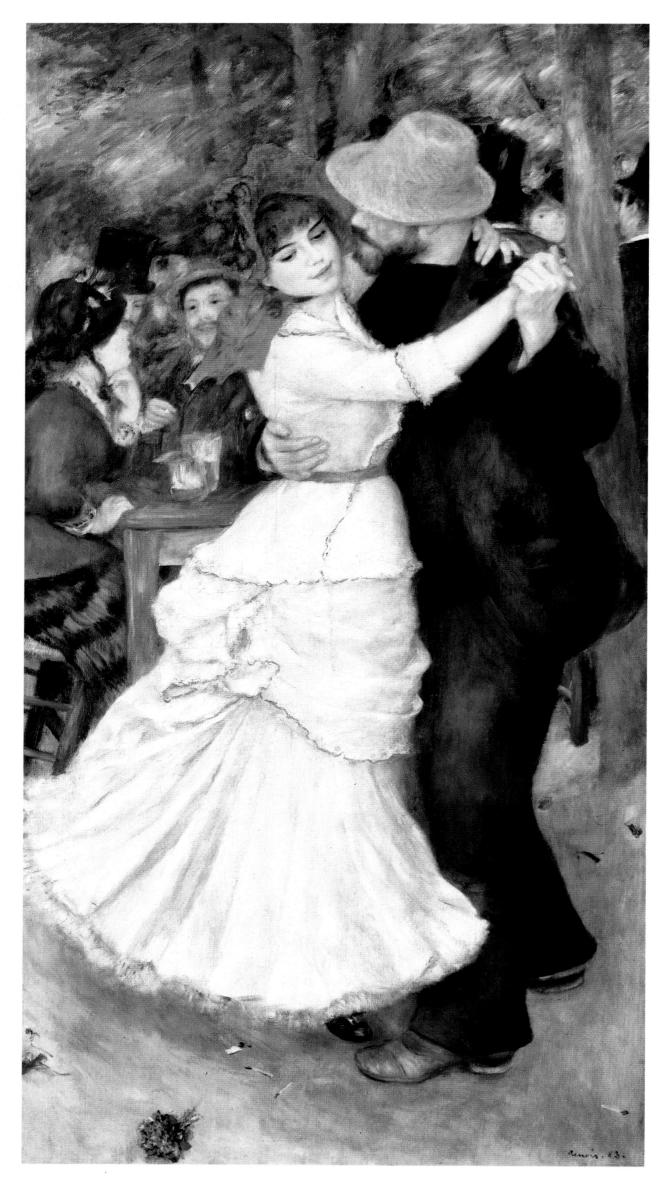

Dance at Bougival, 1883

Oil on canvas
71½×38½ inches (182×98 cm)
Museum of Fine Arts, Boston
Picture Fund Purchase

While staying at L'Estaque at the beginning of 1882, Renoir caught pneumonia and on his doctor's advice he went to Algeria to recuperate, spending March and April there. It was only on his return to Paris in the summer that he could start to put into practice some of the lessons he had learned in Italy in the winter of 1882-83. *Dance at Bougival* along with two other works which treat the same subject of a couple dancing, *Dance in the City* (page 124) and *Dance in the Country* (page 125) were his first large-scale works in which he seems to have been attempting to work in a more decorative way, in emulation of the frescoes by Raphael and those from Pompeii which he had seen in Italy, and which he had remarked on in his letters home.

Begun in the summer or fall of 1882, the three paintings seem to have been worked on simultaneously, though never consciously planned as a group. *Dance at Bougival* was of a slightly different format to the other two, and therefore set apart from

them. By the following spring the works were completed and the dealer Durand-Ruel was so pleased with this work that he shipped it to London, for an exhibition that was held there from April to July 1883. The woman modelling for *Dance at Bougival* was Maria-Clémentine Valadon (1867-1938), who changed her name to Suzanne Valadon after 1900. She later became a painter herself, although she is probably best remembered as the mother of the artist Maurice Utrillo (1883-1955). It is sometimes suggested that Renoir was his father, but he had probably finished using her as a model for this work by the time she became pregnant, since her son was not born until December 1883. The man with whom she is dancing, sometimes identified as Renoir's brother Edmond, is more likely to have been the painter Paul Lhote who had accompanied him on his first trip to Algeria and who appeared wearing a straw hat in the upper right corner of *The Luncheon of the Boating Party* (page 112).

123

Dance in the City, 1883

Oil on canvas
70⅞×35½ inches (100×90 cm)
Musée d'Orsay, Paris

While *Dance at Bougival* (page 122) shares the same subject-matter as *Dance in the Country* (page 125) and *Dance in the City*, the three works were not conceived as a trio. Rather, the latter pair seem like a refinement of some of the ideas used in *Dance at Bougival*. These two works were painted on the same size of canvas, and were clearly intended to be regarded as a pair from the outset. Their unusual format contributes to their decorative quality (which had concerned Renoir in the *Dance at Bougival*) and the references that exist between the two works heighten their interdependency. In each, we have a couple dancing in what appears to be the same position, only the spectator's viewpoint has shifted. *Dance in the City* seems to depict a fashionable dancing hall in Paris, with a smart clientele. *Dance in the Country*, on the other hand, represents an outdoor scene (a restaurant terrace to judge from the figures in the background) in a much more suburban setting, which is patronized by a less formal social class than their chic city counterparts. The couple here seem to be sufficiently at ease to have abandoned their dessert and liqueur on the table in the background, and the straw boater in the foreground. The woman is using a fan and it is presumably a warm summer's evening, whereas *Dance in the City* may well represent a winter ball.

Once again, Renoir used Lhote and Valadon as models for this work. Technically, it seems to have developed out of the *Dance at Bougival*, since its decorative quality is more resolved. The rather incidental and distracting background figures which appeared in *Dance at Bougival* have been substituted by a cool white background wall and large decorative palm. Consequently, the figures present a sharply delineated silhouette, and the the contrast provided by their black and white costumes is particularly marked.

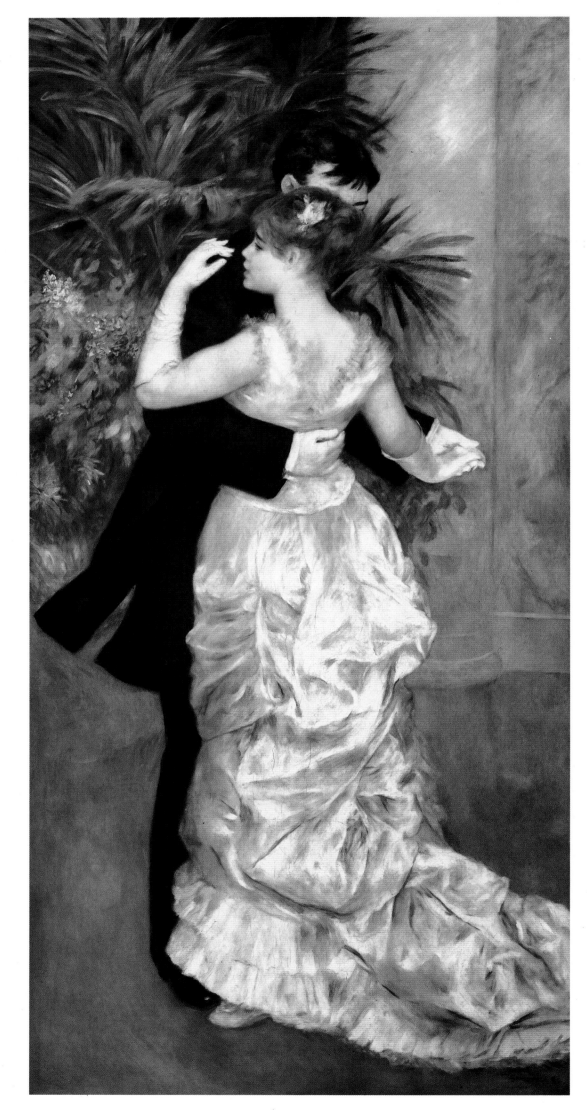

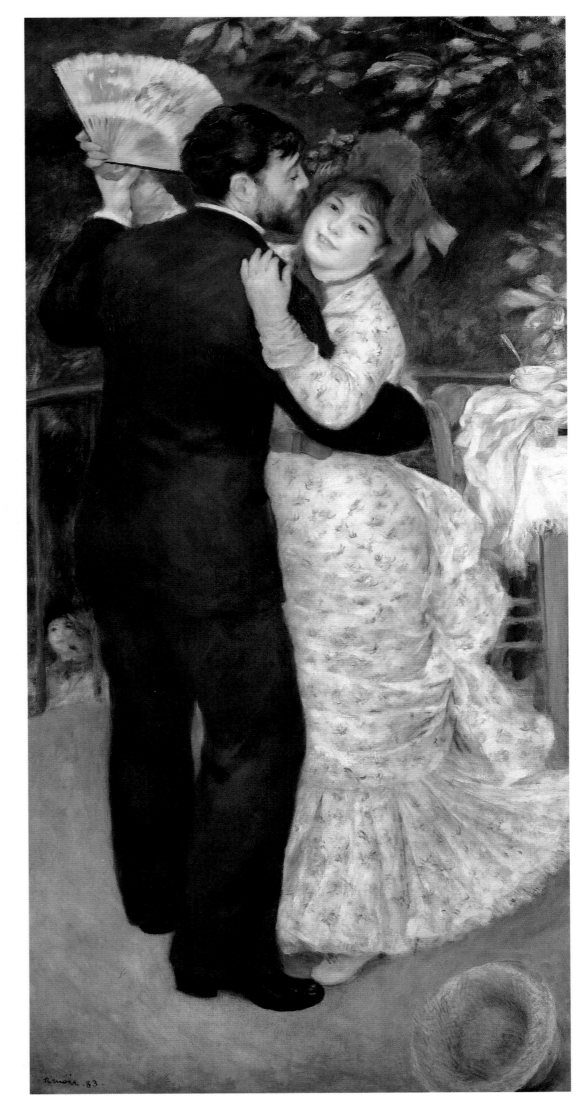

Dance in the Country, 1883

Oil on canvas
70⅞×35½ inches (180×90 cm)
Musée d'Orsay, Paris

Once again, Paul Lhote has modelled for the male dancer, but Valadon has been replaced by Aline Charigot, Renoir's lover and future wife. While the pose struck by the couple in this work is virtually identical to that in *Dance in the City* (page 124), in fact there is a much greater sense of intimacy suggested between the two figures here. The elegant city dancers appear proper and rather aloof, while the different angle from which the figures have been viewed in *Dance in the Country* means that the woman appears physically and psychologically closer to the spectator. That Renoir may have been emotionally involved with both female models at this time may be no coincidence; and may explain why he has shown Aline Charigot as open and flirtatious. Certainly, he has found qualities in the country girl which were lacking in her city counterpart. These works constitute some of his final attempts at depicting genre scenes which were identifiably urban or suburban, increasingly the women he was to paint were of this winsome, rather rustic type.

It was only in August 1891 that Durand-Ruel acquired all three *Dance* pictures. He paid Renoir 7500 francs for each of them, a very high price which demonstrates that these works were regarded as important and pioneering of the new style which began to emerge after Renoir's trip to Italy.

Moulin Huet Bay, Guernsey, 1883

Oil on canvas
11½×21¼ inches (29×54 cm)
National Gallery, London

In September 1883 Renoir visited the Channel Islands of Jersey and Guernsey, where he stayed for a month and painted a number of landscapes, including this one with the distinctive Cradle Rock on the right-hand side and Les Tas de Pois d'Amont in the background. He wrote of it: 'one would imagine oneself much more in a landscape by Watteau than in reality.'

By the 1880s, after his trip to Italy, Renoir was concerned with finding much

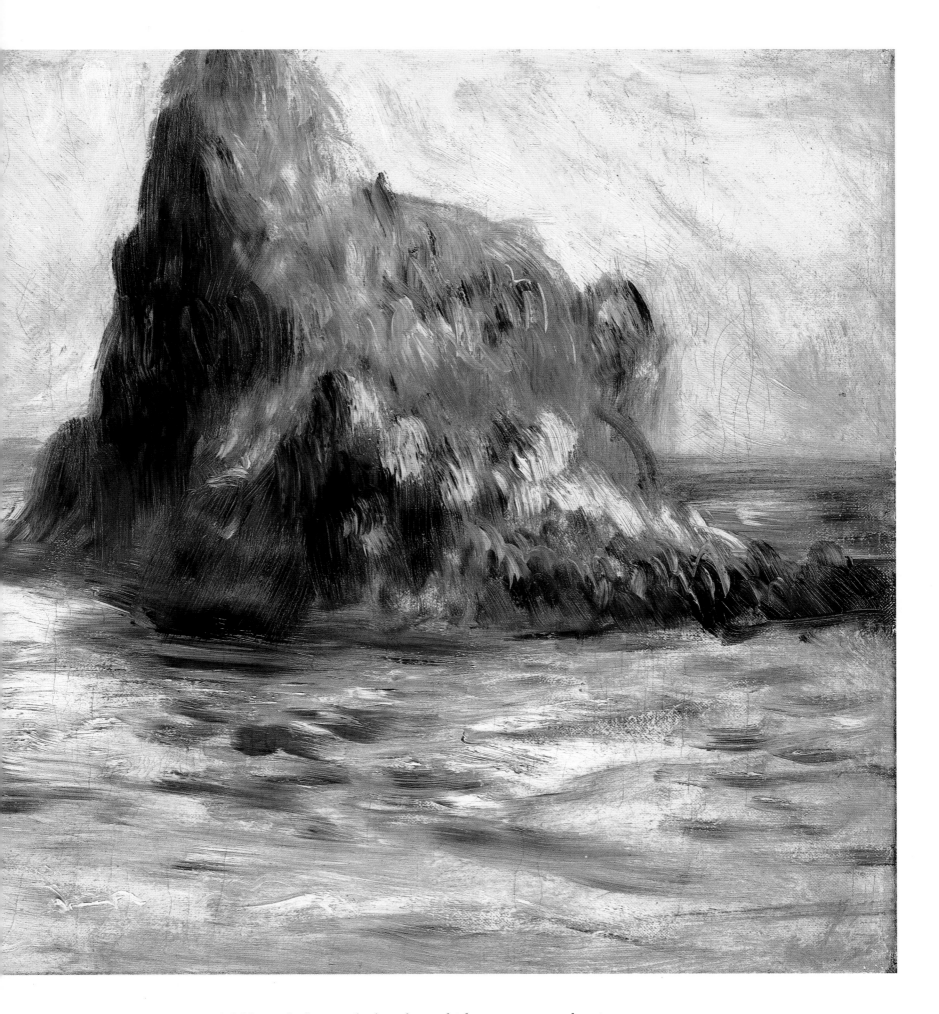

more timeless images and deliberately distanced himself from representations of city life which had concerned him earlier in his career, and which he had explored for the last time in the *Dance* pictures (pages 124 and 125) completed that same year. In Guernsey he found the perfect subject for the rural idyll which was to occupy him increasingly in his later work. By the end of September there were few tourists, and there were none of the facilities such as bathing huts which were commonplace in popular French bathing resorts on the river Seine or on the Channel coast. That he should have described this landscape as reminiscent of that of the French eighteenth-century painter Watteau, reveals the extent to which he was aligning himself with the highly idealized *fêtes galantes*, a tendency his friend Rivière had already found in his works of the mid-1870s, such as *The Swing* (page 91).

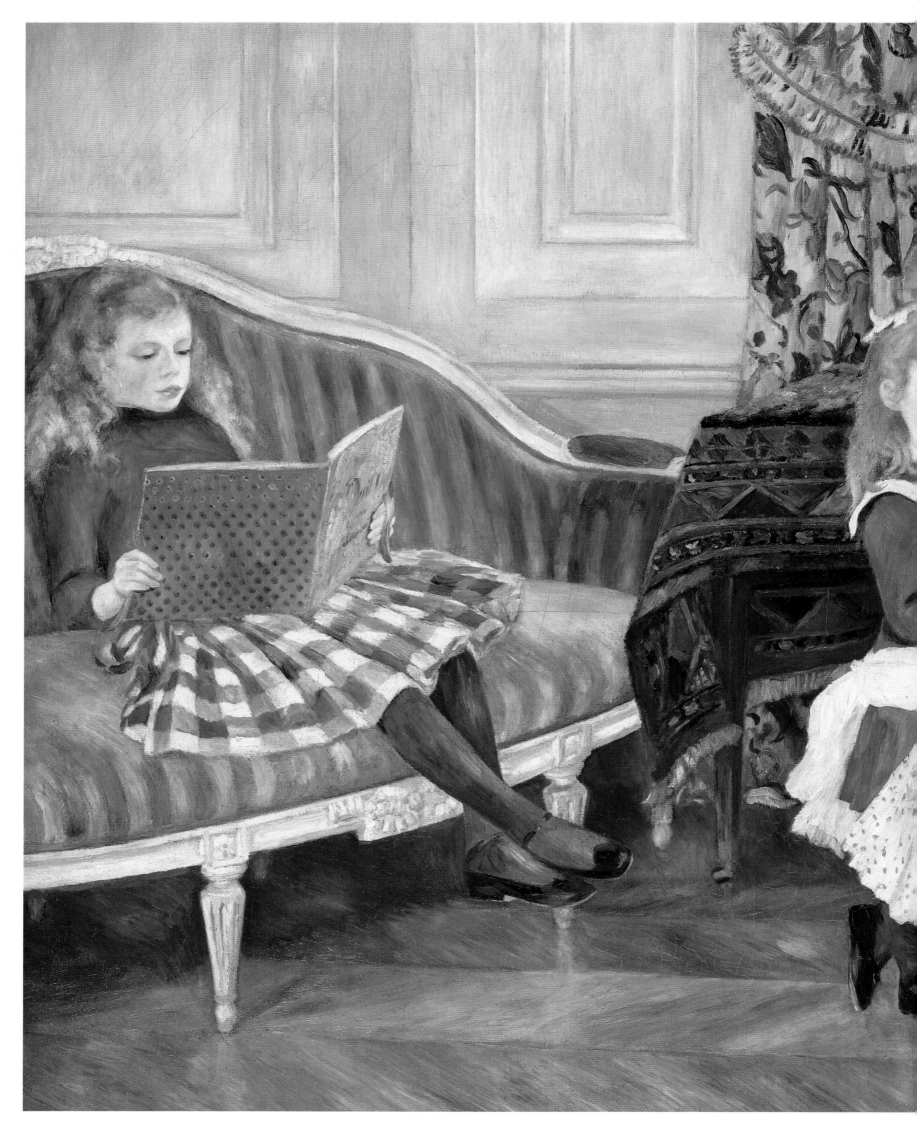

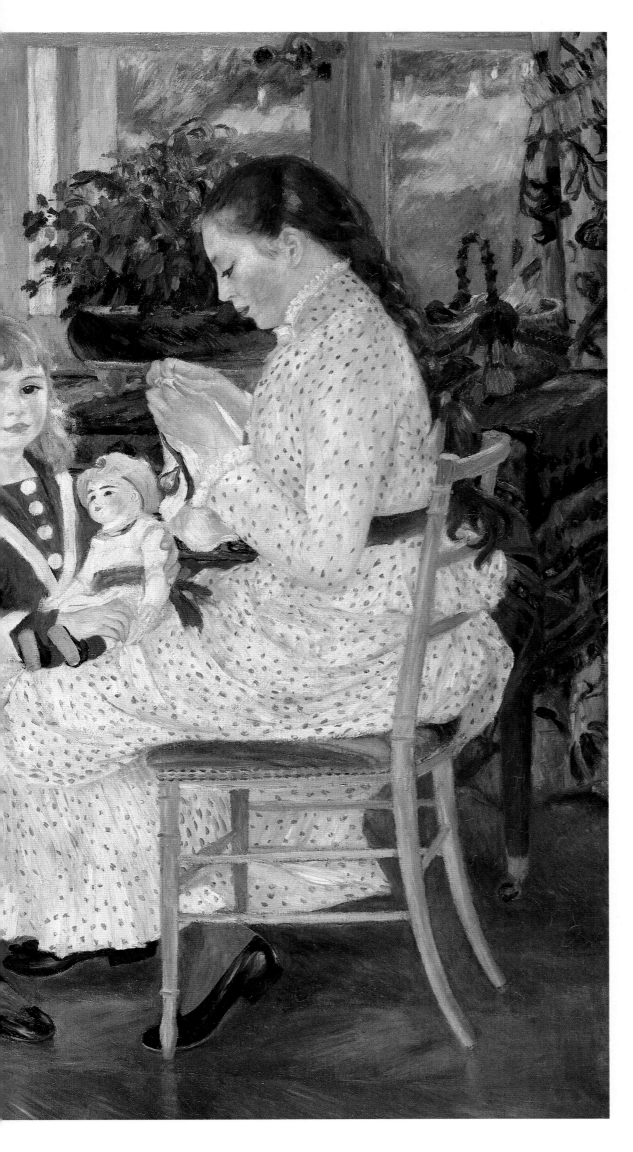

The Children's Afternoon at Wargemont, 1884

Oil on canvas
51⅛×67 inches (130×170 cm)
Staatliche Museen Preußischer
Kulturbesitz, Nationalgalerie, Berlin

Renoir had met the banker and diplomat
Paul Berard (1833-1905) at Madame Char-
pentier's Salon in 1879, the year in which
he had exhibited her portrait at the Salon.
Since then, the artist had been a frequent
guest at the Berard home at Wargemont in
Normandy on the Channel coast, where he
had painted a number of works for his
patron. *The Children's Afternoon at Warge-
mont* is by far the most ambitious work,
which rivals *Madame Charpentier and her
Children* (page 98) in scale and conception,
although the composition and handling
has changed quite drastically in the inter-
vening years, partly as a result of his trip to
Italy.

The work was painted in the early sum-
mer of 1884 and depicted Berard's three
daughters. The eldest, Marthe, was four-
teen and is shown attending to her needle-
work. Her younger sister, Margot, who is
reading, was ten. The youngest child,
Lucie, playing with her doll, was four. Yet
despite this childish activity, the work is
remarkably frozen in appearance, and the
children are arranged in a frieze-like com-
position along the frontal plane of the pic-
ture-space. The use of clearly-defined sil-
houettes (especially Marthe's profile)
seems to have developed out of works such
as *Dance in the City* (page 124), in response
to the decorative frescoes Renoir had seen
in Italy. This effect is heightened by the
clear colors and the lack of chiaroscuro
modelling. The features of the children are
rather stylized, and establish a pattern
which he was to use in later representa-
tions of children. The oval face, almond-
shaped eyes and lack of internal modelling
was typical of much later works such as
Claude Renoir as a Clown (page 158).

The theme of children occupying them-
selves in worthwhile tasks had been a favo-
rite of eighteenth-century artists like Char-
din (1699-1779), who liked to depict the
benefits of education, often using an older
girl in the painting as a 'little mother'
figure, presiding over younger children, in
much the same role as that assigned to
Marthe Berard. Renoir was said to dislike
Chardin, preferring his more fanciful
Rococo peers.

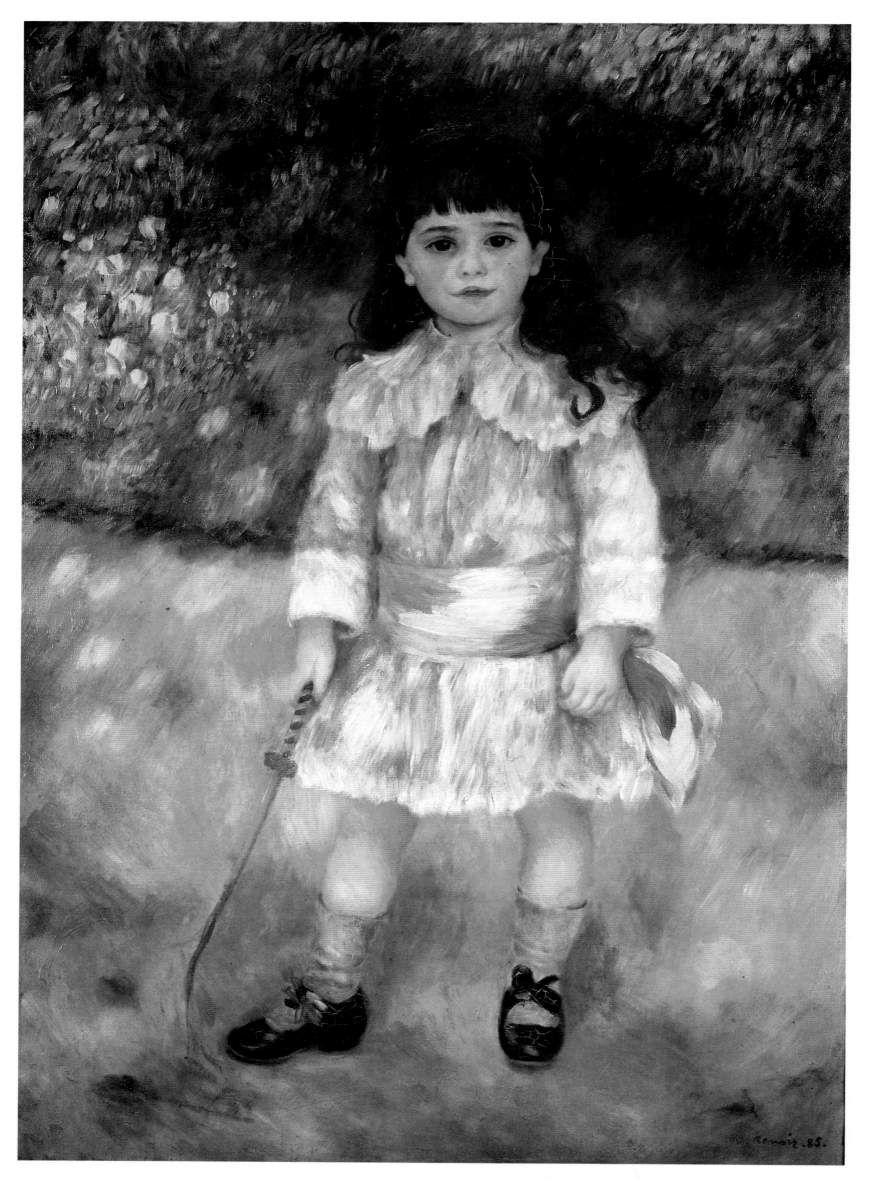

Child with a Whip, 1885

Oil on canvas
41⅜×29½ inches (105×75 cm)
State Museum, Leningrad

This portrait is of Etienne Goujon (1880-1945), whose father had commissioned portraits of all four of his children from Renoir. The work forms a pendant to *Girl with a Hoop* (National Gallery of Art, Washington DC). Although working within the conventions governing commissioned portraits, the work is quite different from contemporary examples such as *The Children's Afternoon at Wargemont* (page 130), which is claustrophobic and domestic in mood. To paint *Child with a Hoop*, Renoir has favored a garden setting, and the effect is of dappled sunlight streaming through foliage overhead. The handling bears a similarity to that of Cézanne with whom Renoir painted in the summer of 1885. The parallel diagonal hatching which covers the surface of the canvas, but is most evident in the grass and bushes in the background, resembles Cézanne's so-called constructive stroke, which he had developed at the end of the 1870s, and is visible in works such as *The Castle at Médan* (page 21). Only the hands and face are spared this consistent touch, and the highly stylized features conform to the type established in *The Children's Afternoon at Wargemont*.

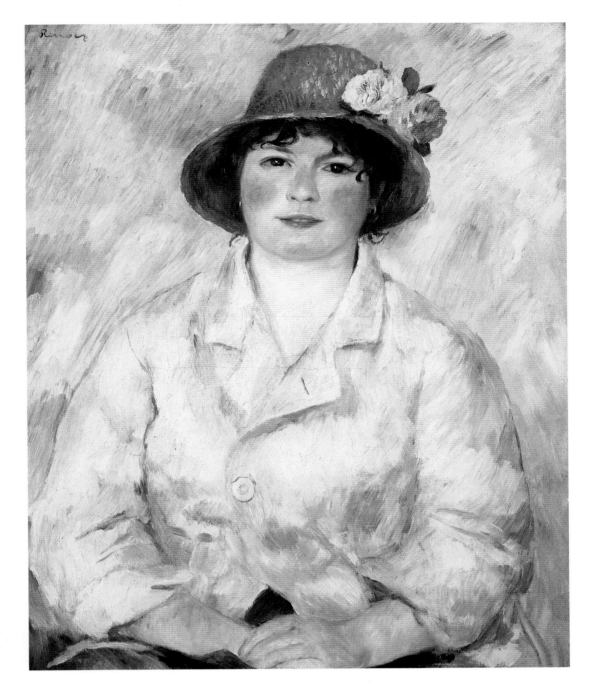

Portrait of Aline Charigot, c. 1885

Oil on canvas
25½×21¼ inches (65×54 cm)
Philadelphia Museum of Art

Aline Charigot was born in Essoyes, in Champagne on 23 May 1859, but later moved to Paris to live with her mother, and earn her living as a dressmaker, a common profession for young women in the capital. She met Renoir in the summer or fall of 1880, and agreed to pose for him, making her artistic début in the ambitious *Luncheon of the Boating Party* (page 112), painted in 1880-81. In this work she appeared as a *grisette*, a fashionable young working-class girl, at home in her suburban environment. In this portrait, she appears in quite a different role, presumably one closer to her actual appearance. The disparity between Aline the model and Aline the woman is made clear in a letter

Berthe Morisot wrote shortly after their first meeting: 'I shall never succeed in describing to you my astonishment at the sight of this ungainly woman whom, I don't know why, I had imagined to be like her husband's paintings.'

It is quite possible that the work was painted in Essoyes, to which Aline Charigot took Renoir for the first time in the fall of 1885, after the birth of their first son Pierre in March that year. Her outfit is less concerned with elegance than those worn in the earlier paintings for which she had posed, and may betray her rural surroundings. As Aline adapted to motherhood and married life (after 1890) it was in this guise that she appeared in Renoir's works, and her ample curves were emphasized. Towards the end of her life she suffered from diabetes and general ill-health, exacerbated by her obesity. She died in Nice on 27 June 1915.

La Roche-Guyon, c. 1885

Oil on canvas
18½×22 inches (47×56 cm)
Aberdeen Art Gallery

This vibrant landscape was painted at La Roche-Guyon, a village on the river Seine to the north west of Paris, where Renoir, Aline and Pierre spent much of the summer of 1885. Claude Monet had recently moved to Giverny which was just a few miles away; and for a month from June to July, the Renoirs were joined by Cézanne, Hortense Fiquet, whom he was to marry the following year, and their thirteen-year-old son. The influence of Cézanne's handling is evident in this work, and allows us to date it with a degree of probability to that summer.

Cézanne's so-called constructive stroke which he had pioneered in works like the *Castle at Médan* (page 21), with its consistent, diagonal brushwork which has the effect of unifying near and far and emphasizing the surface qualities of the painting, had been used by Renoir on a number of occasions (for example page 130) but *La Roche-Guyon* is his most conscious attempt to emulate the other artist's work. Although the effect is of a very ambiguous spatial relationships between the different objects within the picture space (are those blue hills in the upper part of the picture space?) the use of complementaries and color modelling save the work from appearing two-dimensional.

After the trip to Italy, Renoir was searching for solutions to how to order his picture space, and turned to a much more systematic handling of the surface of his paintings. It was Cézanne, rather than his old ally Monet, to whom he turned for inspiration at this time.

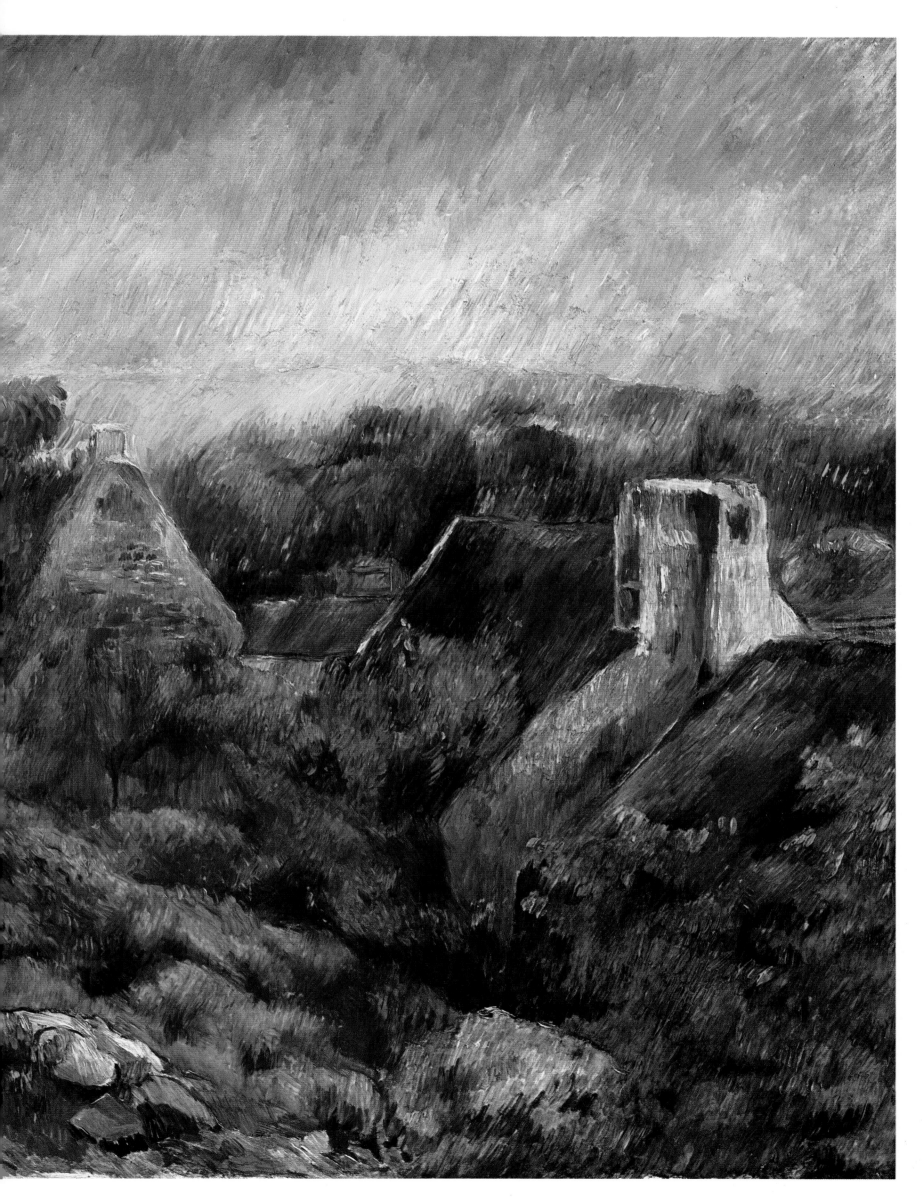

133

The Umbrellas, 1881-82 and 1885-86

Oil on canvas
70⅞×45¼ inches (180×115 cm)
National Gallery, London

Renoir began *The Umbrellas* before travelling to Italy and only completed it in the light of the discoveries made on that important trip. The canvas was conceived of as a multi-figure, large-scale studio painting, quite different from the much smaller, more intimate landscapes with which he was occupied before the trips to Italy, such as *The Skiff* (page 108). In that respect, it is the natural successor of *The Ball at the Moulin de la Galette* (page 92). However, even before going to Italy, where it was the large-scale decorative works, with their insistence on a linear scaffolding as the basis for a successful painting that had so impressed him, Renoir had begun to worry about the logical implications of the impressionist style, which could result in a total disintegration of the picture surface. Recognizing these limitations, he seems to have turned to large ambitious works, carefully planned and executed in the studio, like *The Umbrellas*. Before going to Italy, he completed the two foregoround children and the woman holding an umbrella who stands behind them. They are dressed in the latest fashion of 1881.

On his return, Renoir turned again to the canvas, and added the other figures and the framing arcs of the umbrellas. The difference in style is quite dramatic. The features and costumes of these later additions are much more crisply treated, and the palette is discernibly different. While the blues used in the earlier right-hand dresses are mixed with yellows, those on the left-hand side are much more somber, and they have been modelled with crimson. The left-hand woman and the man behind, who shelters her with his umbrella, are tightly locked together in the manner of the couple in *The Dance* works (pages 124 and 125). This later woman is dressed in fashions conspicuously different from the earlier figures, and allows a date of no earlier than 1885 to be assigned to this portion of the canvas. A comparison of the faces of the two forward-facing adult women demonstrates the difference in handling. The earlier woman is treated with the soft feathery style found, for example, in *Place Clichy* (page 111), while the other woman has the stylized, more clearly delineated features that Renoir had used in *The Children's Afternoon at Wargemont* (page 128) of 1884.

The Umbrellas occupies an important place in Renoir's oeuvre. It shows him grappling with the problems of the impressionist style and the effect the Italian trip had on his technical development. Given the very apparent differences between the two halves, in terms of both handling and the inconsistencies of dress, it is not surprising that when Durand-Ruel purchased it from the artist in 1892, he only paid 1400 francs for it, a very small sum given the size of the canvas, and the amount of labor that had gone into it, and very much less than the 7500 francs he paid for the comparable *Dance in the Country* (page 125) at about the same time. This, and the fact that the dealer did not exhibit it in any of Renoir's major shows, suggests that it was regarded as an experimental piece.

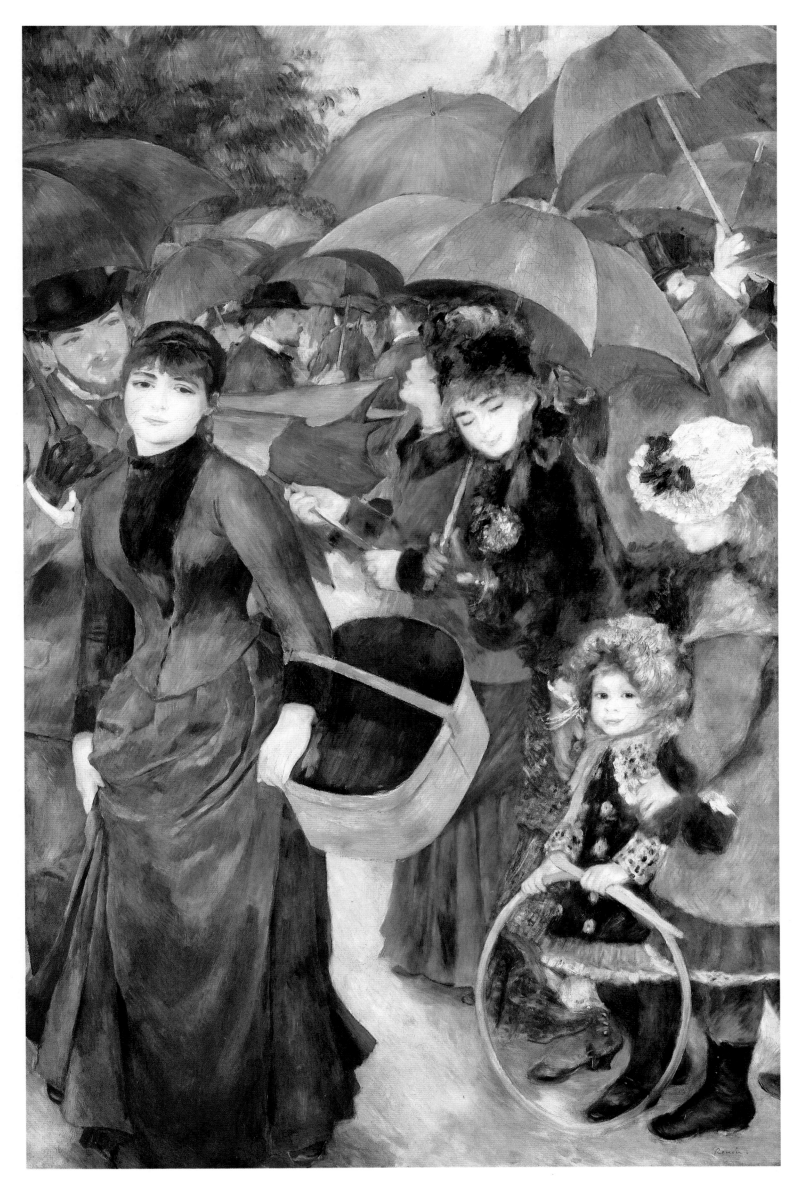

Bathers, 1887

Oil on canvas
46⅜×67¼ inches (117.8×170.8 cm)
Philadelphia Museum of Art
Mr and Mrs Caroll S Tyson Collection

When the *Bathers* was shown at Georges Petit's gallery in May 1887, the title in the catalogue accompanying it was *Baigneuses; essai de peinture décorative*, indicating that Renoir wished it to be recognized that its prime purpose was decorative and that it was to be regarded as experimental in nature. However, it had occupied Renoir for a long time, from his first working on sketches and studies related to it at the end of 1884, until its exhibition in 1887. Its conception properly dates from the time of his trip to Italy and forms the climax of the 'dry' style which was the outcome of his researches following the contact with the monumental, decorative wall-paintings by Raphael and from Pompeii which he had seen there.

For over twenty years Renoir had painted very few nudes, and those were mostly demonstrations of his virtuosity with the genre for the Salon (pages 39 and 59). However, along with his reassessment of technique and style with resulted from his Italian trip, he seems to have recognized the ability of the nude to express the universal, timeless values that he sought in his life as much as his art, and which were the result of changes taking place in his personal life at this time. His good friend Berthe Morisot wrote in her journal on 11 January 1886:

Visit to Renoir . . . he is a draftsman of the first order; it would be interesting to show all these preparatory studies for a painting to the public, which generally imagines that the Impressionists work in a very casual way. I do not think it possible to go further in the rendering of form; two drawings of women going into the water I find as charming as the drawings of Ingres. He said the nude seemed to him to be one of the essential forms of art.

Aline Charigot and Suzanne Valadon posed for the foreground figures, but the nudes' appearance depends on a number of sources. The interlocked, unstable pose derives from a bas-relief sculpture at Versailles by Girardon (page 20). Their monumentality and the generally high key is influenced by the frescoes which Renoir had seen in Italy. The crisp, static nudes of Ingres, as Berthe Morisot quite rightly observed, influenced the final work, but

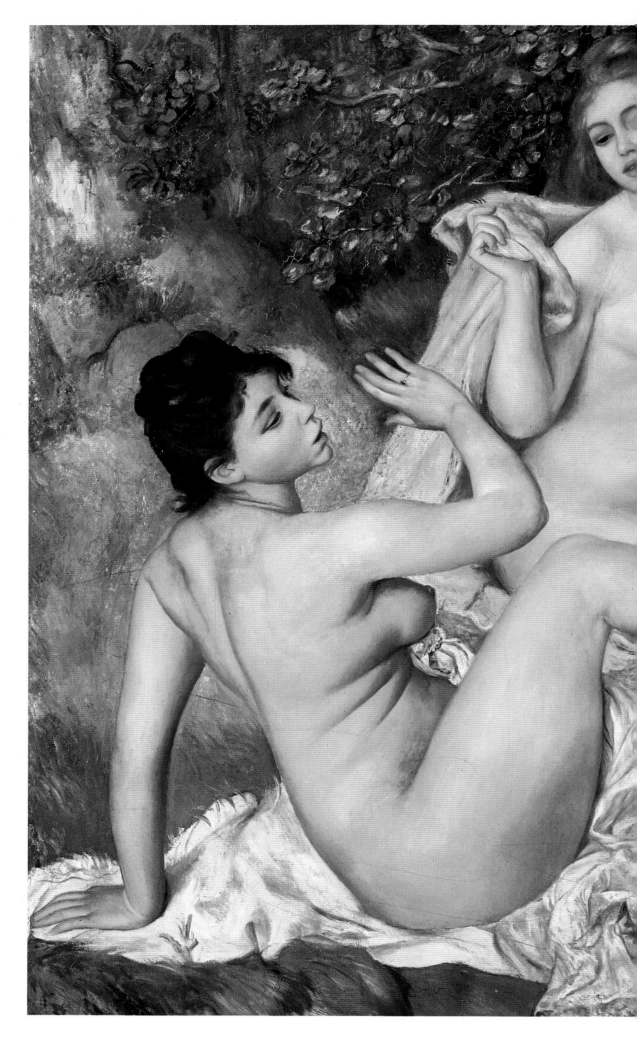

then there were equally overtones of Salon nudes, such as the highly successful *Birth of Venus* (page 10) by Cabanel in the general mood of frozen sensuality. At the same time, a fairly systematized impressionist style in the background landscape and figures is evident. Not surprisingly, this apparent eclecticism infuriated some of Renoir's former supporters. As Camille Pissarro wrote to his son Lucien, when he saw the work on display at Petit's: 'I do not understand what he is trying to do, it is not proper to want to stand still, but he chose to concentrate on line, his figures are all

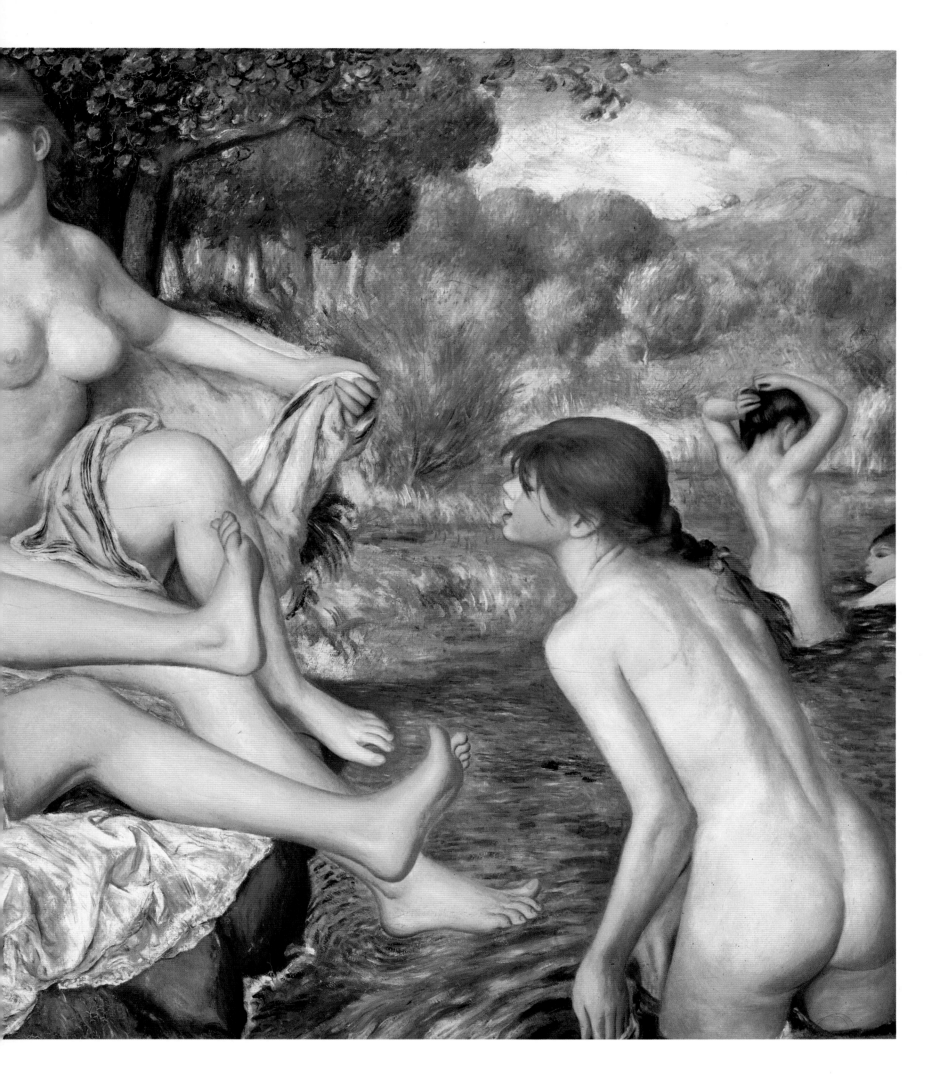

separate entities, detached from another
without regard for color.'

The work seems to have been greeted
with incomprehension by most who saw it.
It remained unsold for two years until it
was bought by Jacques-Emile Blanche
(1861-1942) for a mere 1000 francs.

Little Girl with a Sheaf of Corn,
1888

Oil on canvas
25½×21¼ inches (65×54 cm)
Museu de Arte de São Paulo

The *Bathers* (page 136) was the highpoint of the 'dry' style which preoccupied Renoir after his return from Italy. The critical incomprehension and the lack of financial success which accompanied it meant that he had to find a way of synthesizing its monumental, timeless and, above all, structured qualities with the more sen-

suous handling and color, which had characterized the impressionist style. In *Little Girl with a Sheaf of Corn* Renoir attempts to reconcile these two strands in his art. The systematic brushwork and lush color that he had used in the landscape of *La Roche-Guyon* (page 132), which derived from a close analysis of Cézanne's work, is

Montagne Sainte-Victoire,

c. 1888-89

Oil on canvas
20⅞×25¼ inches (53×64⅛ cm)
Yale University Art Gallery, New Haven,
Connecticut
The Katharine Ordway Collection

evident here, but is combined with a time-less vision of the little harvester who stands against a cornfield, rather than depicted working in it. In that respect, he has re-tained the decorative aspects of the *Bathers*.

The work was bought in 1892 by Durand-Ruel who entered it in his stock ledger as *Little Girl Carrying Flowers*. However, her basket appears to contain corn from the field behind her rather than flowers. Moreover, the theme of the female harvester, often a peasant ingénue, had been a popular one at the Salon and it seems more likely that Renoir has chosen this traditional subject, which would have conformed to his desire for timeless sub-jects, suggesting an existence in which man is in harmony with the landscape. The contrast between the child and the bounty of nature would have typified this more tellingly than had she been carrying a bunch of flowers.

At the end of the 1880s Cézanne intro-duced Renoir to the motif of the mountain of Sainte-Victoire outside Aix-en-Provence, which was the subject of dozens of Cézanne's works from the 1880s until the end of his life in 1906. There is a second version of the *Montagne Saint-Victoire* (in the Barnes Foundation, Merion Station,

Pennyslvania) dated 1889, probably painted when Renoir was staying in a house he rented from Cézanne's brother-in-law. This painting may date from the same time, or from the previous year when the two artists worked together.

The parallel diagonal hatchings which Renoir appropriated from Cézanne's working procedure and used in works such as *La Roche-Guyon* (page 132) are evi-dent in this work but in a less consistent way than that adopted by Cézanne. The strokes are used to mold the windswept foreground trees to give them a sense of rich texture, rather than as a device to emphasize the surface pattern of the paint-ing, as Cézanne had done.

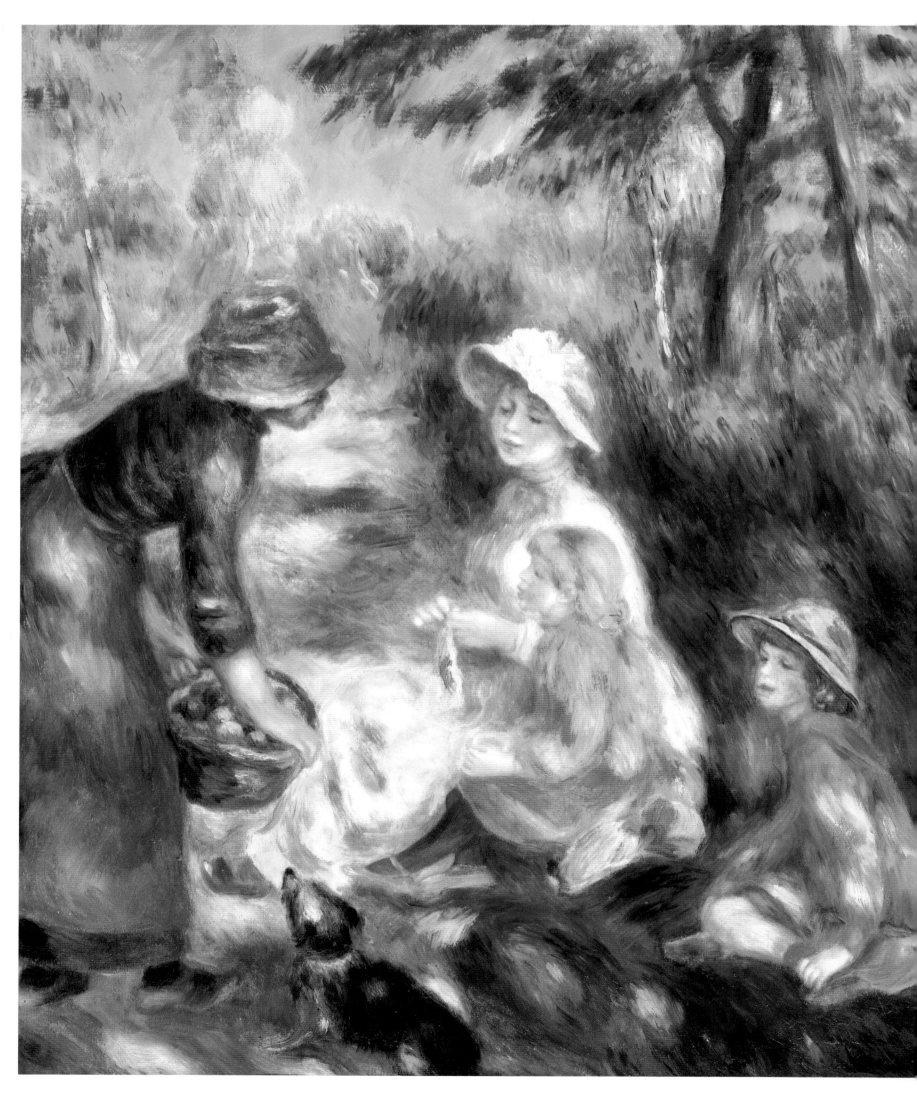

The Apple-Seller, c. 1890

Oil on canvas
26×21¼ inches (66×54 cm)
Cleveland Museum of Art
Bequest of Leonard C Hanna Jr

The Apple-Seller is one of three versions, and we may therefore conclude that this it was an important theme for the artist. The figures in the work have been identified as Madame Renoir (Aline Charigot had married Renoir in the spring of 1890, five years after the birth of their first child), her son Pierre, and Renoir's nephew Edmond (born 1884). However, despite the practice of little boys having long hair until starting school, this child is probably a girl. The 'apple-seller' may be Gabrielle Renard (1879-1959) who was to join the Renoir household in 1894. If so, the work must have been painted in Aline Charigot's native Essoyes. The apples allow us to date the work to the fall.

If the 'apple-seller' herself is Gabrielle Renard, then her role is very similar to that she was assigned in *The Artist's Family* (page 24) of 1896. Madame Renoir and the two children appear to be relaxing in the countryside, wearing clothing that would identify them as belonging to the leisured middle-classes. They are joined by a woman, wearing rustic clothing – a straw hat, apron, and clogs – who profers a large basket of apples. The contrast between the woman who lives and works in the countryside and those who use it as a site for their leisure is masked by an adulterated Cézannesque touch, which elides any social divisions, and clothes the harmonious vision of nature in a web of soft-focus. This vision of Madame Renoir is in marked contrast to the sturdy peasant woman whom Renoir had depicted on their first trip to Essoyes (page 131) in 1885. The difference in approach may stem from Renoir's social aspirations at this point in his career. In the fall of 1890, when her husband painted *The Apple-Seller*, Aline Charigot became pregnant for a second time, although she later miscarried. Their marriage earlier that year, and the expected addition to their family, may have been responsible for consolidating Renoir's conservatism.

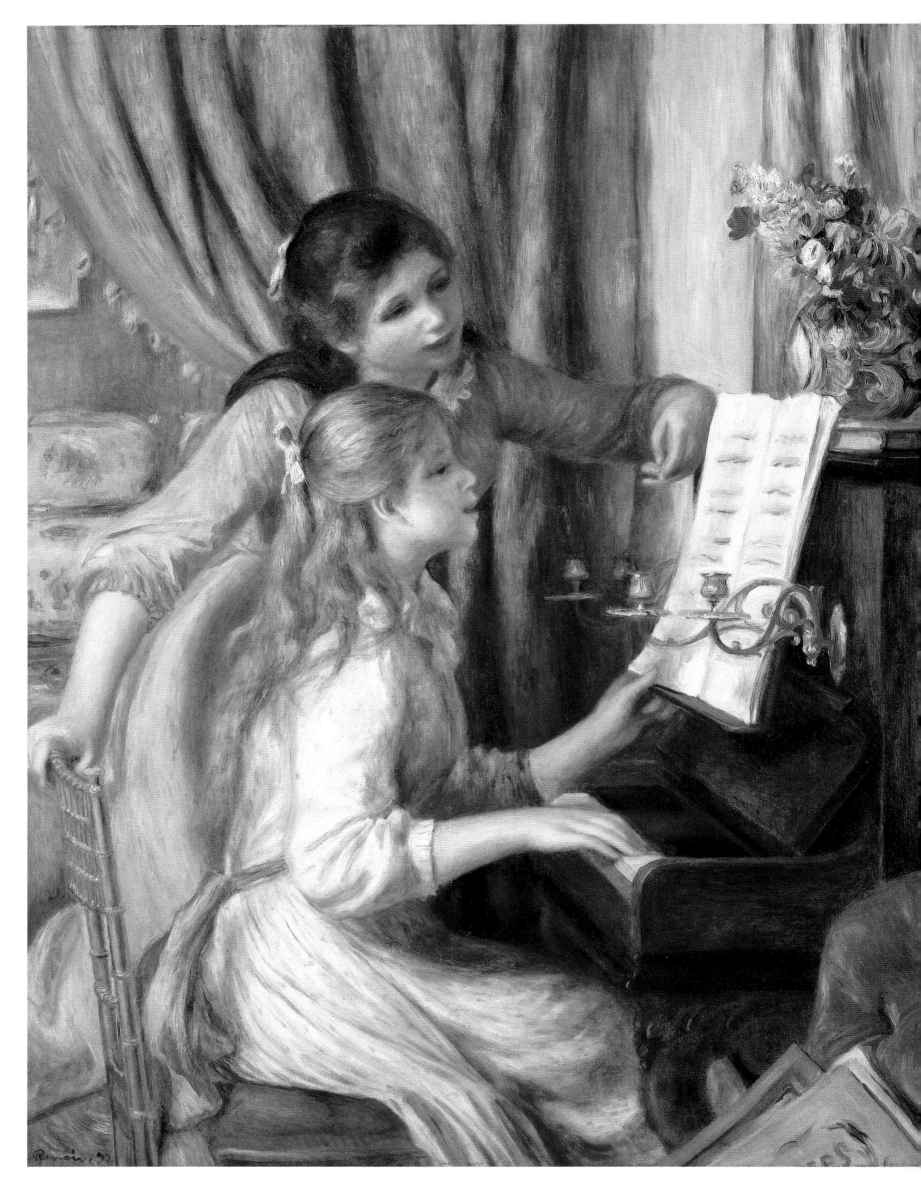

Two Girls at the Piano, c. 1890

Oil on canvas
44×34 inches (11.8×86.4 cm)
Metropolitan Museum of Art, New York
Robert Lehman Collection, 1975

In 1890 Renoir made his final submission to the Salon, which had long ceased to be of importance to him. The work he exhibited that year was a double portrait, *The Daughters of Catulle Mendès,* which represented them at the piano. In May 1892 the French State acknowledged Renoir's artistic achievement by purchasing a version of *Two Girls at the Piano* for 4000 francs, for the Musée du Luxembourg, the museum devoted to contemporary art. He had been requested to paint the picture some months before, and the informal commission seems to have preoccupied him to such an extent that he produced no fewer than five oil paintings dealing with this subject. This version was originally purchased by Durand-Ruel.

The theme of two young women at the piano was therefore a very popular one in the late 1880s and early 1890s, and it was one to which Renoir would later return (page 148). The theme of the music lesson had been a common one in the art of the eighteenth century which Renoir admired, but in the *fêtes galantes* it was used as a metaphor for love, and typically men court women by music and song. In depicting two women, Renoir is providing no more than a passing allusion to these paintings. Clearly the theme of love is absent, but more importantly music-making in the eighteenth-century works had been the pastime of an aristocratic few. Renoir's musicians, on the other hand, belong to the bourgeoisie who aspire to an upright piano in their sitting room. The artist Giorgio de Chirico (1888-1978) noted this phenomenon when he wrote about Renoir's depictions of women:

The type of woman whom Renoir left us is the petite bourgeoise, the housewife, the mother, the maid, or the young girl; she may be at a piano, in the backyard or in the garden, but always in a somewhat stifling setting, These women, when indoors, always seen to be in somewhat low-ceilinged rooms.

Girls Putting Flowers on their Hats, 1893-94

Oil on canvas
25½×20½ inches (65×52 cm)
E G Bührle Collection, Zurich

The two girls are traditionally identified as Julie Manet (born 1878), daughter of Berthe Morisot, who became Renoir's ward in 1895 after her mother's death, and her cousin Paule Gobillard. However, even if this identification is correct, the work is a genre painting rather than a portrait. It is close in mood to *Two Girls at the Piano* (page 142); the two girls are apparently lost in each other's company, spending their time in tranquil pleasures. Like other women whom Renoir painted at this time, they do not perform any task which necessitates intellectual activity. As the artist later explained to his son:

I consider women writers, lawyers, and politicians ... as monsters and nothing but five-legged calves. The woman artist is merely ridiculous, but I am in favor of the female singer and dancer. In Antiquity and among simple peoples, the woman sings and dances and does not therefore become less feminine. Gracefulness is her domain and even a duty.

In the self-contained world which Renoir's women inhabit, he established a set of norms to which they conform and which, by implication, he prescribed for women in general. Their role is decorative and although they appear self-absorbed, their reference to a male spectator is left in little doubt. As Renoir's vision of a harmonious world became more explicit in his art, women increasingly took a central role, albeit one directly controlled by the artist.

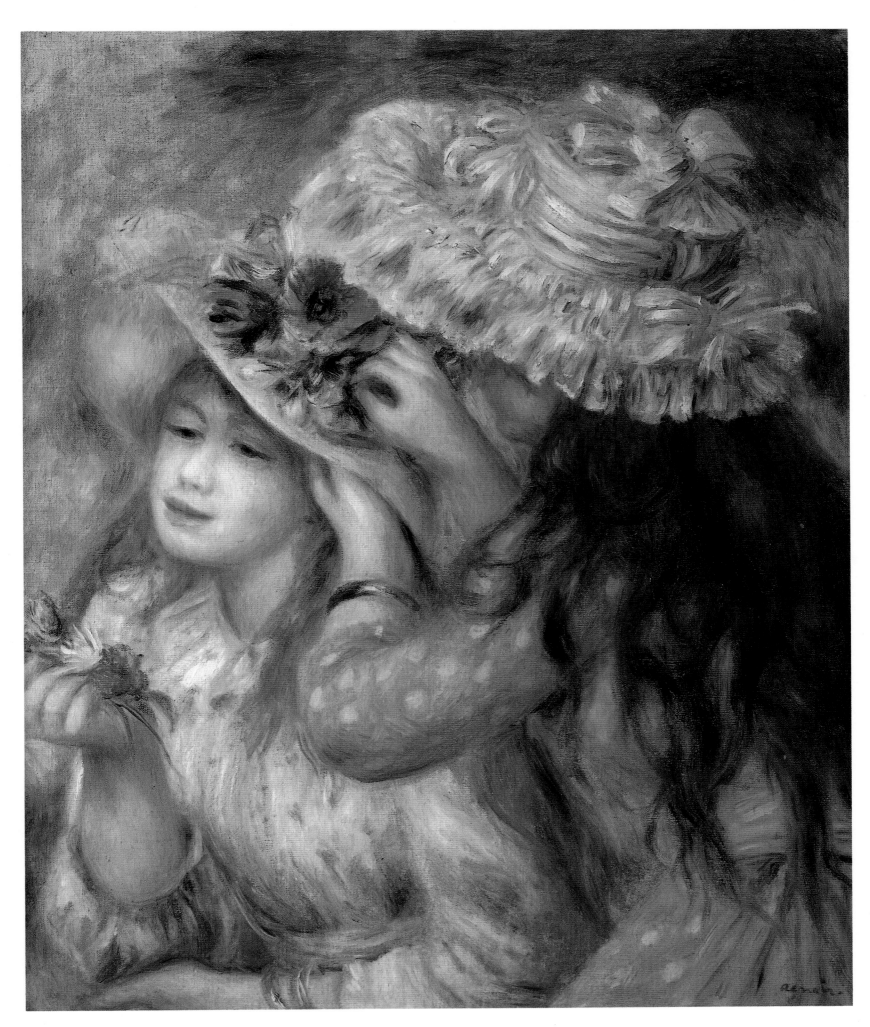

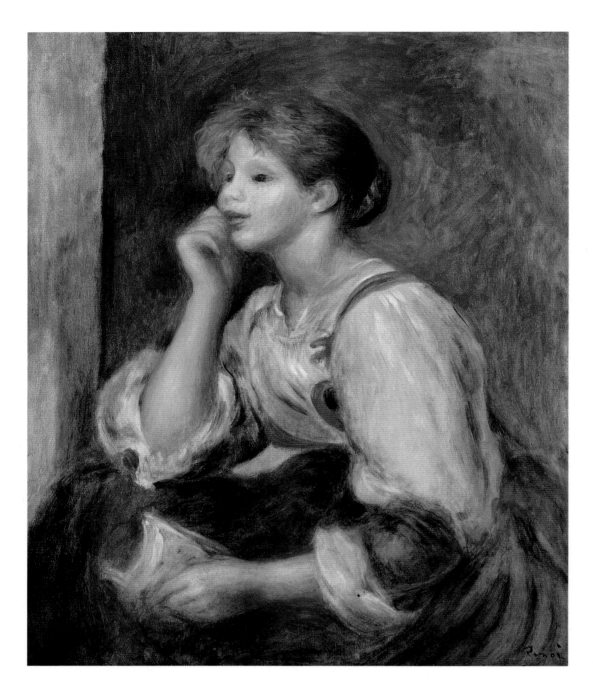

Woman with a Letter, 1894

Oil on canvas
25½ × 21¼ inches (65 × 54 cm)
Musée de l'Orangerie, Paris

Gustave Geffroy (1855-1926), an early biographer of Monet and who had an article about Renoir in *La Vie Artistique* in 1894, gave an account of a visit to the gallery of Ambroise Vollard (1868-1939) in 1895, not long after the dealer had met Renoir. Geffroy described a recent canvas by Cézanne he had seen there which depicted a *Boy in a Red Waistcoat* (Bührle Collection, Zurich). Although the handling and style of Cézanne's work is very different from *Woman with a Letter*, the mood and subject are similar. In both the figure is a rustic type, who sits meditating, head resting on a hand and contemplating the contents of a letter. In the *Boy with a Red Waistcoat* the mood is somber, the young woman whom Renoir depicts, however, is presumably in receipt of a love letter rather than the gas bill, to judge from the way in which she stares dreamily into the middle distance. The narrative quality of the work, and the theme of love to owes something to eighteenth-century prototypes.

Gabrielle and Jean, c. 1895

Oil on canvas
25½ × 21¼ inches (65 × 54 cm)
Musée de l'Orangerie, Paris

Despite its appearance, the work is not an example of the traditional mother and child theme, but is in fact a depiction of Renoir's second son and the family servant

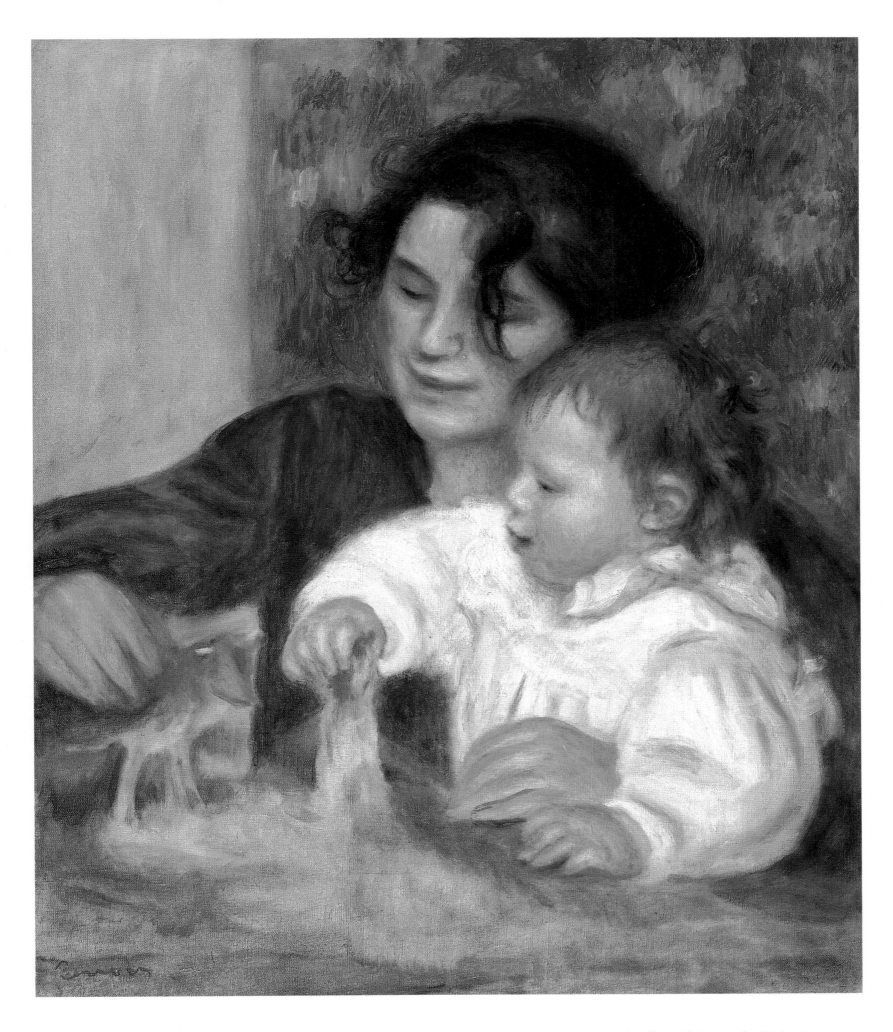

Gabrielle Renard (1879-1959). She was a distant cousin of Madame Renoir who came from Essoyes to join the family in the summer of 1894, shortly before Jean's birth that September. In the twenty years she spent with the family, Gabrielle Renard became Renoir's most frequently painted model. In 1914 she left the family and married the American painter, Conrad Hersler

Slade. She died in San Francisco in 1959. Jean Renoir (1894-1979) became a film director and wrote the popular biography *Renoir, my Father*, published in 1962.

Renard's position in the family appears to have fluctuated between that of faithful servant and a member of the young, bohemian crowd that surrounded Renoir towards the end of his life. In works like

Gabrielle and Jean, of which there were several versions, the subject has affinities with traditional tender depictions of virgin and child, but in a quite different group of paintings that depict Gabrielle Renard, the overriding atmosphere was overtly erotic (page 154). She was the perfect model for Renoir, switching roles with ease and epitomizing his vision of an ideal woman.

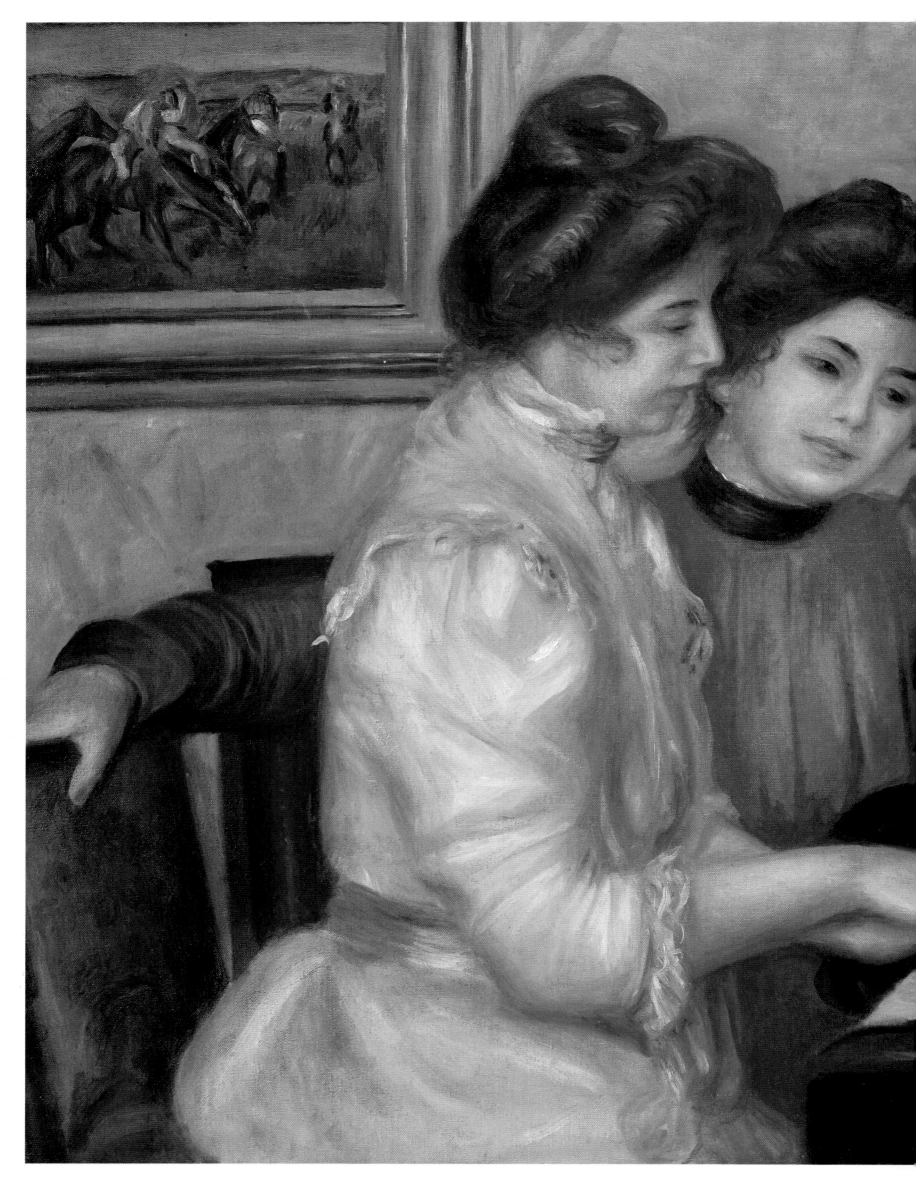

Yvonne and Christine Lerolle at the Piano, 1897

Oil on canvas
28¾×36¾ inches
Musée de l'Orangerie, Paris

This painting continues a theme that had preoccupied Renoir earlier in the 1890s, that of two young women at the piano; one playing and her companion following the music (page 142). In this instance, however, the work is a double portrait of the two elder daughters of the painter and collector Henri Lerolle (1848-1929) and his wife, who hosted a fashionable salon at which Debussy and the painter Maurice Denis (1870-1943), among others, were regulars. Evidence of Lerolle's collection is evident in the background, where two works by Degas are prominently displayed. The models were Christine (born 1879) in the red dress and her elder sister Yvonne (born 1877) in white.

By the late 1890s, Renoir was enjoying a way of life quite different from that of the 1860s and 1870s. He was married with two young children, and the family enjoyed a comfortable existence with a home in Essoyes and one in Paris. His work had been bought by the French state, and the year in which he painted *Yvonne and Christine Lerolle at the Piano* a number of his works had entered the Luxembourg museum as part of the Caillebotte bequest. He no longer had to exhibit at the Salon to make his name. When he painted this portrait of his friends' daughters, he was representing a social milieu with all its trappings to which he at last belonged.

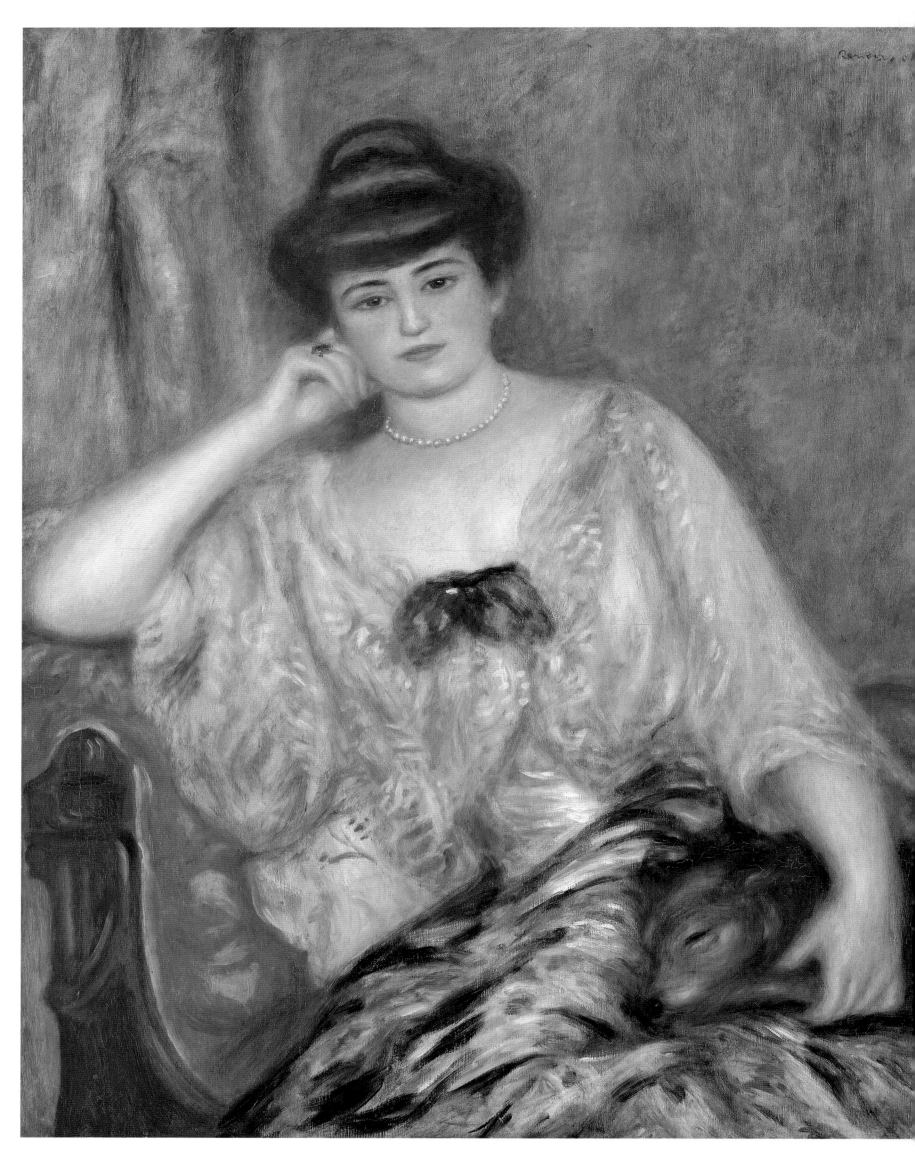

Misia Sert, 1904
Oil on canvas
36×23½ inches (91.4×58.4 cm)
National Gallery, London

In 1904 Renoir was commissioned to paint two portraits of the Polish former wife of Thadée Natanson, Misia Godebska (1872-1950). In 1903 she had begun living with the financier Alfred Edwards, owner of the newspaper *Le Matin,* and was in the process of divorcing Natanson. She is generally known by the name of her last husband, the Spanish painter José Maria Sert. Misia Godebska was a prominent figure in artistic circles at the beginning of the twentieth century, and is caricatured in Proust's *Remembrance of Things Past.*

In her memoirs, written in her old age, Misia gave a rather lurid account of the sittings for Renoir, and of the painter's agitated state:

'Lower, lower, I beg you' he insisted. 'My God!

Why don't you show your breasts? It's criminal!' Several times I saw him on the verge of tears when I refused. No one could appreciate better than he the texture of skin, or, in painting, give it such rare pearl-like transparency. After his death I often reproached myself for not letting him see all he wanted.

This story seems rather fanciful. Renoir was more than capable of distinguising between pragmatism and impropriety in the production of portraits of society women. Even in his representations of his wife or of Gabrielle Renard the difference between a portrait and the depiction of a type is made quite clear. His portraits of other upper-class women, who were paying for the privilege of sitting for him, were models of elegant seemliness (pages 62 and 98).

151

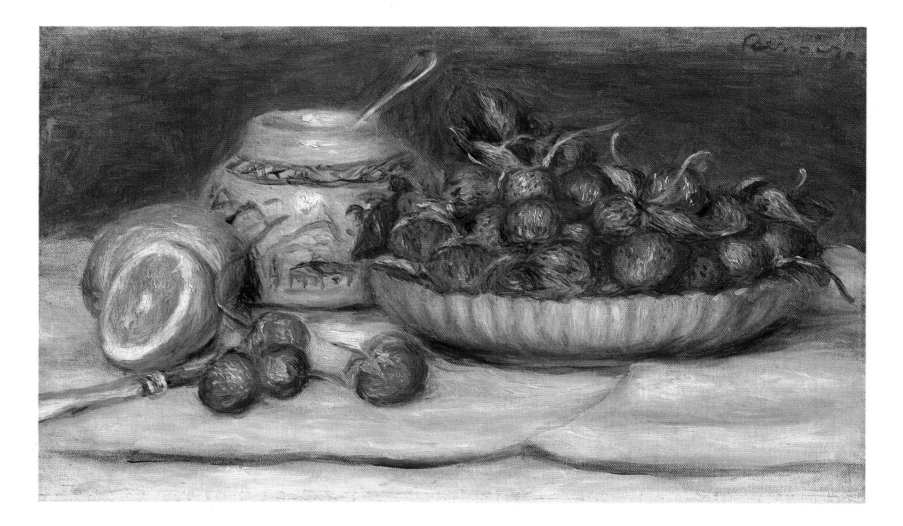

Strawberries, c. 1905

Oil on canvas
11×18⅛ inches (28×46 cm)
Musée de l'Orangerie, Paris

In the last decades of his life, Renoir painted a number of small, informal works like *Strawberries* which served a two-fold purpose: as money-spinners, as he freely acknowledged to Durand-Ruel, and as a means of refining his technique, much as he had painted still lifes at the beginning of his career (page 31). Julie Manet, whom Renoir taught to paint, wrote in her journal on 15 January 1898 that he advised painting still lifes in order to learn to work quickly. As Renoir became less mobile and tied to his studio with the worsening of his arthritis, the still life was the perfect genre on which to concentrate, as it involved the minimum of props (and those in *Strawberries* recur in a number of other works) and its small-scale made it more physically manageable.

The work draws on certain still-life conventions which were intended to appeal to the viewer's palate, juxtaposing the sharpness of the halved lemon with the sweetness implied by the sugar bowl. The dainty colors contribute to the sensual quality of the work. Compositionally, Renoir's still lifes were more tied to traditional prototypes than his treatment of the other genres. The objects placed at eyelevel within a shallow picture space draws on seventeenth and eighteenth-century French and Dutch models. However, the practice of dissection of fruits to contrast inner and outer surfaces – the juicy flesh against the grainy skin of the lemon – has been divorced from its original allegorical connotations and the four rogue strawberries were little more than an empty cliché.

The third Renoir son, Claude, was born on 4 August 1901 in Essoyes, when his father was sixty years old, and his mother was forty-two. Claude, or 'Coco' as he was affectionately known, was the most frequently painted of Renoir's children, probably because of his father's increasing immobility, which tied him to his home and studio in later life. This work may be fairly securely dated to around 1905, judging by the appearance of the child. Jean Renoir later recounted similar sessions he had undergone as a model for his father, and explained that Renoir liked to paint informal works, in which his children were absorbed in play (page 147). The artist did not need his young models to remain perfectly still, and indeed welcomed the sense of spontaneity that their lack of rigidity gave to his works. Only occasionally might he ask the child to remain still in order to capture a characteristic pose.

The red of Coco's garment was a favorite color at this time and the way in which Renoir has offset it against the pearly flesh of his model is reminiscent of the work of Rubens, that he had seen in the Louvre and which he was particularly to admire in the museum in Munich in 1910. The intimacy of the subject is heightened by the close viewpoint, but the relatively secret world of childhood is underlined by the high angle from which the work has been painted, emphasizing the adult looking down at the child. The other Impressionist painter who specialized in depictions of children, Mary Cassatt (1844-1926), often modified her viewpoint to take account of this disparity and provide a richer insight into her young models.

Claude Renoir Playing, c. 1905

Oil on canvas
18⅛×22 inches (46×55 cm)
Musée de l'Orangerie, Paris

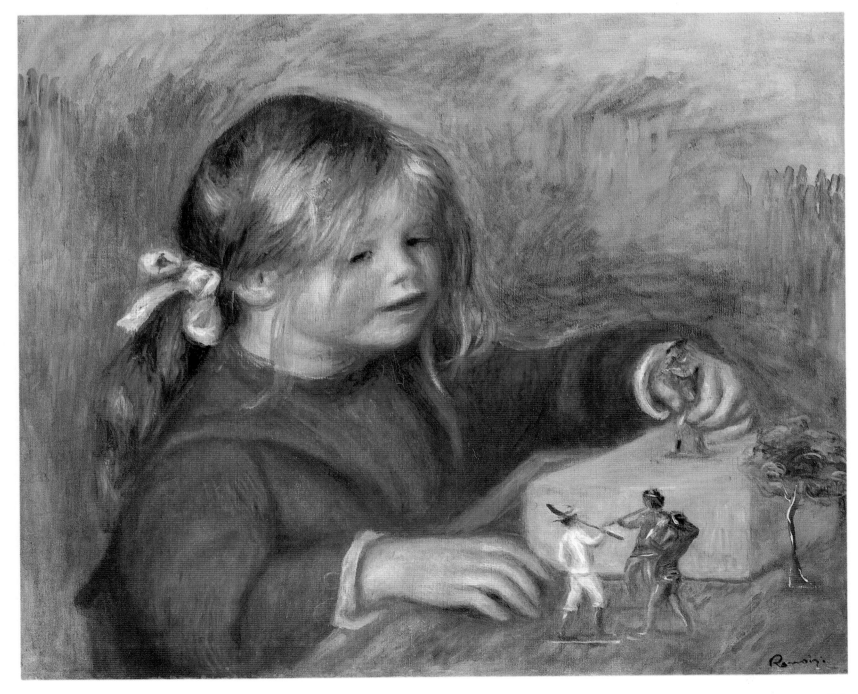

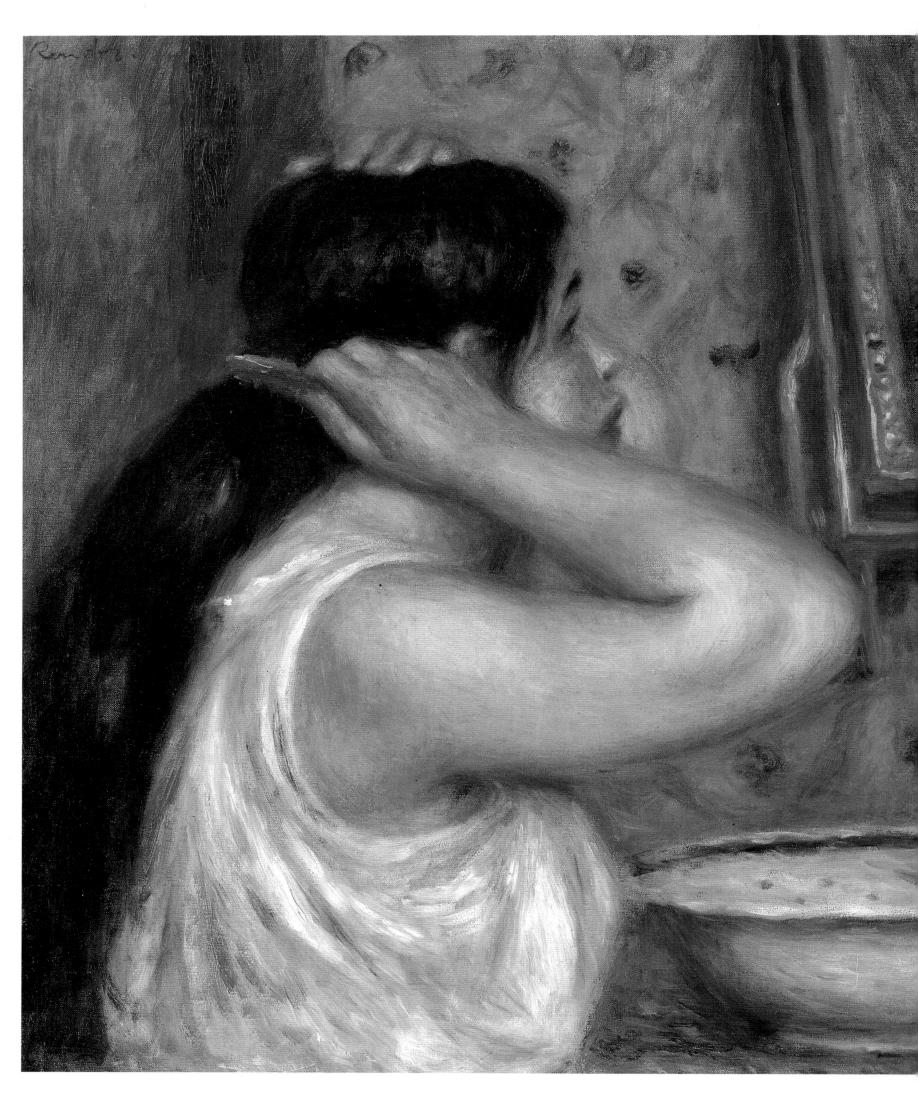

154

The Toilet: Woman Combing her Hair, 1907-08

Oil on canvas
22×18¼ inches (55×46.5 cm)
Musée d'Orsay, Paris

For several years, Renoir had been producing representations of full-length nudes in which the women perform some task associated with their toilet, often drying their legs. *The Toilet: Woman Combing her Hair* is a refinement of that subject-matter, and provides a synthesis of the nude and a more intimate genre scene. The young woman is depicted in her bedroom (there is a patterned wallpaper in the background), in front of a mirror and washstand, arranging her hair. Yet at the same time, Renoir has used this as a device for the study of the skin of her arms and shoulders.

Like so many of Renoir's other works at this time, this painting derives from eighteenth-century prototypes. Watteau and Fragonard both painted women at their toilet, intimate scenes to which the spectator is privy. This same sense of intrusion, that we are somehow looking at the young woman through a keyhole, was a crucial feature in the work of Degas, one of the original members of the Impressionist circle. However, while Degas would frequently paint women in ungainly poses, Renoir was always acutely aware of the more picturesque potential of such works. Any overt references to the early twentieth century are masked in a generalized and ritualized depiction of the toilet.

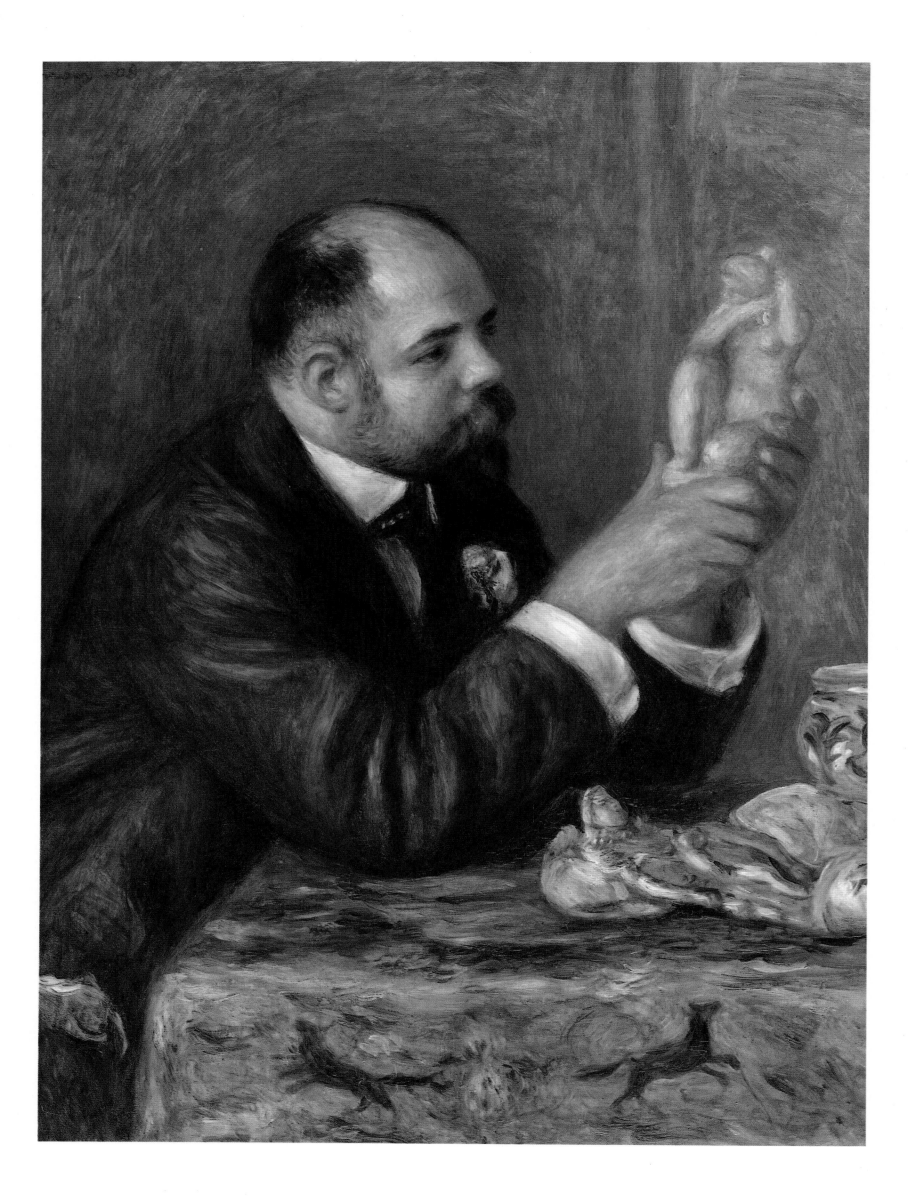

Portrait of Ambroise Vollard,

1908

Oil on canvas

31⅛×25½ inches (79×65 cm)

Courtauld Institute Galleries, University of London

Ambroise Vollard (1868-1939) arrived in Paris from his native Réunion, to the south west of Mauritius, in 1888. He met Renoir in 1894 or 1895 and became one of the most important figures in the last twenty years of his life. Not only did he deal in Impressionist works from his gallery at 39 rue Laffitte, but was also responsible for the promotion of early twentieth-century avant-garde artists, particularly Picasso, Matisse, Chagall, and Rouault. The biographies he wrote on several of the Impressionist painters form some of the most important, if rather colorful, primary sources. He also introduced Renoir to sculpture.

In this portrait Vollard is caressing a plaster statuette of a *Crouching Woman* by the French sculptor Aristide Maillol (1861-1944). In the summer of 1908, the same year that this work was painted, the sculptor visited Renoir at Essoyes to execute a bust of him, at Vollard's request. It may have been the same year that the dealer suggested Renoir try sculpture for himself, but it was only in 1913 that he introduced him to the young sculptor Richard Guino, who helped realize his ideas in clay by working according to his direction. Guino, whom Vollard paid to assist Renoir, had been trained by Maillol, and the type of work on which the two collaborated is therefore highly reminiscent of the work of Maillol (page 28). This was only one instance among many of Vollard's control over Renoir's production in terms of both subject-matter and style.

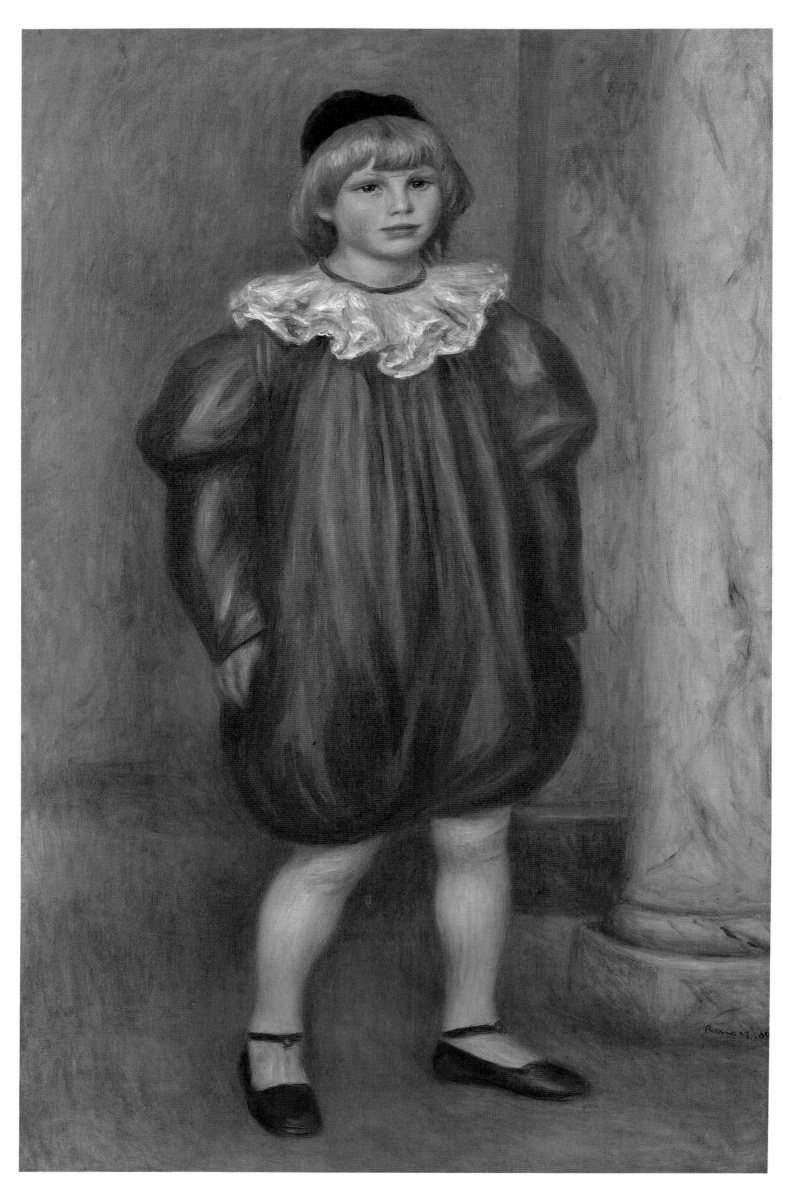

Claude Renoir as a Clown, 1909

Oil on canvas
47¼×30⅓ inches (120×77 cm)
Musée de l'Orangerie, Paris

This fairly large portrait of Renoir's youngest son, eight-year-old Coco, is unusual in that the boy has been dressed up and asked to pose for the painting, making it very different in conception from earlier works in which spontaneity and informality were paramount (page 153). That Renoir should have done this suggests that he may have been seeking to emulate other artists. In 1888 Cézanne had painted a *Mardi Gras* scene for Victor Chocquet, in which his son and another youth had posed in harlequin costume against the rather theatrical backdrop of a rich drape. Renoir has used a similar baroque device, favored by seventeenth-century portraitists, of a column which must surely have been a pictorial invention rather than a feature of his newly built house in Cagnes. A memory of

Cézanne's work may have influenced this painting, particularly since in a letter to Monet written in December 1909, Renoir had expressed his dislike of the idea of a commemorative monument to Cézanne, who had died in 1906, and whom he felt should be judged solely by his works. There are also echoes of the work of courtly painters of the seventeenth century like Velázquez. The most important reference is to the French eighteenth-century figure of Pierrot, best depicted in Watteau's *Gilles* in the Louvre.

Despite its large format and the picturesque subject-matter, which suggest the work may have been painted to be sold, it remained in the artist's possession until his death. Claude Renoir later became a successful ceramicist.

Dancing Girl with Castanets,

1909

Oil on canvas
61×25½ inches (155×65 cm)
National Gallery, London

This work, together with its partner, *Dancing Girl with Tambourine* (page 161), was painted for the dining-room of Maurice Gangnat's apartment on the avenue de Friedland in Paris. Gangnat, who met Renoir around 1905, began commissioning works from him, including portraits of members of his family. By the time of Renoir's death in 1919, Gangnat owned over 150 of his oil paintings. He formed a close friendship with the artist and was a frequent guest at Les Collettes, where Renoir gathered a wide circle of friends and acquaintances around him as he became less able to travel. When the works were begun in the summer of 1909, Gangnat made it clear from the outset that they were to be conceived of as a pair, that their purpose was to be essentially decorative, and that they were to hang on either side of a mirror in his dining-room. A sense of balance between the two works was therefore of the greatest importance. Whether it was the patron or the artist who proposed that the two women should bear dishes of fruit, is unclear. Such a combination of women and fruit would have been particularly appropriate for a dining-room and as a theme it had the benefit of a long and distinguised tradition in allegorical paintings: female nymphs and bacchanalian figures often carry cornucopiae and baskets of harvested fruits, as a metaphor for bounty and plenty and with more than a passing allusion to their own sexual attractions. It was presumably in this allegorical mode that the figures were first planned, but the idea was eventually scrapped, in favor of the musical instruments which they now hold.

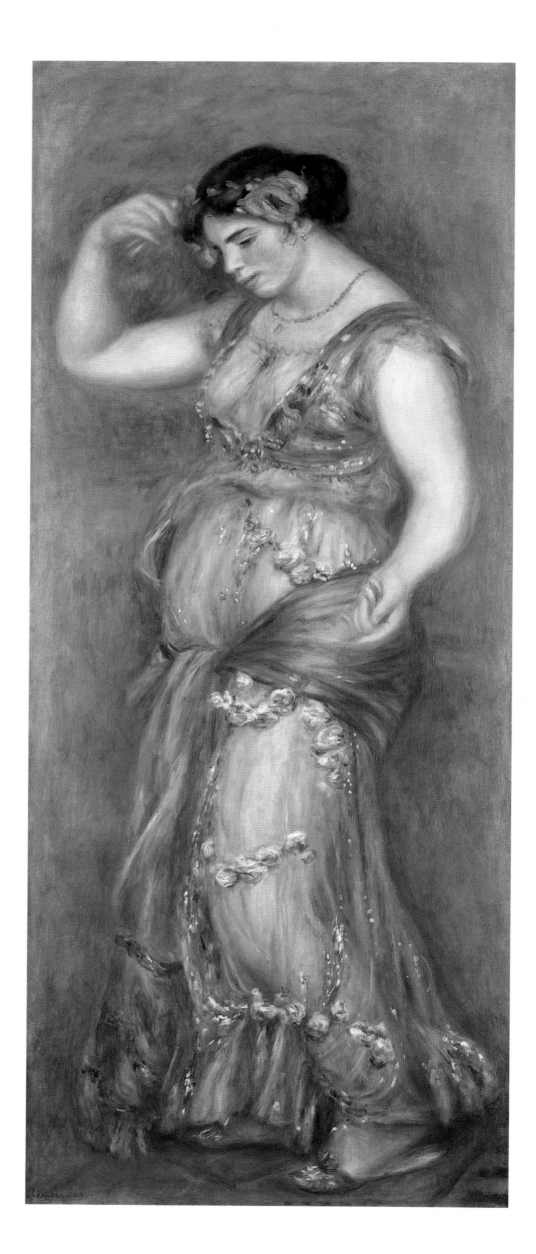

Dancing Girl with Tambourine,

1909
Oil on canvas
61×25½ inches (155×65 cm)
National Gallery, London

The model for both this work and its partner *Dancing Girl with Castanets*, (page 160) was Georgette Pigeot, although the head for the latter was partly modelled on Gabrielle Renard, who posed for a great number of Renoir's late paintings, particularly as his sons grew older and her duties as nursemaid lessened. In these two works the artist has returned to the theme of the *Dance in the City* (page 124) and *Dance in the Country* (page 125) which he had painted over twenty-five years earlier and in which he experimented with the monumental decorative qualities of the subject; the outcome of his trip to Italy in 1881. Like the earlier works, these two have that same format, although they are slightly smaller, being just under life-size, a factor presumably determined by their proposed site. Like the earlier dance pictures, these two rely on a good strong silhouette against a minimal backdrop to enhance the decorative qualities of the theme.

In all four dance paintings the subject-matter helps determine the format and treatment. As Renoir was fond of saying, he liked women best when they fulfilled a pleasing, decorative function, and he particularly enjoyed listening to them sing as they performed their household tasks. In the Gangnat paintings, the women are dressed in strangely timeless yet rather exotic costumes, with any references to the external world carefully removed. The sense of harmony they convey, both metaphorically and literally with their rudimentary musical instruments, helps to make these the supreme examples of Renoir's skills as a decorator. Renoir himself regarded these as two of the most important works from his late period.

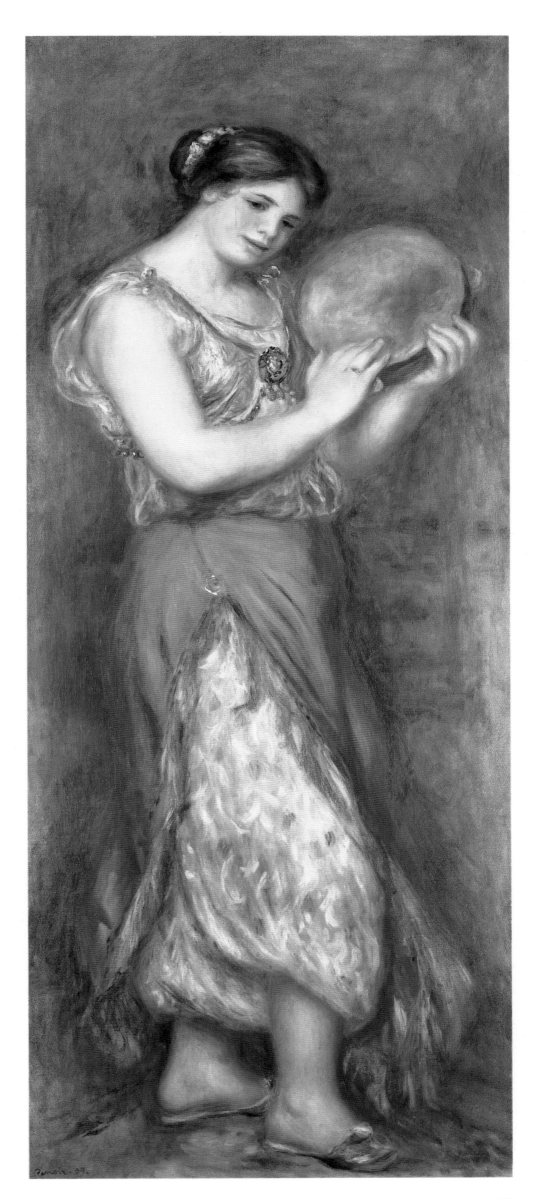

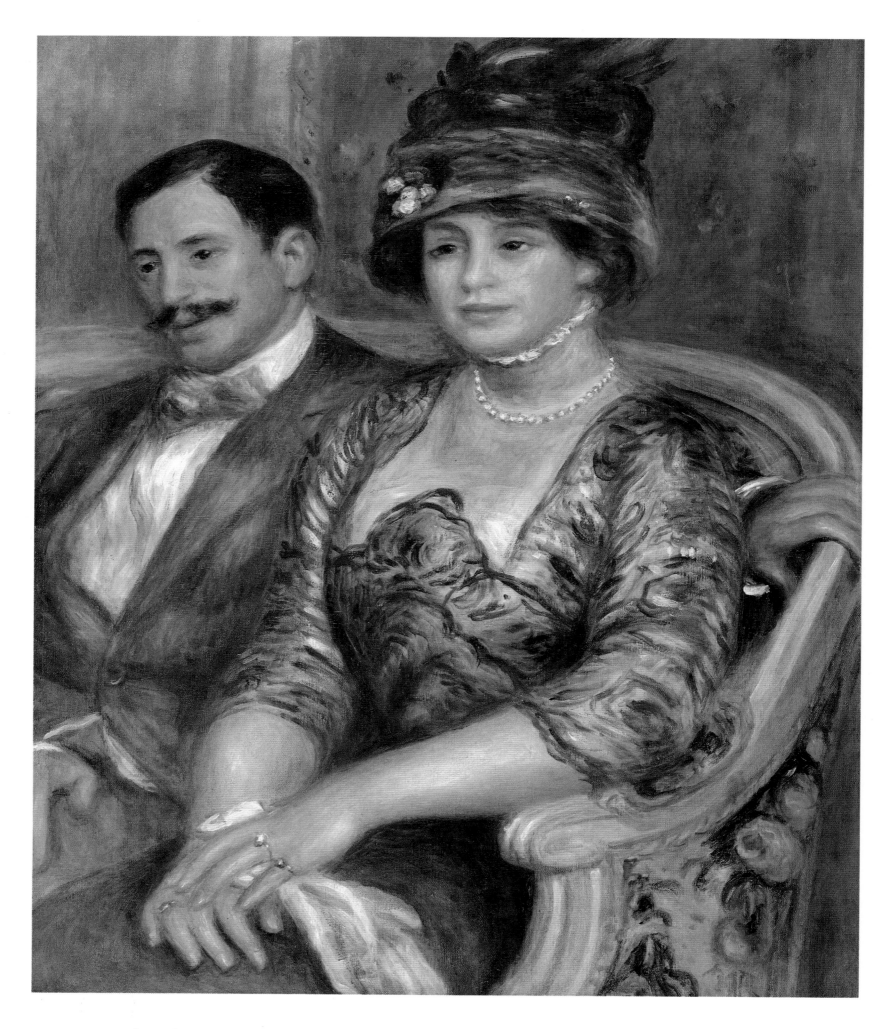

Monsieur and Madame
Bernheim de Villers, 1910

Oil on canvas
31⅞×25¾ inches (81×65.5 cm)
Musée d'Orsay, Paris

This double portrait represents Gaston Bernheim de Villers (1870-1953) who was the director of a Parisian art gallery and his wife Suzanne Adler (1883-1961). The Bernheim de Villers commissioned a number of works from Renoir, including a portrait of Madame Bernheim de Villers sitting in a garden, painted in 1901 and one of their daughter *Geneviève Bernheim de Villers,*

also of 1910 (both are now in the Musée d'Orsay). However, this work is unusual in that in mood it is closer to the works of the 1870s, such as *La Loge* (page 79), rather than the more generalized depictions of friends and acquaintances that Renoir painted towards the end of his life. Presumably the very elegant, fashionable clothes that the couple wear, their chic sur-

roundings, and Madame Bernheim de Viller's jewellery have been emphasized at the request of the sitters, rather than at the artist's suggestion.

By the time that Renoir painted this work he was one of the most sought-after artists in Paris, with three dealers specializing in his work; he was represented in the Musée du Luxembourg; and had had an entire room devoted to his work in the Salon d'Automne of 1904. The year after it was painted he was decorated by the French State and created an Officier de la Légion d'Honneur, effectively upgrading the order he had already received in 1900.

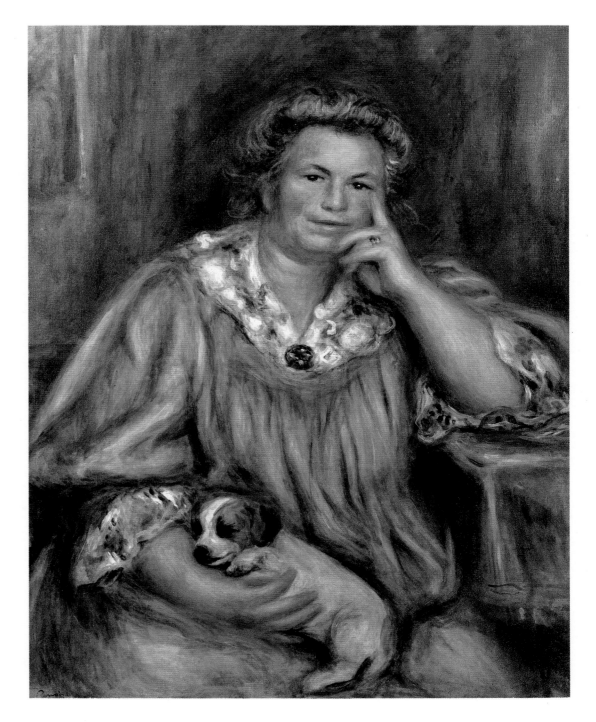

Madame Renoir and Bob, c. 1910

Oil on canvas
32×25⅝ inches (81×65 cm)
Wadsworth Atheneum, Hartford,
Connecticut
Ella Gallup Sumner and Mary Catlin
Summer Collection

This is one of the few depictions Renoir made of his wife in which he portrayed her in an intimate mood rather than as the subject for one of his representations of the nude or in a genre scene (pages 125 and 136). A sense of Aline Renoir's simplicity had prevailed in the portrait he painted of his wife in 1885, after the birth of their first son (page 131), and it has been accentuated in this work. There is not even a vestige of the pert model from *The Luncheon of the Boating Party* (page 112). Her complexion is ruddy and her arms strong, while the little puppy is almost lost in her ample lap. However, at the time the portrait was painted Madame Renoir was over fifty and

in poor health. In a letter written in February 1914 to Durand-Ruel's son, the Impressionist painter Mary Cassatt, who freely admitted her dislike of Aline Renoir wrote:

I saw Renoir this afternoon. . . . Madame [Renoir] was not there, she had gone to Nice. He told me that she was also very well. But their cook [said] that that wasn't true, that she was not herself and that she [the cook] thought her diabetes was going to her head. . .

The monumental figure that is the subject of this work is far removed from the ailing middle-aged woman of contemporary accounts. She appears oddly ageless and this contributes to the monumental quality of the work. The little dog, a household pet mentioned by Jean Renoir, heightens her statuesque and maternal qualities. Even in a tender portrait of the woman with whom he had shared his life for over thirty years Renoir has created an idealized vision.

163

Alexander Thurneyssen as a Shepherd, 1911

Oil on canvas
29⅝×36½ inches
Museum of Art, Rhode Island
School of Design, Providence, Rhode
Island

In the summer of 1910 Renoir, accompanied by his family and Gabrielle Renard, was invited to the house of Dr Franz Thurneyssen in the outskirts of Munich to paint a double portrait of his wife and daugher. Frau Thérèse Thurneyssen (b. 1866) was the niece of Paul Berard and Renoir had already painted her portrait at Wargemont in 1879. The following summer the Thurneyssens commissioned this painting of their son Alexander. The subject-matter is not strictly a portrait but is mythological in conception. The subject is reclining, wearing what appears to be a sheepskin, holding pipes and charming the wild birds. His features have been generalized, and this coupled with his rounded limbs make it difficult to determine his sex.

The work is a rare example of Renoir treating a male subject in a mythological guise. It was only towards the end of his life that he returned to this kind of bucolic subject-matter which allowed him to treat the figure within a landscape in an essentially decorative way, most notably in a version of the *Judgment of Paris*, which he had painted in 1908 and which he tackled again in 1913 (page 170). The influence of the paintings by Rubens which he had seen in the Alte Pinakothek in Munich may have been instrumental in his taking up the treatment of mythological subjects at this time.

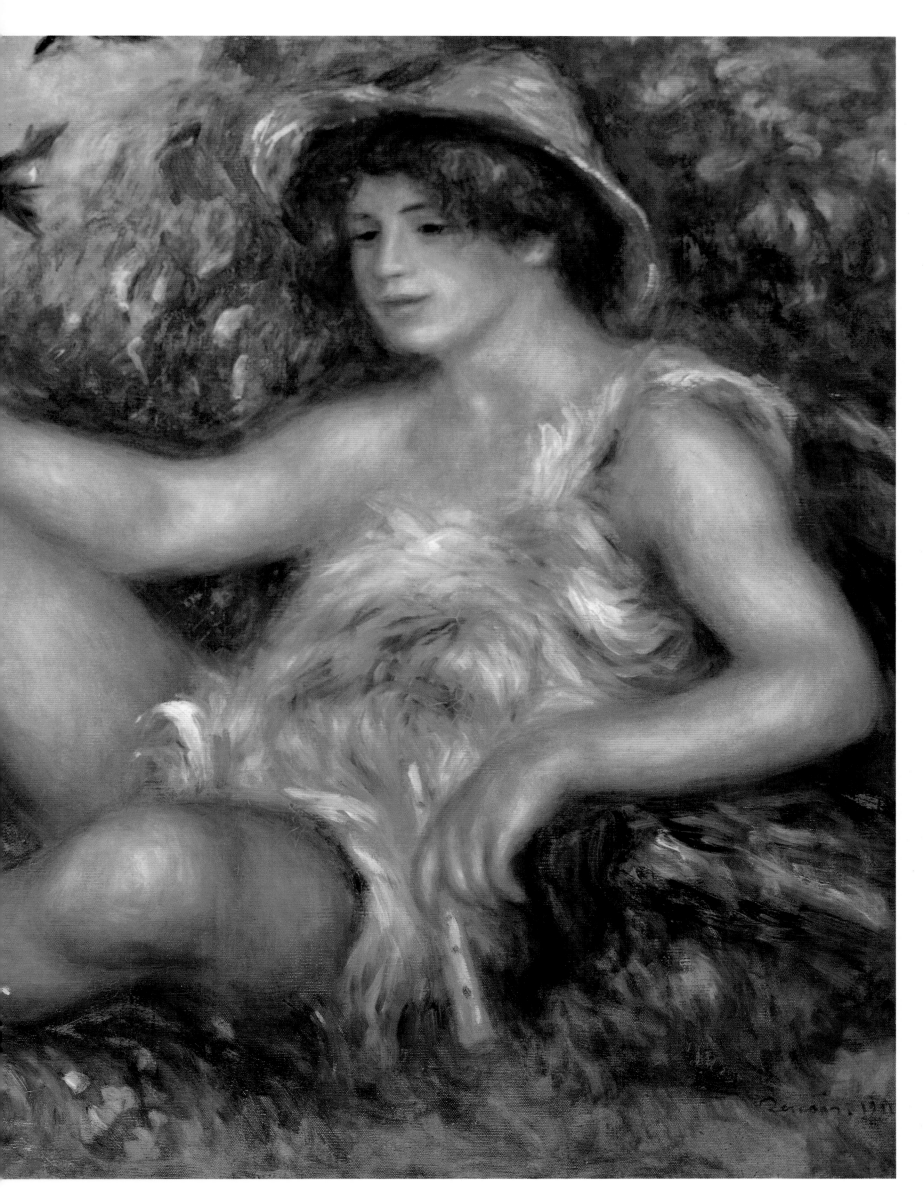

Gabrielle with a Rose, 1911

Oil on canvas
22¼×18½ inches (55.5×47 cm)
Musée d'Orsay, Paris

This is the final canvas in a series that had occupied Renoir for a number of years in which he depicted Gabrielle Renard in a flimsy, semi-tranparent blouse, which is open to reveal her breasts. In these works, the model tends to toy with objects alluding to personal adornment, like jewelry or, as here, roses which she holds up to her dark hair, and against the bloom of her cheek. In this, Renoir was adopting a fairly standard conceit in which the beauty and fragility of flowers were contrasted with their feminine counterparts. The canvas originally belonged to Maurice Gangnat who may have suggested a similar analogy in his large, decorative *Dancer* paintings (pages 160 and 161).

While this work depicts Gabrielle, it is not strictly a portrait but rather a much more generalized evocation of Renoir's vision of femininity. The sense of intrusion, of our witnessing a scene which is properly private, while the model poses artlessly for the implied male spectator was a common one in the eighteenth-century rococo works that Renoir admired (pages 9 and 22). It is this sense of 'harmony', of an existence untroubled by any external concerns and which was applied in particular to his female models, that Renoir admired in the art of the past, as much as the craftsmanship and delicate coloring.

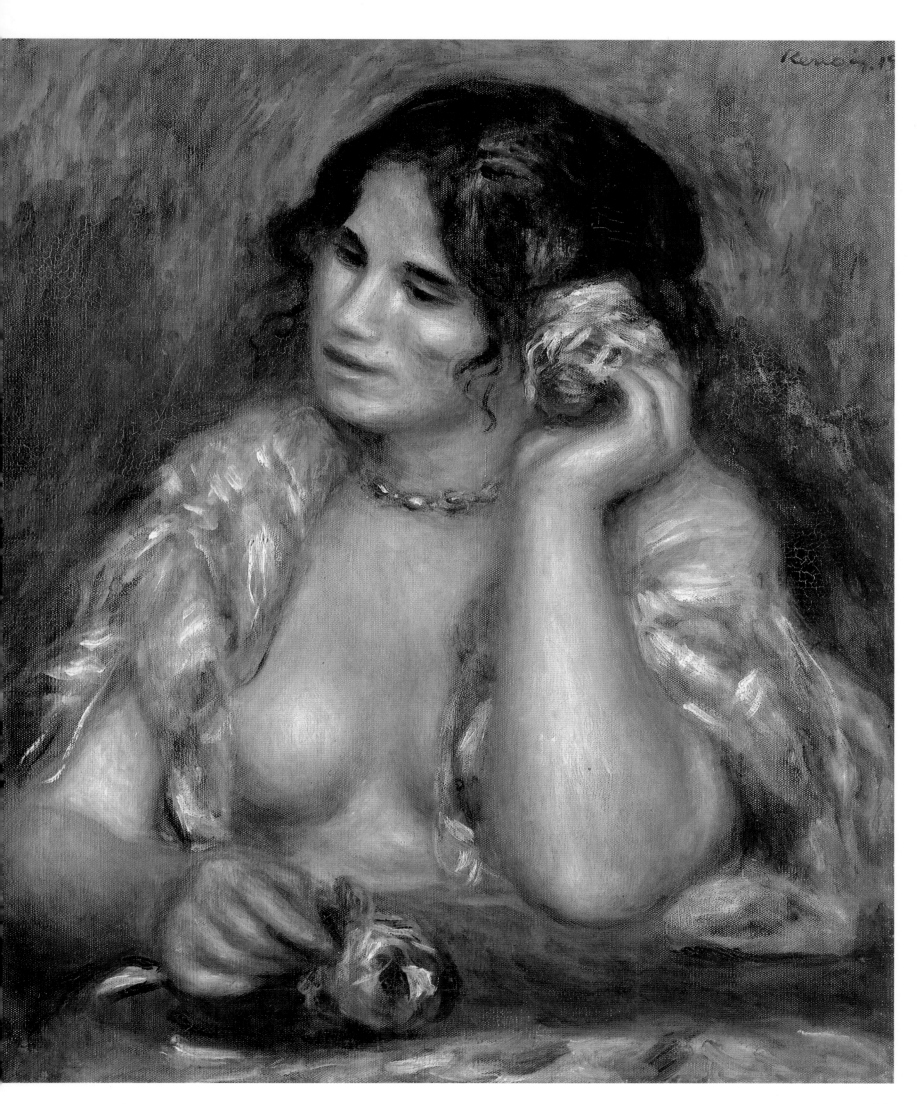

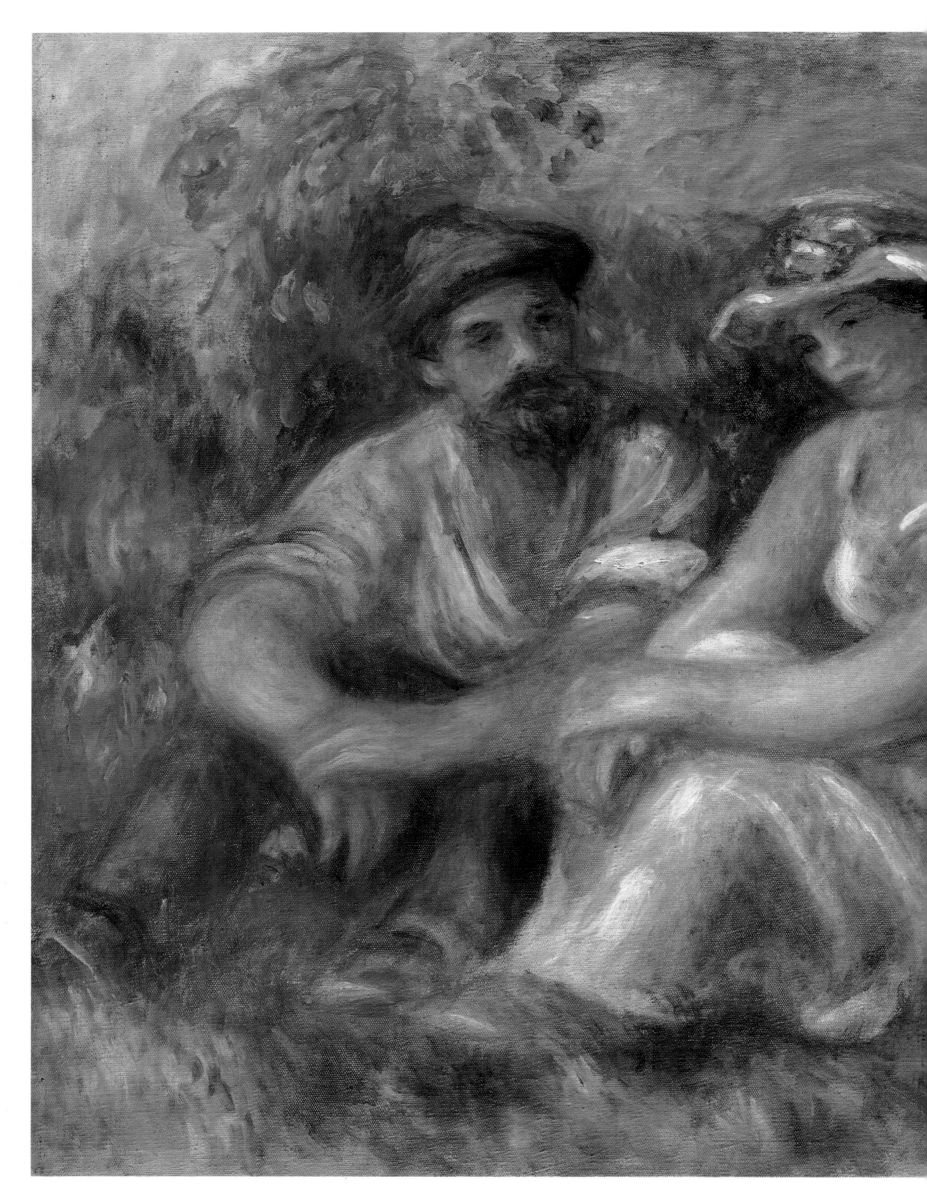

Seated Couple, 1912

Oil on canvas
20½×24¾ inches (52×63 cm)
National Museum of Wales, Cardiff

In the summer of 1910, Renoir had given up walking, but in June of 1912 his patrons the Bernheims introduced him to a new doctor who attempted to cure him. Unfortunately, he had to admit that he would never walk again and would henceforth depend on his wheelchair and the growing band of helpers who surrounded him at his home in Cagnes and in a studio he had rented in Nice at the beginning of 1912. The practical constraints imposed by sitting down, and the difficulty of holding a brush, meant that Renoir turned increasingly to small, horizontal format works, while conserving his strength for the occasional large statement (page 173). These small works, rapidly brushed and informal, were ideal for selling since, as Renoir's reputation was assured, there was a growing market to satisfy.

This work differed from other genre scenes painted at the end of Renoir's life, in that he reverted to a subject that had preoccupied him in the early 1870s – that of the courting couple (page 46). *Seated Couple*, however, depicts a pair of country people, rather than the elegant urban visitors who peopled Renoir's landscapes earlier in his career. The inclusion of a man in his genre scenes was unusual at the end of his life. Men were gradually excluded from his paintings, except for official commissions (page 164), reflecting Renoir's apparent desire for a world inhabited exclusively by women, over which the artist (and the patron) presided.

Judgment of Paris 1913-14

Oil on canvas
28¾×36¼ inches (73×92 cm)
Hiroshima Museum of Art

Renoir had only occasionally depicted mythological subjects before undertaking *The Judgment of Paris*, most notably in the early Salon painting of *Diana* (page 39). In 1908, he had painted another version of this subject, but without the winged figure of Mercury in the upper left-hand side. The theme is perhaps the most popular in paintings of mythological subjects, allowing for the depiction of three voluptuous female nudes. The shepherd Paris, wearing a Phyrgian bonnet and crouched in the lower left-hand corner of the painting, is the judge of a beauty contest between the three goddesses Venus, Juno, and Minerva. The central figure of Venus is the victor, and steps forward to receive her prize of the golden apple. Any suggestion of the tragic consequences of this choice, which resulted in the Trojan war, are absent from this scene of pastoral bliss. It was perhaps to a work such as this that Mary Cassatt referred in a letter to a friend in 1913, when she reported 'He is doing the most awful pictures or rather studies of enormously fat red women with very small heads.'

Just why this subject-matter should have preoccupied Renoir at this time is not clear, and he went on to develop the pose of Venus accepting the apple into his large and important sculpture of *Venus Victorious* (page 28), which is virtually identical in pose, except that the goddess now holds the fruit. Certainly as a device for depicting female nudes it was unrivalled, but Renoir had already painted a number of female nudes grouped together in a landscape, using the stratagem of bathing (page 136). Certainly, the influence of Rubens whom he had admired in Madrid and Munich may have been partly responsible, and the theme was one which Rubens made a speciality (page 29). But Renoir had had access to one of the best collections of Rubens' work throughout his life in Paris and he does not seem to have drawn directly on his subject-matter before this time. The work may have had a more personal significance for him, which corresponded to his vision of an ideal world. The role that the shepherd Paris has been assigned in these works, that of the arbitor of beauty, was similar to that which Renoir himself adopted. For him, men were judges and indeed creators of beauty and solely responsible for culture. Women, in the landscape and in their 'natural' state of nudity were the mere objects of this civilizing process, and assigned a passive role.

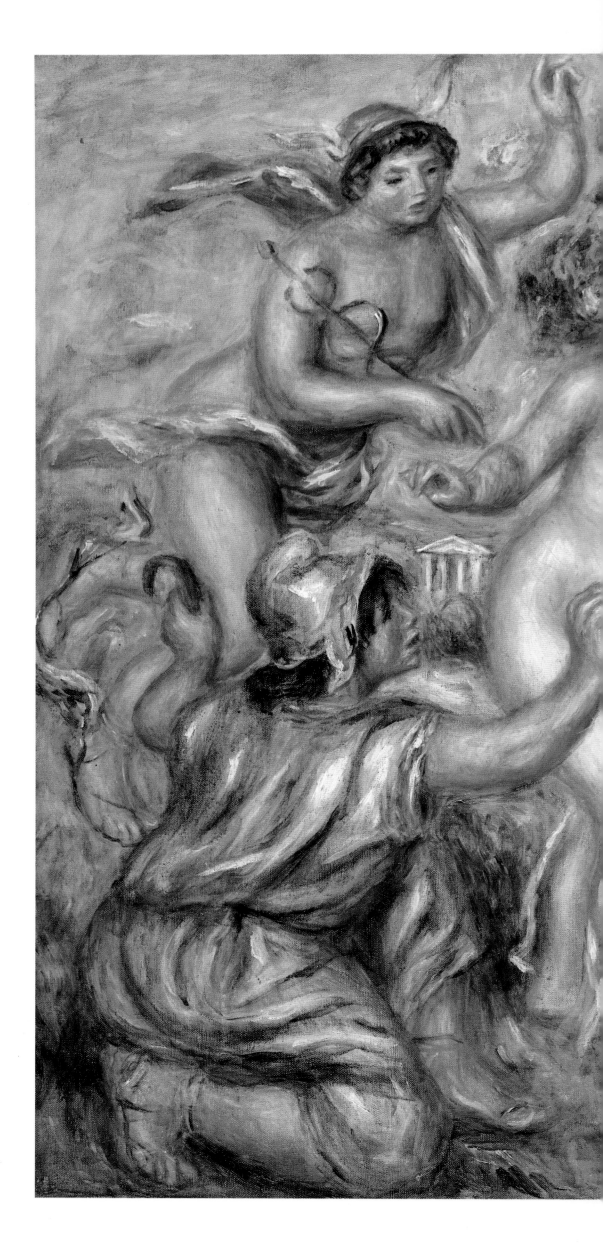

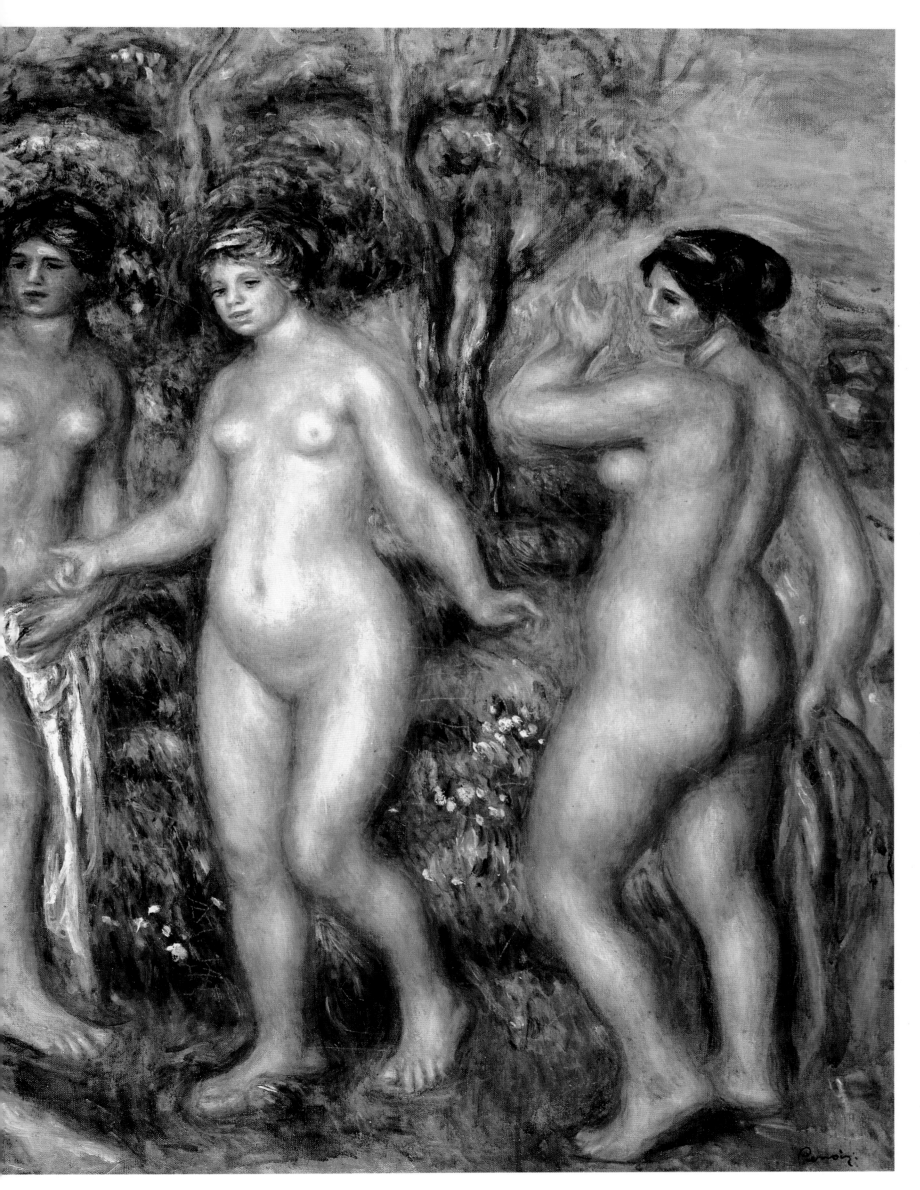

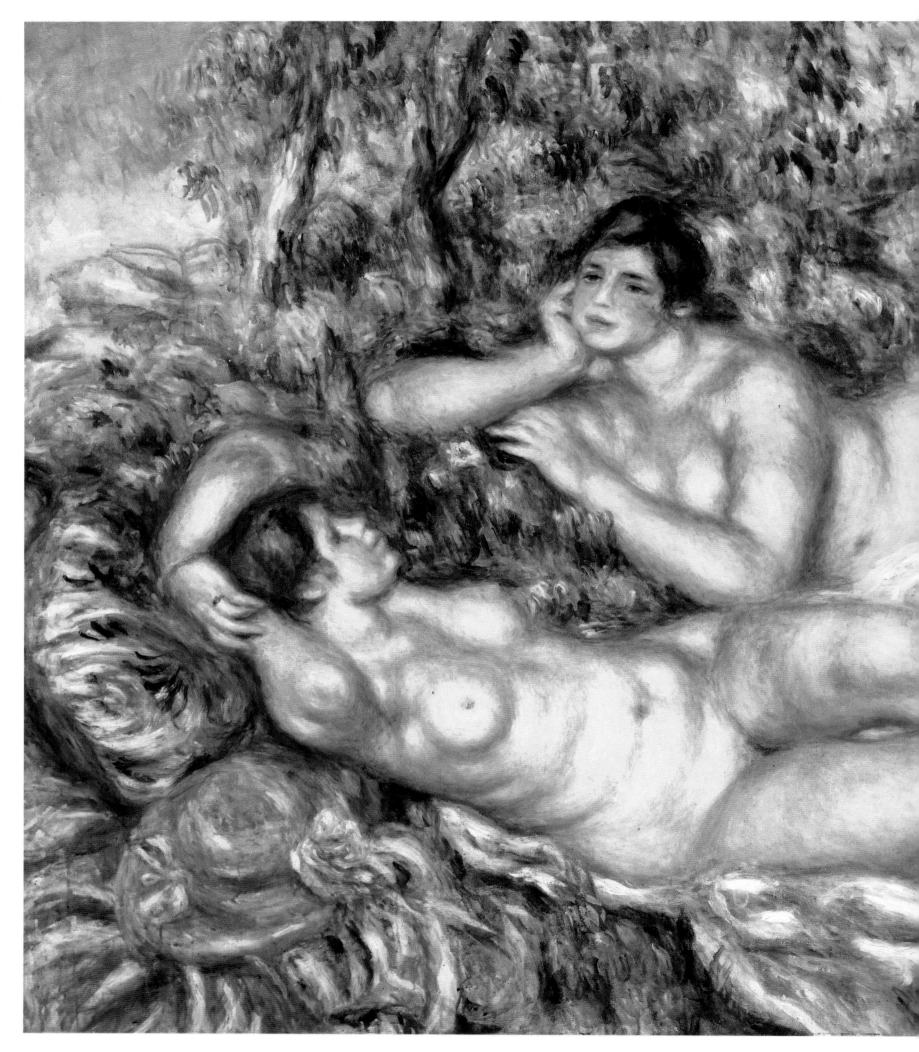

172

The Bathers, 1918-19

Oil on canvas
43⅓×63 inches (110×160 cm)
Musée d'Orsay, Paris

By 1918, when he began this work, Renoir was crippled, unable to walk and could only hold a paintbrush with great difficulty. His wife had died and the world was at war. When the armistice was signed on 11 November 1918, Renoir was at Cagnes, and may have begun this work in response to that event. According to Jean Renoir, the artist considered it the 'culmination of his life's work,' when he turned once again to the theme of the nude in a landscape. It shares certain similarities with the *Bathers* of 1887 (page 136). The two works were almost the same size and used the same device of small background figures to counterbalance the monumental foreground nudes. They share the same ideal vision of a calm, untroubled world. However, in appearance the works are quite different. The *Bathers* of thirty years previously resembled marble whereas the late work pulsates with hot, sensuous flesh. Using a system of pulleys, Renoir could raise and lower his unstretched canvas, and paint more easily while seated. A new model posed for this work, sixteen-year old redhaired Dédée Hessling whom Jean Renoir married after his father's death.

The work has excited some controversy. The 'awful pictures . . . of enormously fat red women with small heads' to which Mary Cassatt had objected in 1913, were not universally admired. The appearance of the voluptuous nudes held little relevance for contemporary women, who were pressing for emancipation and whose heroines were more likely to be drawn from the popular cinema than from the vision of a 78-year old man's paintings. In a major retrospective of Renoir's work, held at the Musée de l'Orangerie in 1933, Madame Gérard d'Hourville, writing in *Le Figaro* found little to praise in the *Bathers*:

a group of Pomonas – inflated pneumatic figures, smeared with a sort of reddish oil – are reclining in an orchard, where they appear to be ripening, and are wholly resigned to their fate of becoming monsters prior to being eaten.

Index

Acknowledgments

The publisher would like to thank Martin Bristow, who designed this book, Moira Dykes, the picture researcher, Alison Smart, the indexer, and Aileen Reid, the editor. We would also like to thank the following agencies, individuals, and institutions for supplying the illustrations:

Aberdeen Art Gallery: pages 12-13
The Art Institute of Chicago/Potter Palmer Collection: pages 100-101, 102/Lewis Larned Coburn Memorial Collection: page 107/Mr and Mrs Martin A Ryerson Collection: page 119
The Barnes Foundation, Merion Station, PA 19066 (photograph © 1991): page 24
Bison Group: page 18 (below), 15 (below)
The Burrell Collection, Glasgow: page 21
The Cleveland Museum of Art/Bequest of Leonard C Hanna, Jr: page 140
Collection Sirot/Weidenfeld Archive: page 12
Courtauld Institute Galleries, University of London: pages 79, 156
E G Bührle Collection, Zurich: pages 110, 145
The Fine Arts Museum of San Francisco/Mr and Mrs Prentis Cobb Hale in honor of Thomas Carr Howe, Jr: page 63
Fitzwilliam Museum, Cambridge: pages 27, 111
Fogg Art Gallery, Harvard University/Bequest of Maurice Wertheim, Class of 1906: page 7/Grenville L Winthrop Bequest: page 33
Folkwang Museum, Essen: page 41
Hermitage Museum, Leningrad/Bridgeman Art Library: page 130
Hiroshima Museum of Art: pages 170-171
Kunsthalle, Hamburg: page 71
The Metropolitan Museum of Art/Wolfe Fund, 1907, Catharine Lorillard Wolfe Collection: pages 98-99/Robert Lehman Collection, 1975: page 142
The Minneapolis Institute of Arts/John R Van Derlip Fund: pages 116-117
Musée du Louvre/Réunion des Musées Nationaux: pages 9, 10 (above), 19 (below)
Musée Marmottan, Paris: page 70
Musée de l'Orangerie/Réunion des Musées Nationaux: pages 148-149, 152, 153, 158/Collection Walter et Guillaume: pages 86, 87, 146, 147
Musée d'Orsay/Réunion des Musées Nationaux: pages 1, 10 below), 11 (below), 14 (above), 30, 37, 65, 83, 91, 92-93, 94-95, 118, 121, 124, 125, 162, 167, 172-173
Musée du Petit Palais, Paris/Photo BULLOZ/Weidenfeld Archive: page 6
Museu de Arte de São Paulo/Photo Luiz Hossaka: pages 36, 59, 115, 138
Museum of Art, Rhode Island School of Design/Museum Works of Art Fund: pages 164-165
Museum of Fine Arts, Boston/Bequest of John T Spaulding: page 57/Juliana Cheney Edwards Collection: pages 120, 122
Museum of Fine Arts, Houston: page 64
Courtesy of the Trustees of the National Gallery, London: pages 13, 29, 50-51, 97, 108-109, 126-127, 135, 150, 160, 161
National Gallery of Art, Washington DC/Chester Dale Collection: pages 2, 39, 60-61/Ailsa Mellon Bruce Collection: pages 68-69, 82-83/Weidener Collection: page 77
National Museum of Wales, Cardiff: pages 21 (above), 74-75, 168-169
National Museum of Western Art, Tokyo: page 66
Nationalmuseum, Stockholm/photograph Statens Konstmuseer: pages 34, 52-53
Neue Pinakothek, Munich: page 15 (above)
The Norton Simon Foundation, Pasadena, CA: pages 42-43
Oskar Reinhart Collection 'Am Römerholz,' Winterthur: pages 31, 54-55, 88
Parc de Versailles/Réunion des Musées Nationaux: page 20
Philadelphia Museum of Art/The Henry P McIlhenny Collection in memory of Frances P McIlhenny: pages 84, 131/Mr and Mrs Carroll S Tyson Collection: pages 136-137
The Phillips Collection, Washington DC: pages 112-113
Portland Art Museum, Portland, Oregon: page 81
Private Collection/Weidenfeld Archive: page 13 (above)
Rijksmuseum Kröller-Müller, Otterlo: page 48
Roger-Viollet, Paris: page 17 (below)
Staatliche Museen Preussischer Kulturbesitz, Nationalgalerie, Berlin: pages 44, 128-129
Staatsgalerie, Stuttgart: page 89
Städelsche Kunstinstitut, Frankfurt: page 104
The Saint Louis Art Museum, St Louis, Missouri/Museum Purchase: page 49
The Tate Gallery, London: page 28
Wadsworth Atheneum, Hartford, CT/Bequest of Anne Parrish Titzell: pages 73-73/Ellen Gallup Sumner and Mary Catlin Sumner Collection: page 163
The Wallace Collection, London: page 22
Wallraf-Richartz-Museum, Cologne: page 46
Weidenfeld Archive: pages 14, 17 (above), 18 (above), 25 (both), 26 (both), 27 (both)
Worcester Art Museum, Worcester, MA: page 85
Yale University Art Gallery, New Haven, CT/The Katharine Ordway Collection: page 139